vious book,

The Case of the Missing Links

"For your summer reading list: *The Case of the Missing Links* follows two detectives who prowl Pebble Beach to recover a stolen golf course design."

—*Golf for Women*

"There's plenty of foreplay and wordplay in this golfing mystery debut by sports columnist Tyler.... Win and June are congenial heroes, and the author displays enough wit to make this trip around the links an enjoyable one."

—*Publishers Weekly*

"A charming and literate entry in the golf mystery genre, with captivating characters and an evocative sense of place."

—Lora Roberts, creator of the Liz Sullivan mystery series

"In this charming bit of mystery fiction from golf writer Tyler, a famous golf-course architect 'loses' his only set of plans for a new course.... This is well focused, crisply written, and often humorous."

—*Library Journal*

"Somebody has stolen a golf course! Private detectives Jacobs and Winslow are hired to solve the mystery. They soon discover that everybody is a suspect in this most unusual of crimes. This light tale is a humorous and quick read that is highly recommended for a rainy day."

—*Schwing! Magazine*

The Teed-Off Ghost

A Hawaiian Golf Mystery

 Lee Tyler

Fithian Press, Santa Barbara · 2002

Any resemblance to actual persons is simply coincidental. I also ask indulgence of the people of Hawai'i for taking certain liberties for the sake of the story with their islands' history, legends and myths.

Published by Fithian Press
A division of Daniel and Daniel, Publishers, Inc.
Post Office Box 1525
Santa Barbara, CA 93102

Cover photo: Thirteenth hole at Mauna Kea Golf Course.

LIBRARY OF CONGRESS CATALOGING-IN-PUBLICATION DATA
 Tyler, Lee, (date)
 The teed-off ghost : a Hawaiian golf mystery / by Lee Tyler.
 p. cm.
 ISBN 1-56474-389-6 (pbk. : alk. paper)
 1. Private investigators—Hawaii—Kona (Hawaii Island)—Fiction.
2. Golf courses—Design and construction—Fiction. 3. Kona (Hawaii Island, Hawaii)—Fiction. 4. Golfers—Fiction. I. Title.
 PS3570.Y48 T44 2002
 813'.54—dc21

 2001004150

*I dedicate this book to the memory
of an extraordinary innkeeper,
Grace Buscher Guslander,
and also to the skill and devotion of
Hawai'i's golf course superintendents*

For their encouragement and help with *The Teed-Off Ghost*, my most sincere thanks to the following people.

On the mainland: golf architects Arthur Jack Snyder and Geoffrey S. Cornish; former Hawai'i Visitors Bureau manager in San Francisco, the late Anne K. Holt; course superintendent Steve Carlton, then of Crystal Springs Golf Course; my amiable ghost model, George Ambrosio; mystery lover Carol Ann Stafford, and ardent Hawai'i travelers Bill West and Caroline Condon McHenry.

In Hawai'i: *mahalo* to golf writers Bill Bachran on Oahu and Emily Gail on the big island; cultural teachers Ku'ulei Keakealani, Earl Kamakaonaona Regidor and Bill Boyd; wise *kahu* Charles Ka'upu and also the Rev. Nani Saffery; romance director Pinkie Crowe; course superintendents Russ Dooge, Short Honma, Bob Itamoto, Pancho Nakamoto, Steve Olsen; golf club managers Neil (Buster) Bustamante and Dave Gleason; and Donna Kimura, public relations manager, The Orchid at Mauna Lani.

Also: If'i So'o, fire dancer; Lanihuli Friedenburg, museum manager, Lahaina Restoration Foundation; golf pros Dennis Rose and Howard Kihuna; John Capone, tapa cloth artist; Gordon Medcalf and Lowell Matuoka of Island Coins and Stamps, Lahaina; Sharon Sakai, Kohala Coast Resort Association; barman George Kaluna, Alan Kaaekuahiwi of the Mauna Kea Golf Course; Linn Nishikawa, former P.R. person for Kapalua; Luly Unemori, formerly of the Wailea Golf Courses; and Catherine Tarleton, marketing assistant for the Mauna Kea and Hapuna Prince resorts.

And deep gratitude to my editor and publisher, John Daniel, without whom there would be no ghost.

The Primary Characters

Mainlanders —

June Jacobs, *a private investigator from Burlingame, California*

Harry ("Win") Winslow, *her partner and lover*

Doug Banner, *their old friend and a noted golf course designer*

Wally ("Whambo") Wood, *a professional golf champion*

Margaret (Meg) Hartwell, *Wally's bride-to-be*

Islanders —

Martha Masters, *the owner and manager of the Mauna Makai Resort*

Charlie Leong, *the resort's concierge and cultural historian*

Sugar Boyd, *the resort's Director of Romance*

Keoki Kalama, *jack-of-all-trades and grounds manager for the Mauna Makai*

Ted Tamura, *greenkeeper and course superintendent for Kukuna, the golf course at Mauna Makai*

Moke Kahoohano, *the resort's resident* kahuna

Aiulani Kalama, *star dancer in the resort's hula show, and Keoki's daughter*

Sonny Apaka, *the firedancer in the hula show*

Ben Kamelele, *the hula show's emcee and star performer*

and —

Angus MacNeil, *a Scottish sailor, born in 1775*

The Teed-Off Ghost

Prologue

On a warm morning in May, 1790, Angus MacNeil gazed out over the ship's rail at the tropical island his captain called "Ow-why-hee."

Angus, a lad of fifteen, had run away from his home in Scotland—from his grim parents, from the grimmer weather, from the prospect of working the rest of his grim life in his father's grim shop—and had signed onto an English trading ship as a carpenter's apprentice. Angus wanted adventure. He wanted to see the world. For over a year now he'd sailed the Pacific Ocean, but as a lad, he was not allowed off the ship, no matter where she docked. The unfortunate boy listened to the tales the sailors told after their binges in the ports of San Francisco and Shanghai, and he grumbled to himself, as only a Scottish adolescent knows how. Someday, Angus swore, someday he'd go ashore and see the world for himself.

They'd been anchored off this beautiful tropical island for a week. It had been a week of hard work, taking on fresh provisions. The natives had been cooperative and friendly, the weather had been balmy, the view like paradise, and the sailors all looked forward to that afternoon, when all the work would be finished and the captain would allow them a shore leave. All but Angus. Angus would stay on board that evening and mope. But there was nothing to do about it. Angus knew better than to disobey his captain.

Early in the week two of the natives had tried to steal a longboat. The captain had caught them and personally whipped

them, then tossed their bleeding bodies overboard so they could swim back to shore. The punishment had been severe, but effective: the natives had given them no more trouble and had cooperated fully, supplying the visiting ship with water, fresh fruit, hogs and chickens, in exchange for beads and buttons and calico cloth.

Angus was the first to see the phalanx of canoes shove off from shore. The captain and crew joined him at the rail and watched the natives paddle out to their ship and surround it, making gestures that seemed friendly and inviting.

"Lower the ropes," the captain ordered. "Let the buggers up. Maybe they have more trinkets to trade."

Aboard they came, the natives pulling themselves up and over the railings, grinning like fiends. They were still grinning when they pulled their daggers from beneath their loincloths.

Angus quickly hid himself under a lifeboat, where he listened to the war-whoops and the cries of anguish. The whole massacre took less than half an hour, and when Angus heard the natives diving off the ship and then chanting as they paddled back to shore, he crept out from his hiding place and observed the carnage: the decks slippery with blood and strewn with the decapitated bodies of his captain and shipmates.

That night Angus slipped down into the warm black water and swam to shore. It was just in time, too, for from his spot on the beach, he watched the canoes returning to the ship with blazing torches. Angus saw his home devoured by flames. Then, when he saw the canoes coming back and headed his way, he fled from the beach, up the bank to a grove of coconut palms, where he spent the night in a cave.

Angus MacNeil stayed in Hawai'i the rest of his life. He learned to trust and like the smiling natives, and they learned to trust and like him. He taught them how to use hammer and nails, how to shoot a gun, and how to bargain better with the English trading ships. During his time in Hawai'i, he saw volcanoes erupt, and he saw island wars, but life was good, and he married a

beautiful maiden who cared for him and taught him love. She brought to the marriage a dowry of land. Angus had a home.

Angus was happy in this tropical paradise, and he did not miss stern Scotland one bit. The only thing he missed was the game he had played a few times as a boy in his home town of St. Andrews. And so one day he cut a slender branch from a sandalwood tree, one with a wedge shape at one end. He found a few small round lava pebbles and began hitting them up and down the beach. When he decided that sand wasn't an ideal surface for this game, he found an open field, where he cut the vegetation down to a pleasant green lawn. From then on, till the end of his life, he spent his days swatting the lava balls around that field with his sandalwood club, while the natives looked on, smiling in wonder.

Angus was never able to teach the Hawaiians to play golf. They were never able to teach him to smile. But he was a happy man.

In 1832, an influenza came to Hawai'i aboard a Portuguese ship. Angus had a raging fever as he buried his wife. Then he walked down to the sea one last time, using his sandalwood club for support. He bathed, then, dressed in the sailor's clothes he hadn't worn for over forty years, he crawled into the cave where he had spent his first night in Hawai'i, and there he died, in the midst of a delirious dream about the green links of St. Andrews.

On a hot afternoon in November, 1884, Captain William Brush paused from his labor, mopped his brow, and looked down upon the lava field that stretched to the sea. He loved this strange land he now called home, and he was giving it the loving touch it needed: he was building a wall. Having grown up in stony New England, he knew that building and mending walls was the way to love and honor one's land.

William Brush had retired from a long hard life as the captain of a trading ship plying the Pacific. When he decided to settle in Hawai'i in the mid-1850s, he sent for his long-neglected wife.

Sarah had never quite adapted to Hawaiian life. She missed snow, she missed Boston society, and she missed her family, especially her sister, Susan Hartwell, to whom she wrote long letters, once a month. William had one of those letters with him that November afternoon; it rested on a low spot of the unfinished wall, in an envelope that also included a collection of small gifts. The envelope was addressed and stamped, and then well wrapped in tapa cloth. When William reached the harbor that afternoon, the tapa cloth would be unwrapped by the postmaster, the package would be registered in a log book, and then the package would be rewrapped in the sturdy tapa cloth to seal it against whatever weather it might encounter on its way across sea. The tapa cloth would be removed in an American port, and the envelope would continue its journey overland to Boston. Poor Sarah. How she missed Boston.

But William was content. He had his ranch, and he had his walls to build. He wished he could persuade the natives to help him build the walls, but they'd turned him down, telling him that they were not wall-builders. "But there are walls all over this part of the island," he had pointed out. They'd smiled at him and shook their heads. Those walls were called *pāpōhaku*, they said, and they were built by ghosts. *Menehune*. The little people.

And that was another thing Captain Brush wished he could do: convince these islanders that their superstitions were poppycock. Walls are built by honest Christian sweat, not by ghosts. There are no ghosts. *Menehune*, whoever they are supposed to be, do not exist; of this he was sure. Ghosts, indeed!

The captain was lifting a large stone when he heard a shout from behind him: "Fore!" He set the stone down on top of the package his wife had given him to mail and turned around, just in time to see a small stone whiz past him. Then he saw an old man dressed as a sailor walking across the field toward him, carrying a strange stick. Fear gripped Captain Brush. The natives were trustworthy, but one could never tell about these foreign sailors who

came onto the islands looking for fun. Some of them were drunks, and some of them were thieves. This man had thrown a stone, and he was brandishing a club. Captain Brush had nothing on his person worth stealing, but to protect his wife's package he hastily piled a few more rocks on top of it until it was invisible.

"Sorry I almost hit you," the sailor said when he reached William. "Did you see where my ball went?"

"What are you doing on my land?" the captain asked. "You're welcome, of course, but..."

"This was my land once," said the sailor.

"I've owned this ranch for thirty years," the captain insisted. "Bought it from a native family."

"My wife's family."

"Then you are...?"

"Angus MacNeil. Ah, there's my ball," the old sailor said, and with that, he walked through the wall. Not over, not around. Through.

Angus retrieved his lava ball and walked back to the wall, but when he got there, Captain William Brush was nowhere to be seen. Must have frightened the poor fellow, Angus thought. Well, the least I can do is give him a hand with his wall. Angus set down his club and spent the rest of that afternoon finishing that stretch of the captain's wall.

In the cool of a July morning in the year 2000, a team of Caterpillar tractors fanned out across the vast field of long-hardened lava. Like great greedy monsters from a prehistoric past, they chopped and slashed vegetation and pulverized the black rocks in their way.

This stretch of the coast had once been a fertile place, a favorite dwelling spot for fishermen and growers of luscious fruits and taro. Volcanic eruptions from the brooding mountains above had buried all that, but a new era was dawning. What had been a bleak field of lava for hundreds of years would, over the next two years, be transformed into the ninety-first golf course built in the

Hawaiian Islands. Golf was becoming the industry that would heal the land, enriching the Hawaiian economy, and providing pleasure to countless vacationers.

The late Robert Trent Jones, Sr. had proved it could be done, when he built the famous Mauna Kea course back in 1960. He had ordered all earthmoving equipment for that pioneering course to be fitted with special high-intensity rollers that could not only crush the lava but make it powdery and receptive to seedlings for green, healthy golf grass.

If Mauna Kea could do it, so could Mauna Lani, Hāpuna, Waikoloa, and Hualalai. And now Mauna Makai, the newest and the best, scheduled to be opened in October, 2002. It would be the jewel in the crown of the Kohala Coast of the Big Island, a paradise for golfers from all over the world.

The Cat operators were in high spirits. They were earning good money, and they were having fun. From high up in their seats over their roaring machines, they worked as individuals and as a team, making pass after pass over the quadrants of lava, grinding and spitting black residue into the tropical air. Manny, the operator of machine number five, was especially happy; he was going to get to knock down that low stone wall that separated the lava field from the vegetation on the other side. He'd been looking forward to that demolition for days.

But as he lumbered toward the wall, Manny noticed a strange old man sitting on it, waving a strange wooden stick. Manny cut the engine, removed his industrial earmuffs, climbed down from his lordly perch, and stomped across the black rocks to the wall. "You'll have to get off that wall, sir," he told the old man. "I'm about to demolish it."

"You'll do nothing of the kind," the old man said.

"Who are you?"

"I built this wall with my own hands. This part of it anyway."

"That's crazy," Manny said. "This wall's been here for over a hundred years."

"Did I say it hadn't?" the old man replied.

"Whatever, dude," Manny growled. "Now move along, because I'm coming this way, and this wall's coming down whether you're sitting on it or not."

"I doubt that," the old man said. He waved his stick in the direction of the Caterpillar tractor, and Manny heard the engine fire up. He whirled around and saw his tractor lumbering off in the opposite direction, with no driver at the controls.

He spun back to confront the old man, but the old man was nowhere to be seen.

It was five in the morning on a Monday in March, 2002. It was not quite light, and around the grounds of the Mauna Makai resort's nearly completed golf course, waning moonshine cast ghostly shadows. Fingers of palm fronds grasped at nothingness. Old lava rocks guarding a carefully preserved *heiau* glowed like grave markers.

Ben Kamelele was new on the job. He had been at the resort for two months, but he had been working on the greenkeeper's crew for only a couple of weeks, and as the newest member of the team he had been given the responsiblity of opening the maintenance equipment barn every morning. He did not enjoy being out on the golf course while it was still dark. There had been stories of Night Marchers, and no wonder. Some said man had no business changing the land that the volcano goddess Pele had created. Ben didn't mind the hard work. But he was spooked by the dark. Well, it came with the job, and until someone else joined the crew, he had to be the first one out there.

Ben was also the master of ceremonies at the resort's biweekly hula show, and he loved that part of the job. He especially enjoyed spending time with his co-star, the lovely dancer Aiulani. But he needed to earn more money, and so he'd also signed onto Ted Tamura's golf course maintenance team. He hoped to earn enough to win Aiulani's affection.

He fumbled his key into the lock on the barn door. He pushed the door open and walked into the dark, windowless building. He flipped on the light switch.

No response.

Bulb must be out, he thought, as he felt the wall for the security chain that was coiled there. It wasn't there. It hung loose. Hackles rose on the back of his neck.

"We need some light, is what we need," he said aloud, fumbling on the shelf where he hoped to find a replacement bulb. Then, from behind him, came the sound of a rattling chain.

"Who is that?" Ben asked. "Ted, that you?"

No answer but the angry rattle of metal, coming closer. Ben turned around.

A bit of dawn light was now coming through the open barn door, and Ben could see the outline of a muscular male figure wearing only a loincloth on his body and a large beaked helmet that covered his face.

"Who are you?" Ben gasped, already knowing the answer: a Night Marcher. "What do you want?"

The ghost's voice was raspy and low. "I want you to stay away from the hula dancer. Stay away from her!"

Ben pushed past the ghost and fled the barn and took off running.

Sonny Apaka laughed as he took off the helmet. What a sight—the handsome performer running like a frightened rabbit. If Aiulani could see that, she'd quit flirting with Ben, for sure.

Sonny set the helmet down on a workbench and screwed in the lightbulb that he had unscrewed earlier. Light flooded the equipment barn, and that's when Sonny first saw the ancient man sitting on the work bench. A strange old man in a sailor suit.

"Who are you?" Sonny asked the man. "Can I help you?"

"Put on some clothes," the old man replied. "That's not proper attire for a golf course." The old man was not smiling.

Sonny nodded and swallowed. He walked quickly to the wall

where his jeans and T-shirt were hanging and put them on. Then he turned to face the old man again, but the old man was gone. Sonny went to the barn door and looked out into the dawn light.

The old man was nowhere to be seen.

1. Flying to Paradise

"Would you like chicken or beef?" the flight attendant asked with a bright smile.

"Dinner already?" June asked. "It's only four o'clock."

"Actually, this is lunch," the flight attendant explained. "It's only one o'clock in Hawai'i."

"But we had a bite to eat in the San Francisco airport," June said.

"So you're not hungry?"

June turned to Win, her partner and lover, and they both grinned. "Beef," Win said.

June said, "Make that two."

Why not? They were on their way to Hawai'i, for the first time in their relationship. In fact, June had never been to Hawai'i before, although she had always wanted to go there, to see for herself the beauty of that legendary paradise. Win had been to the Islands several times, but he didn't have much to say about them, except to confirm that Hawai'i was indeed paradise. Beautiful courses. Golfing year-round.

Harry ("Win") Winslow and June Jacobs were private investigators who lived and worked in Burlingame, California, just south of San Francisco. They were also both avid golfers. Although they very much enjoyed working together—which they had been doing for several years now, first as partners on the Burlingame Police Force and now as a team of private eyes—they seldom played golf together. Win had taught June the game, and right from the beginning June had displayed an almost magical gift for it. So

much so that she consistently beat the pants off Win every time they played together. So they agreed to have separate tee times as a general rule, largely for the sake of Win's ego, but also to keep competition out of their love affair.

In business, though, Win and June worked well together, and had built up a strong reputation as the best P.I. team in the country among those who specialized in solving golf cases. As far as June knew, they were the *only* private investigators who had that specialty, which was an easy way of being the best, but the reputation was well earned. Their cases had been written up in all the golf magazines, and their smiling faces had even made the cover of *Golf Digest.*

And now they were off to Hawai'i, about which June knew nothing but what she'd seen in the movies and on television: hula dancers, surfers, ukuleles, and lei. She couldn't wait to get there. If only they were going there on vacation. She and Win needed a vacation. They needed time together, without work, without golf....

Well, not this time. This trip was all golf, and all work. Still, they'd be in paradise, for a whole week. A great place to spend a week in mid-November.

After they had finished either their dinner or their lunch and the flight attendant had taken the trays away, June reached for the in-flight magazine in the seat pocket in front of her, and opened it to an article about Hawaiian petroglyphs.

Win opened up his briefcase and took out the FedEx package they had received just that morning. It contained a letter from their friend Doug Banner, a distinguished golf course architect, who was in the final stages of building a new golf course at Mauna Makai, the newest resort on the Kohala Coast of the Big Island. The package also contained a confirmed reservation for a week's stay at the resort and a brochure about the place featuring photos of the beautiful golf course in progress. It had also contained two round-trip tickets from San Francisco to Kona. And Doug's letter, of course. Win unfolded the letter and read it again:

Dear June and Win,

Help!

Sorry to impose on you guys, but I'm in big trouble, and
so is my golf course. Please come *right away*. I'm sending
this overnight, even ordering a Saturday delivery to your
home so you'll get it in time. Don't ask questions, folks, just
hop on the plane. I'll meet you when you get here, and I'll
explain the whole mess.

Okay, here are a few details. The Mauna Makai resort
has been open about a year, and it's been doing well, but
like all the other resorts on the Kohala Coast, its real attrac-
tion will be the golf course, which I've had the honor and
pleasure of designing. Kukuna (that's the name of my new
course) is supposed to open on Thursday morning. It'll be a
big event. The press, including the golf press, will be on
hand. We even have a star celebrity for the occasion: the
first game will be played by Wally "Whambo" Wood and his
foursome. The entire golf world is going to be watching. It's
the crowning achievement of my career, too, my best golf
course ever! You don't want to miss this event!

Unfortunately, there's more to the story. For some
reason, somebody, I don't know who, doesn't want the
Kukuna to open on time. I don't know who it is, and I don't
know why. And I can't stick around to find out. I have a rush
job on the mainland that I need to get back to right away.
I'm flying out on Sunday. That's why I need you here, to
watch over things. The Mauna Makai will put you up for a
week, meals included, and also pay you your usual fee. The
plane tickets are on me.

Hurry!

Your pal in distress,

Doug

Win took another look at the resort brochure. The front panel featured a photo of a beautiful fairway, with a green in the distance, a bunker to the side, and the sparkling sea beyond. In the foreground was a four-foot-tall black wall that stretched across the fairway. That's an unusual feature, Win thought. Trust Doug to throw in something original. Wonder how long it took to build?

Then he read the letter again. He turned to June and said, "You know, there's something about this whole business that I don't like."

"What's that? Besides the leather in gravy that you just ate for lunch?"

"Look," he said, showing her the Mauna Makai brochure. "The newest golf course in the world, at one of the most beautiful resorts in the world, and it's all expenses paid."

"So who's complaining? What's wrong with that setup?"

"Kukuna won't be open till Thursday, and that day will be taken up with a celebrity match. We probably won't get to play golf till Friday. That's what's wrong."

"You've got a one-track mind," June said, slapping his belly with her magazine. "Maybe we can find something else fun to do."

"Like what?"

June looked at him with seductive intensity, raised her eyebrows, and slowly winked one eye.

Win chuckled. "You're the one with a one-track mind."

"Look!" she exclaimed, pointing beyond Win, out the window.

There in the distance, a dark green island rose from a dark blue sea. As the plane approached it, the island seemed to grow like a living thing, and then they were flying over it, marveling at the lush forested mountains, the pastures, the great clefts of valleys. They even saw waterfalls. "It's so green!" June gasped. "Have I died and are we on our way to heaven?"

And then, as if to answer her question, the landscape changed. Just like that the vista became dark, intense, brooding.

Now the jet was sinking, and it was flying over an ugly, inhospitable black field. "Yikes," she murmured. "That's not heaven."

"It is too," Win beamed. "It's the Kohala Coast. Home of some of the world's greatest courses. It goes on for forty miles."

"We're landing," June said. "I'm going to shut my eyes, just in case we crash. I don't want that landscape to be the last thing I see. Hold my hand. Give me some gum. This is spooky, Win."

Win held her hand through the gentle ordeal of a perfect landing, and when she dared to open her eyes again, she looked out the window at Kona International Airport. It looked like a colony of little thatched huts. There were palm trees all around, their fronds tossing in the breeze. It was obviously a warm afternoon, because the people waiting for the plane to arrive wore shorts and colorful Hawaiian shirts. One of those people was their friend Doug, who had a couple of welcoming lei draped over one arm.

The engines stopped, the seat-belt sign went off, and the passengers rose from their seats. "Okay, partner," June said. "Welcome to the land of leisure. Let's go to work."

2. Aloha

Hugs all around.

Doug draped the strings of orchids over the necks of his mainland friends and said, "Aloha, you two. I sure am glad to see you!"

"Is this the Doug we know?" June exclaimed. "I don't think I've ever seen you without a tie around your neck. Have you gone native?"

Doug chuckled. "No, not hardly. I can't wait to be done with this place, frankly. But meanwhile, I do as the Romans. Ties aren't legal here, you know. It's a state law."

Win said, "What's the matter? Aren't you having a good time?"

"Let's get your luggage," Doug answered. As they walked to the baggage claim, he said, "Actually, I love this place, and yes, I've had a good time here. The climate is heavenly, the people are lovely, the scenery gorgeous, the food is to die for. But lately it's been one headache after another. Believe me, I'm ready to go back to my air-conditioned office in Silicon Valley, put on my tie, settle for fast-food lunches, and get some work done with a bunch of other Type-A cell-phone junkies. At least they live in the real world."

"And this isn't the real world?" June asked. "Sure smells nice here."

"Yeah," Doug admitted. "Especially in the late afternoon. Are those your bags?"

"That's us," Win said, pulling two golf bags off the carousel.

"That's it? No clothes?"

"They're in our carry-on. And there's some more stuffed into the golf bags."

Doug rolled one of the golf bags and Win took the other, while June rolled the carry-on behind her. They crossed the parking lot and stopped at a white stretch limousine, and Doug opened the trunk. "Nice wheels," Win commented.

"This belongs to the hotel," Doug said. "Martha Masters lets me use it. She's the hotel owner and manager."

"Very nice of her."

"Oh, Martha's nice all right. Nicest slave-driver I've ever worked for."

They got into the limo and left the parking lot and got out onto the Queen Ka'ahumanu Highway. As they drove north, they could see the sky turn rosy over the western sea. The lava landscape beside the road was decorated with messages spelled out in white coral rocks, which June read out loud: "'Love you, Donna,' 'Aloha Jack,' 'Sue loves Sam,'...Are these some of those famous petroglyphs I've read about?"

"Nah," Doug answered. "That's just graffiti. You'll see real petroglyphs tomorrow. They're one of my problems."

"Oh?"

"Look!" Win exclaimed. "There's the Hualalai Resort!" Down by the sea, where the lava ended, they could barely make out the fingers of that golf course, still emerald in the late afternoon light.

"And there's Waikoloa," Doug pointed out, a few miles later. "Two golf courses in there."

"This is paradise, all right," Win sighed.

"A few miles down the road is the Mauna Lani, and then, after that, the Mauna Kea, where it all began in 1964. That's where they proved that golf courses could be built out of lava. Mr. Jones, Sr. built that. I think he had beginner's luck."

"Robert Trent Jones, Sr. was no beginner in 1964, was he?" June asked.

"No," Doug admitted. "And I don't mean to make fun of him, because he's one of my heroes. But I don't know how he came up with the crazy idea of converting lava fields into fairways and greens."

"Won't support vegetation?" Win asked.

"That's not the problem."

"So what's the problem?"

"Madame Pele. The temperamental lady who gave us the lava in the first place."

"The goddess of the volcanoes?" June said.

"So they say. Here we are."

On their left a bed of multicolored impatiens spelled out the words Mauna Makai. Doug slowed down and turned off the highway, through a gate and onto a winding asphalt drive. As they zigzagged over the eerie black terrain, the sky before them was becoming a dramatic sunset full of rose and peach patterns.

"This is the strangest landscape I've ever seen," June remarked. "I feel like we're on the moon."

"Welcome to Planet Earth," Doug answered, "turned inside-out."

Finally, after a three-mile winding drive, they reached the Mauna Makai resort hotel, a colony of white low-rise buildings with bold red bougainvillea spilling from their balconies. As they got out of the car and stretched, June remarked, "Nice spread you got here, Mr. Banner."

"It's great," Doug said. "Not a bad room in the hotel. Half of them face the mountains, the others look out to sea."

"Not bad either way," Win observed. The sunset over the ocean was a spectacle of sweeping reds and deep oranges, and the mountains inland loomed like purple giants in the last light of day.

Rolling their luggage, they walked into the spacious lobby, which was comfortably elegant, made of tile and teak and tropical plants. When they reached the front desk, a door opened behind it and a woman emerged wearing a mu'umu'u and a warm smile. "Ah, Doug," she said. "You've brought your friends to the rescue! Welcome! I'm Martha Masters."

"June Jacobs," June said, shaking hands across the counter.

"Aloha, June." Martha turned to Win and said, "You must be Mr. Winslow."

"Call me Win," Win said, with his glamorous grin. June loved that cornball grin, which always got a little broader in the company of attractive women. And Martha was attractive all right, June noticed. In her mid-fifties, she displayed power and warmth at the same time, her auburn hair nicely coiffed and her bright teeth flashing.

"We're so glad to have you here," Martha said. "So relieved, right Doug?"

"You bet, Mrs. M."

Martha said, "You'll need to register, but your stay is on the house. We're counting on you to get to the bottom of our problem and prevent any more monkey business. You see, our golf course *has* to open on Thursday. I expect Doug's told you? That's why you're here. The golf course *must* open on Thursday." The smile was still there, but it was a smile that meant business.

"Gotcha," June said. "We'll do our best."

"I want you to act like regular guests," Martha added. "Nobody knows that you're detectives, and I'd prefer it that way." She took the registration card from Win and said, "Here are your keys. One for your room and another for the personal safe in your closet. I advise you to keep your valuables locked up. We've never had a theft, but our insurance policy requires me to give you that advice. Also, be careful with that key. If it's lost it can be a real headache. Our concierge has the only master key for the safes, and he's not always available."

Martha hit the bell on the counter and a young Hawaiian man appeared through the door behind her. "Ezra, our new guests are in suite six. Please make sure they have whatever they need."

"Yes, Mrs. M."

"The dining room is open till eight, if you're hungry," Martha said. "Or call for room service. I want you to be happy, so that you can get to work early tomorrow morning. Okay?"

Win said, "Very good. Ezra, lead on. Doug, we'll see you tomorrow morning?"

"Meet me tomorrow morning," Doug said. "Eight o'clock? Right here?"

Ezra arranged both golf bags and the carry-on on a hand truck and led the way. The evening was darkening, and lanterns glowed on the pathways through the hotel compound. Ezra led them between buildings and through the gardens, by the swimming pool, across the romantic footbridge to the door of suite 6. All along the way they heard the gentle sweet strains of ukulele music, which Ezra told them was piped all over the complex during the early evening hours.

He showed them into their quarters, a two-room suite beautifully furnished in cool whites and rich woods, with the softest of carpeting underfoot. Color accents mimicked the island's bright flowers, and a vaulted ceiling, partly glass, soared above the large

inviting living room. There were two bathrooms, one equipped with conventional amenities, the other offering bathing outdoors within the privacy of a lava wall enclosure. As for the bedroom, it cried, "Aloha!" The bed was plumped with fat pillows and covered with an exquisite hand-embroidered Hawaiian quilt.

Win gave Ezra a generous tip, and he departed without saying a word.

June wandered over to the screen door that opened onto a spacious *lānai*. She stepped out into the warm, gentle breeze and breathed in the perfumed air. The last light of evening glowed at the far end of the world. She heard her lover approach her from behind and felt his arms encircle her waist.

"So here we are, babe," Win said. "Are you hungry? Want to freshen up and go to the restaurant?"

June put her head back against Win's shoulder and said, "You know, Win, it's almost ten o'clock in California. And we've already had two lunches, one of which could pass for dinner. Maybe we should just go to bed."

"Tired, huh? Must be jet lag?"

"Who said I was tired?"

Hand in hand they walked into their bedroom, where their bed was turned down and the bedside lamp was turned low. On the pillow nearest to the lamp they found a gift. Where they might have expected to find a chocolate or an orchid, they found a stylish card with a legend printed on it.

SWEET DREAMS
The assistance of Hawaiian gods, friends, and *kahuna* (specialists) were often called upon in old Hawai'i to attract a new love, to set an existing relationship right, or even to end an unwanted affair. Sugar cane played an important role in the ceremonial prayer because of the power of words. The *manu lele* (flying bird) sugar cane was used to attract a new love. The *pa pa'a* (burned or overdone) cane was used

to strengthen or "heat up" a weakening relationship. The *pili mai* (cling, close) cane was used to bring love closer. To sever an undesirable love affair, the *lau kona* (despised, unfriendly) cane was used.

"How interesting," June said. "All those uses for sugar. Let's be sure we never put any lau kona sugar in our coffee."

Win gently pushed June backwards onto the bed and kissed her nose. "You're the only sugar I need," he said. "And that's a promise."

She pulled his face close to hers and whispered, "One lump or two?"

3. Coincidences

They walked into the lobby bright and early, after a good breakfast of papaya, mango, and eggs with Portuguese sausage for Win, macadamia nut pancakes for June, guava juice, and several refills of fragrant Kona coffee. Doug was waiting for them beside a glass display case that stood against the far wall.

"What's with the fancy clothes?" June asked him. He was dressed in slacks and a blue oxford-cloth button-down shirt. "Should we have dressed up?" She and Win both had on shorts and golf shirts, and their feet were clad in flip-flops.

"Of course not," Doug answered. "But I've got a plane to catch after we tour the golf course. As I told you yesterday, an emergency's come up back at the office."

"Can you do that, Doug?" Win asked. "Don't you have to be part of the grand opening?"

"Luckily, I have you two to take care of that for me. I can't tell you how relieved I am about that. So, are you ready to have a look at the scene of the crimes?"

"But Doug, we've hardly had a chance to talk. And now you're going to leave us on our own here?" June asked.

"No, you'll be in good hands. Starting with Ted Tamura. Let's go." He led them out the front door and across the hotel driveway to the Kukuna pro shop. But they didn't stop at the pro shop; instead, they walked down a dead-end road to a barnlike building on the edge of the course. "The maintenance shed," Doug said. "The course superintendent's headquarters." The door was open, and Doug called out, "Ted, you in there?"

"I'll be right out."

A short, balding, moon-faced man clad in practical khakis shambled out of the building, smiling shyly.

"Ted, I want you to meet June Jacobs and Harry Winslow, my friends from California. Guys, this is Ted Tamura, the best green-keeper I've ever worked with."

"Call me Win," Win said, offering his hand.

"So you two are private eyes, huh?" Ted said. "Gonna find out why everything's been going haywire around here?"

"We'll do our best," June said. "Do you have any ideas about what's been going wrong?"

Ted gave them a smile and a shrug that could have meant anything. "Come on. We'll go for a ride." He led them around the side of the equipment barn and climbed into one of the utility vehicles parked in the back. He switched on the ignition, then frowned as he listened to the motor. "Damn Sonny," he sputtered. "I told him to fix that damn transmission. The kid's useless anymore. Okay, let's take this other one."

"Why don't we walk?" June said.

Doug said, "I'm on a tight schedule, I'm afraid. I have a flight to catch. Besides, it's six miles all the way around, and not much level ground. The course wanders up into the slopes of the volcano."

"That's not dangerous?"

"This particular volcano hasn't erupted in over two hundred

years," Ted said. "Of course that doesn't mean it's not dangerous."

"Ted, we've been through all this before. We've cleared it legally, environmentally, geologically, historically, yadda yadda yadda. What danger could there be?" Doug turned to his friends and said, "Ted's worried about upsetting Madame Pele."

Ted shrugged. "Things could go wrong," he said simply. "Things already have gone wrong. All set?" He turned on the motor, and the utility cart rolled out onto Kukuna.

As they lurched along toward the first hole, Ted said, "I live up-country, up there, about ten miles away." He pointed to a mountain in the distance. "See that rainbow? That's Waimea, where I live. Sometimes in the middle of the night, I hear this golf course calling to me. Like it's crying for help. So I get up at like two in the morning and get dressed and drive down here to check on things. My wife thinks I'm crazy. Doug here thinks I'm superstitious. Me, I'm just doing my job. And you know what? Every time I've come down here, there's been something screwy. Like majorly wrong." He turned to Doug and said, "Explain that with your mainland logic."

"Like what?" Win asked. "What's gone wrong?"

"One time I found the course on fire. Just a small blaze in the rough by the sixteenth hole, but if I hadn't gotten there in time, we'd have had a serious problem. Then another time I found the sprinklers going full tilt all over the course. Explain that if you can."

"Glitch in the sprinkler system?" Win said. "Somebody messed with the plumbing?"

"The plumbing's fine. All underground. And the schedule is controlled by computer, and I'm the only one who can run it. The computer program checks out fine. No, this was something else. Don't ask me. I guess it's up to you guys to figure out what's going wrong around here. All I know is if I hadn't heard the golf course calling to me and if I hadn't come running, my grass would have drowned. Here we are at the first hole."

They looked out over the broad, sweeping fairway. A thick

carpet of welcome and promise, an easy walk in the park if it weren't for four gaping bunkers and a small lake in the way of the green.

"Beautiful, Doug," Win said. "Can't wait to play it." He turned to Ted and said, "And you've done a great job of keeping it beautiful."

"It's nice now," Ted agreed. "But I had a hell of a time getting the grass to grow green. Kept dying on me. Then I discovered that the fertilizer and grass seed mixture was full of salt. My God, d'you know what salt can do to a golf course?"

"Sounds like somebody on your crew has some kind of a grudge," June suggested.

"No way," Ted answered. "They're all good guys, and they're all Hawaiians. None of them would intentionally hurt the land."

"What about this Sonny you were complaining about?"

"Sonny's okay. He's a flake, but he's okay. He just happens to be a nineteen-year-old kid in love with the wrong girl, and as a result he doesn't take care of business."

They drove on along the course, past the second and third holes. "Nothing remarkable here," Doug commented. "These holes are just confidence builders."

Ted steered away from the path and stopped in back of the third green. He hopped out and said, "Follow me." He led them through a thicket of *kiawe* trees into a sudden clearing. There before them was a swirl of smooth lava into which had been carved stick figures of men and women, canoes, and fish.

"Petroglyphs?" June asked.

Ted nodded proudly. "This isn't as big a display as the fields at Waikoloa, Puako, or Mauna Lani, but I'm told these are more beautiful. Whoever carved these was a master artist."

"We discovered this field while we were carving up the land," Doug said. "My shapers would have torn it all up if the equipment hadn't broken down that day. That was a lucky coincidence."

"That's what you call it," Ted said.

"Ted doesn't believe in coincidences. He says there's no such word as 'coincidence' in Hawaiian."

"Is that true, Ted?" June asked.

"It's true that I said it," Ted said, winking. "Come look at this one." He pointed at a figure of a man wielding a stick that was bent to a right angle at the end. "What do you make of that?" The man was holding the stick with both hands and he appeared ready to swing it down from behind his head.

"Holy cow," Win exclaimed. "Now that's art I can relate to."

"A golfer, teeing off," June said. "His form's not too hot. His swing's too upright. Sort of like Win's."

"Hmmph."

Doug chuckled. "Well, chances are this guy never had a golf lesson. These pictures were done hundreds of years ago, long before golf came to the Islands."

"I supposed you'd call this a coincidence," Ted said. "If there were such a thing. Okay, all aboard. Next stop, the bloody bunker."

"The *what?*"

"You'll see."

Ted drove the cart onward, past hole after hole. The fifth through the eighth holes climbed sneakily uphill, now flirting with cool mists and sweater weather, then sidewinding back down again into the tropics. "This sure is pretty," Win sighed. "Doug, you've done a great job here. Kukuna's a beauty."

"A lot of credit goes to Ted," Doug said. "There's not a bad lie on the course, thanks to his expertise."

The par-five ninth streaked up again to a hilltop. June gasped at the spectacular sea view. "We've had mowing machines break down several times going up this hill," Ted said.

"Doesn't seem that steep," Win said.

"It's not. There's just something about this hill that doesn't like mowing machines."

"You talk as if the hill's alive."

"Isn't it?" Ted retorted. "It bleeds." He pointed to the bunker

beside the green. "Last Thursday, a week before we're supposed to open, my crew gets here and finds a big wet red mess on one side of the trap, with a bloody trail leading across the sand to the other side. The trail led off into those woods. My boys were spooked. They took the rest of the day off."

"That's when I decided to call you two," Doug added. "We can't afford any more episodes like this."

"Okay," June said. "Let's play detective. Was it human blood?"

"Maybe," Ted answered. "Or maybe a wild pig. Or maybe both. Probably both, I'd say."

Doug rolled his eyes.

"We have a legend about a half man, half hog. His name was Kamapua'a. He was crazy in love with Madame Pele. He would switch back and forth—pig, man, man, pig—and he could bleed at will, to make Pele feel sorry for him."

"When did he live, this guy? This pig?" Win asked.

"In the past. Who knows how long ago? It was right around here, though. There are remains of his temple—we call that a *heiau*—back in the rough."

"So what did you do about the blood?" June asked. "I see you cleaned it up."

"That's the funny thing," Ted said. "I brought Moke, our kahuna, out here to bless this hole. A kahuna's a wise person in tune with the spirits. I wanted to see what he thought of all this. But by the time we got here, the blood was gone."

"Someone had cleaned it up?"

"I don't think so," Ted said. "Nobody on my crew, anyway, and nobody else is allowed out here."

"But we still missed a day's work," Doug grumbled. "What's next? We still have the back nine."

They climbed back into the utility vehicle and started downhill. They scooted past the tenth and eleventh holes of Kukuna, then rose higher and higher into rural up-country, where they could hear the squealing of pigs and the bawling of cows. "The

whole back nine used to be ranchland," Doug said. "Quite a challenge. A bull got loose in here while we were shaping this dogleg. That's why it turns so abruptly."

"Now we got wild boars down here eating my grass," Ted added. "And next week it's going to be even worse."

"Why's that?" Win asked. "Are you expecting more wild animals?"

"The wildest of all," Ted said. "Golfers."

Suddenly they found themselves at the tee for the fourteenth hole, and Doug was beaming with pride. "There it is," he told his friends. "The jewel of my career. My crowning achievement. What do you think?"

Ted turned off the vehicle and they all got off to stretch and admire the view. Before them was a broad, beautiful fairway, and running right across it was a long stone wall, about four feet high. "I discovered that wall when I was tramping the course for the first time. It had been hidden for years beneath tangled growth. I couldn't believe how well-preserved it was. My first thought was to tear it down, because it was right in the way of the course. But my number one shaper wouldn't go near it. He said he tried once and once was enough. Said it was haunted."

"The ancient Hawaiians built walls like this," Ted explained. "They're called *pāpōhaku*. They're made out of lava rocks, built entirely by hand, without mortar. Some believe they were built by spirits."

"What do you believe, Ted?" June asked.

Ted shrugged. "Spirits or the ancient people. Doesn't much matter, does it? So long as we honor it and leave it alone."

"You've honored it, all right," Win said. "That's the wall on the front of the Kukuna brochure."

"I've got to admit I'm glad we didn't take it down," Doug said. "Even if it was for superstitious reasons."

"Doug, you've got to quit calling our beliefs superstitions," Ted scolded.

"I'm trying to get my work done, Ted. It doesn't help to have to stop work every time someone's afraid of upsetting a spirit." Doug turned to Win and June and said, "One of the reasons I'm glad you guys are here is so you'll find some real flesh-and-blood prankster behind all this trouble. I tell you, this has been really frustrating dealing with a bunch of people who believe in ghosts. Who's running this show, anyway? Me or Madame Pele?"

"If I were you, I wouldn't say stuff like that. It sounds like a dare."

Doug looked at his watch and said, "Well, Ted, you'd better get us back to the hotel. I'm running out of time."

"Suit yourself," Ted said. "Climb aboard."

But when Ted tried to turn the motor on, nothing happened. "It's dead," he announced. "We're stuck. We're going to have to walk."

"Oh, great," Doug grumbled. "Now I'm in big trouble. I'm going to miss my plane."

"Maybe you should have been more tactful when you were talking about the spirits," Ted suggested. "Or do you think this is another coincidence?"

"I don't care what it is. I've got to take off running. I'm never going to make it."

"Hold on, man," Ted said, laughing. He pulled a cell phone out of his trouser pocket and dialed. "Ben? Where are you right now? Good. Drop what you're doing and get over to the fourteenth tee right away in a golf cart." He closed the phone and pocketed it, then turned to Doug and said, "He'll be here in three or four minutes."

"That's a relief. Thanks."

"No problem, my friend. See, I happen to believe there are mysterious spirits and forces in the land and in the air around us, especially on this golf course. That's why I was able to talk to Ben when Ben's almost a mile away."

"You did that with a cell phone," Doug protested.

"Are you saying that's not mysterious? Can you explain to me how it works?"

"No," Doug admitted. "I have no idea."

"Would you call it a coincidence?"

While they waited for the golf cart to arrive, Doug told June and Win more about the wall across the fairway. "The hotel concierge is fascinated by that wall," he said. "You'll meet him. His name's Charlie Leong, and he's a cultural historian. When he heard that I'd discovered the wall he got really excited and ordered me not to let my crew touch it. By that time, of course, my crew wanted nothing to do with the wall, and I had worked it into the design. Now, for some reason, Charlie wants to dismantle the wall, to keep it from being hit by golf balls. It doesn't make any sense. But then nothing makes any sense around here. Good, here's Ben."

The golf cart pulled up to them and stopped. "You guys call a cab?" the handsome young Hawaiian said. "Sorry, I only got room for one."

"That's okay," Win said. "The rest of us will walk home."

Doug said his goodbyes. "Ted, I have to admit, working with you has been a spirited experience. Win, June, I wish you luck, if you believe in luck. I'll call you from the mainland. Thanks for coming. I'm off." With that, he climbed onto the golf cart beside Ben, and they scooted away.

4. Respect for the Dead

"There's another interesting historical feature of this hole," Ted said. "Over beyond the green is a well-preserved section of the King's Trail."

"What's that?" Win asked.

"It's an ancient footpath that was cut through the lava. It runs

the full length of the Kohala Coast, connecting with paths coming down from the mountains. It was how slaves of the upper class ran errands, carried messages, and brought fresh fruit and fish and taro to their masters."

"Sounds neat," June said. "Are we going to have a look?"

Ted consulted his watch and said, "Well, maybe next time. Now that we're on foot, we're a little short on time. And I got one more thing I definitely need to show you two. It's by the sixteenth hole."

They walked. It felt good to be walking, especially on a warm, sunny day on a beautiful, virgin golf course. In about ten minutes they reached the green of the sixteenth hole.

"So this is where the fire was?" Win asked.

"Back there in the rough on the left side of the fairway. We've had a lot of trouble with this hole. You see that bunker?" He pointed at the sand trap that lay between the green and the edge of a steep hill. "Doug almost lost some heavy equipment digging out that hole. Turns out it was right on top of a lava tube. That's like a cavity in the earth. Back when lava was flowing down this hill, it crusted over on the outside as it cooled off. When the lava ran out, it left a cave. Then over the years the area got covered over with soil, so nobody knew it was there, till the bulldozer uncovered it, broke open the top, and almost fell in. That was a close one, I'll tell you. The whole hillside would have caved in."

"So what did you do?"

"The Cat operator walked off the job that day, after almost getting buried alive, and we haven't seen him since. I got my boys to push a bunch of dirt into the hole, till we had a pit about eight feet deep, and then we filled that up with sand."

"End of story?" June asked.

"Not quite. I was worried that the lava tube might be bigger than we thought, so I came out here one morning a week later and scouted around on the hillside down there to see if I could find the opening of the cave."

"Did you?"

"Yup."

"And?"

"I pulled away a bunch of vines and there it was, a cave about the size of a small room. The back was all plugged up with dirt, and the dirt was packed hard as cement, so I figured the bunker was safe and wasn't going to sink anymore."

"Problem solved," Win said.

"Not quite. That's when things really started going wrong. The fire happened that very night, and the sprinklers went haywire a week later."

June said, "Do you think you disturbed some spirits in that cave?"

Ted shook his head. "I don't think that."

"Then—"

"I *know* it." Ted took a deep breath and lowered his voice. "I want to show you two something that Doug doesn't know anything about. Nobody knows about this but me. I'm showing it to you because maybe you'll learn that we have to work with the spirits, not against them. Are you game?"

"You bet," Win answered.

"Promise me two things," Ted said. "Don't tell anybody what I'm about to show you. I don't want to spook the crew, and I don't want a bunch of media or museum people out here messing around."

"And the other thing?"

"Don't touch." He led them to the side of the hill and then the three of them scrambled down about twenty feet, holding onto vines and branches. Ted stopped them at a small ledge and then he dragged away a large bush that was concealing a hole in the hillside. He pulled a small flashlight out of his pocket and said, "Follow me. And don't touch a thing."

Win and June crept in after Ted and they found themselves in a small room about the size of a walk-in closet. "Ready?" Ted

asked. He shone the light into the corner of the cave, and there sat a skeleton. Shreds of blue cloth still clung to its bones.

"My God," Win said. "Who is that?"

"Hell if I know," Ted answered. "We haven't been introduced."

"He looks friendly," June said. "May I borrow your flashlight?" She took the flashlight and approached the skeleton for a closer look. Suddenly an urge came over her, unexplainable and irresistible, and she gave the skeleton an affectionate pat on its skull.

"Stop that!" Ted shouted. "Have you no respect?"

June jumped back, deeply embarrassed. "I don't know what came over me," she cried. "I'm so sorry, Ted."

"Don't apologize to me," Ted answered. "Apologize to him."

"I'm sorry," she told the skeleton. "You know, it felt as if he were inviting me to touch him."

"Maybe he was," Ted said. "But you could still get in a lot of trouble for disturbing the dead. Let's get out of here."

Outside the cave, Ted pulled the bush back in front of the opening. The three of them scrambled back up the hillside and stood once again beside the green of the sixteenth hole.

"So are you going to remove that skeleton?" Win asked. "Seems to me Mr. Bones has been causing a lot of trouble around here."

"He'll cause a lot more trouble if we don't leave him alone," Ted answered. "And let me remind you both, you aren't to tell anyone about this. Nobody is to know about that skeleton. *Nobody.*"

"Are you going to seal off the entrance to the cave?" June asked.

"Nope. How would you like to be trapped inside a dark cave with no way out?" Ted looked up at the sky and said, "Looks like we'd better head on back to the hotel. I don't have anything more to show you, and the weather's changing fast." Storm clouds were

Hawaiian shirts, and moonrises painted on black velvet. He hated junk like that, but it was good to know the going prices when he went to garage sales. Charlie went to every garage sale he could reach by car, boat, or plane, and he always brought home a bundle of treasures. Most of it was junk, but all of it was salable.

Next he surfed the want lists of his clients. He spent half an hour filling orders and writing invoices and mailing labels. He found a buyer for that black pearl brooch he had acquired six weeks before. He was able to supply Mrs. Harris of Milwaukee with the baritone uke she wanted so badly—mint condition with the original ivory pegs. He charged her twelve times what he'd paid for it. Charlie loved a mark-up. Charlie also knew he was getting close to the biggest sale of his career. One little item that had cost practically nothing brand new was going to fetch over eight hundred thousand dollars from that nut in New Jersey. Talk about a mark-up! And to think that Charlie was going to get that little item for free....

Homework time. He surfed through the waves of Hawaiian legends, cutting and pasting from anthropological journals, folklore collections, tourist pamphlets, and bedtime stories, plagiarizing with pleasure. With a little tinkering and embellishment, plus some clip-art and some Photoshop, he had a week's worth of pillow legends for Mauna Makai guests to enjoy.

Next he made a routine stop at www.Hawai'i-Nation.org, a website promoting the Island Sovereignty movement, to learn of the latest events, demonstrations, and meetings. Charlie didn't really care all that much about Hawaiian sovereignty; in fact, his long-range goal was to set himself up with a Pacific Islands import business in San Francisco, and if Hawaiian independence became a reality it would be a major inconvenience. Meanwhile, though, he had to appear sympathetic; he needed the help of the local *hui*. And so he acted as their historical advisor, which kept him in touch with their activities. The time would come when he would have them working for him.

rolling down out of the mountains, and the sun had disappeared. "Shall I call for a cart?"

"No, let's walk," Win said. "It's not that far, is it?"

"No, actually we're almost home."

Rain drenched them as the equipment shed came into sight. They ran the rest of the way to shelter.

As they were drying off in Ted's office, June asked, "Do you think I caused that shower? I mean, because I disturbed that poor man's rest?"

Ted smiled. "It was probably just a coincidence," he said.

5. Big Island Surfer

Charlie Leong was born to surf. He was trained as a historian, and he was employed as a hotel concierge, but surfing was his passion. He did it every afternoon. Sometimes he even surfed long into the late evening hours. He couldn't get enough of it.

Preparing himself for a self-indulgent Sunday afternoon, Charlie stripped off his shirt and gazed out over the ocean. It was a beautiful day. The morning's sudden shower had passed through and dried up, leaving a bright blue sky over the sparkling sea.

Nice, Charlie thought, but I've got surfing to do. He turned his back on the ocean and walked across his mountainside condo to the kitchen, opened the fridge, and pulled out a beer. Then he went into his book-lined study and flipped on his Mac.

The screen brightened with the home page of Charlie's own website: www.islandantiquities.com. He logged in his password and caught the first wave. First he surfed through the usual sites, the purveyors of cornball curios, such as porcelain and ceramic hula girl lamps, plastic palm trees that wobbled on your dashboard, Don Ho LPs, tiki-god keychains, mass-produced rayon

Next he checked his e-mail. A dozen more want lists from Hawaiiana collectors, which he cut, sorted, and pasted onto his master list. E-mails from four separate ladies who had stayed at the Mauna Makai during the last three months, all of them sighing over the romantic times he'd given them and crying over the fact that he never returned their e-mails. One of them asked, for the second time, if the hotel staff had found the black pearl brooch she had carelessly left in her room.

One e-mail from Ezra, dated 8:37 p.m. the night before.

They're here, Charlie. They're pretty dumb, if you ask me. The dude's a bozo. While I was wheeling them to their suite he asks me do I play golf. No sir, I said. As I was about to leave he says, I want to give you two tips. He gives me five bucks and then he says Take up golf. The chick's pretty bright, but I know you'll be able to distract her. Go for it, my man. Give her the ol' wicki wicki wacki Waikiki!

Charlie answered:

Thanks for the update, loyal scout. Let everyone in the movement know they're here. Let everyone know they're detectives, let everyone know they're to tell these two gumshoes absolutely nothing, but nothing, and tell everyone that nobody is supposed to know they're detectives. Got that? Mrs. M thinks that Ted Tamura and I are the only ones who know who these *haoles* are. Now be a good boy and delete this message as soon as you read it. Way to go, Ezra.

Send. Delete.

Next Charlie went to his favorite bookmark, the site of a Massachusetts historical journal he'd discovered seven months ago. It contained a letter received by Miss Susan Hartwell of Boston,

Massachusetts, from her sister Sarah in Hawai'i, written late in the
year of 1885. Dear Susan, the letter read.

> I finally found out what happened to that package of little
> gifts I meant to mail to you nearly a year ago. William, in a
> fit of Christian guilt, finally confessed to me that he buried
> them in a wall he was building. He won't tell me why he
> buried the package, and I've decided not to press him about
> the matter. After all, it wasn't as if the package were full of
> expensive treasures, just a few sentimental trinkets. A dog
> license that once belonged to my darling spaniel Harriet,
> who came with us to Hawai'i. A wooden token made by the
> local sugar plantation; they cut these tokens whenever the
> government runs short of metal, and they're acceptable as
> money. Also some metal coins, a big penny with the head of
> King Kamehameha III, who was dead by the time I joined
> William here, and a silver coin bearing the image of our
> friend King Kālakaua on it. William entertains the king
> lavishly whenever he is on this island. His majesty loves a
> good party. He's also a fine, sensitive and learned gentle-
> man, very concerned for the welfare of his people. He is
> writing a book about the myths and legends of Hawai'i.
> What a pity these little gifts were lost. The whole package
> wasn't worth more than a dollar, including postage. But
> then I've never entirely understood my loving Yankee
> husband. The package was well-wrapped in tapa cloth to
> protect it from the elements, so I expect all those little
> treasures will be safe there forever, buried in a wall. I do
> hope you're now fully recovered from the pneumonia
> and that the weather in New England has become more
> forgiving....

Charlie surfed over to an antiquities price list and checked on the
current values for Hawaiian coins and dog licenses. Good. God

bless inflation. Soon these treasures would be his. Temporarily. He reviewed again his customers' wish lists. Dog license, check. Wooden nickels. Check.

Antique collectors are out of their minds. You gotta love 'em.

Charlie stood up and stretched. He carried his empty beer bottle back to the kitchen, then went out onto the balcony that looked out over the ocean sunset. A good afternoon's surfing.

Time to get dressed for the evening.

Party time.

New lady in town.

6. The Rivals

The lengthening afternoon shadows stretched over the fairways of Kukuna. Ben Kamelele had already put in a hard day's work, and his work day was only half over. Wasn't Sunday supposed to be a day of rest? Not if you worked on a golf course maintenance crew that was short-staffed and behind schedule. Not if you were also the M.C. and headliner of the biweekly *lū'au* hula show at a Kohala destination resort.

Ben loved both of his jobs. He had never had it so good. He enjoyed the warm days working with his buddies, tending the lush fairways and greens, surrounded by tropical scenery from ocean-side to mountainside. He loved even more the warm evenings of song and laughter, spotlights and applause.

Earlier that Sunday, Ben had traded with a friend from Ni'ihau Island the latest Keali'i Reichel CD for a knee-length lei of perfect puka shells. Aiulani would love it. He had taken it back to the maintenance barn and hid it in a drawer. Now, his afternoon's work over, he returned to the barn to retrieve his treasure. He had delayed until he was sure everyone else had gone home; he had already endured enough teasing from the guys

about those little gifts he was always finding for his beautiful costar.

To Ben's surprise, the light was on inside the barn, and inside he found Sonny Apaka still working on the equipment. Sonny was the only part of Ben's job—both of his jobs, in fact—that Ben found difficult.

"Hey, bro," he said. "Workin' late, huh?"

Sonny jumped. "Hey, man, you scared me. Whatchu doin' here so late?"

"Nothing. You?"

"Nothing. I was just, you know, like changing the oil on the mowing machines."

"What for, man? I changed the oil on all the machines this afternoon. Didn't you know that?"

Sonny frowned. "No. I thought I was supposed to change the oil. Okay, whatever." He turned his back on Ben and picked up the cans to put them away.

"Hey!"

Sonny set the cans down on the work bench and said, "Now what?"

"You *pupule*, or what? That's the wrong oil, dude! You got ten-weight there. Christ, man, that will ruin the engines, maybe burn up the grass, injure somebody.... What the hell are you trying to do?"

"I was just trying to help out," Sonny mumbled. "Doin' my job."

"You are so dumb, Sonny. Either dumb, o...."

"I'm not dumb!"

"Then maybe you were trying to sabotage the Kukuna. That it, Sonny? You trying to ruin this golf course? Huh?"

"Shut up, Ben!" Sonny yelled. "I love this golf course more than you do!"

"Then you're just plain stupid. I mean, didn't you check the maintenance log? Look." Ben went over to the corkboard and

pointed at the chart. "See? I changed the oil on all three ma-
chines this afternoon. There's today's date, the time, four-thirty
p.m., and my initials beside each machine. Why didn't you check
that out before you went and…oh. I see."

"What? *What?*"

"You were trying to make me responsible for this. You knew I
changed the oil on these machines. Didn't you? Huh?"

"I don't know what you're talkin' about."

"Yeah. You're tryin' to get me fired, right? Machines break
down tomorrow morning, Ted comes and finds out whose name's
on the maintenance record, and I'm out of here. Right? I said,
right?"

"Aw, come on, Ben," Sonny whined. "Why would I do a thing
like that?"

"You know why, dude. You know as well as I do." Ben pulled
a crowbar off the rack and slapped it on his open palm. "This is all
about Aiulani, right?"

"You leave Aiulani out of this," Sonny growled. "Don't even
mention her name. Her and me have been going together since
fourth grade."

"Maybe she'd rather be going with a grown-up," Ben taunted.

Sonny picked up a bed knife and walked toward Ben, bran-
dishing the razor-sharp tool like a machete. "Put down the crow-
bar, dude, before I give you a haircut you'll never forget."

"I see," Ben said. He turned and gently hung the crowbar
back on the rack. But as he turned back to face his rival, he grace-
fully lifted a weed-whacker, switched it on, and waved the scream-
ing blade like a magic wand. "You want to get serious, bro? That
what you want?"

"Stop it, you two!"

Ben and Sonny froze. Sonny put down the bed knife and Ben
turned off the weed whacker. They turned and faced their boss,
who stood grimly in the open doorway.

"I was halfway home when I got the strange feeling that there

was something wrong," Ted said. "I didn't know what it was. Now I know."

"Nothing's wrong," Sonny said. "Me and Ben were just having a discussion about motor oils."

"You guys are both fired," Ted said. "I don't ever want to see you on my golf course again."

Ben mumbled, "Ted,…"

"Get out," the greenkeeper ordered. "Both of you."

7. *Lū'au*

"June, I think maybe you've had enough."

"Oh, Win, quit being such a stick." June took another mai tai from the waiter's tray and flashed him a smile. "*Mahalo.*"

The waiter grinned and moved on. It was *lū'au* time, and the terrace by the pool of the Mauna Makai had turned into a festive cocktail party, with the tall palms swaying gently against the sunset sky. Guests of the hotel and other tourists chatted and chuckled, showing off their new Hawaiian garb, as the hotel staff wove among them with trays, offering complimentary mai tais.

"What's 'mahalo'?" Win asked.

"It means '*gracias*,'" June told him. "I learned it from the gal in the boutique who sold me this gorgeous gown." She did a gay pirouette, letting her long emerald-green mu'umu'u with a white floral print swish around her legs. As she came to rest, she spilled a splash of her drink on Win's shirt. "Oops. Now I'm going to need another one."

"Maybe this one should be your last," he said, smiling.

"Last, shmast," she countered.

"Smashed is more like it."

"Waiter!"

"Wait right here," Win said. "I'm going to see if I can get a napkin and wipe this stuff off my shirt."

"Stuff shirt is right," June giggled, watching her lover weave his way toward the open bar. Dear Win, she thought. She really did love the man, but why in the world was he wearing a button-down shirt to a *lūʻau*? He had P.I. written all over him.

She realized that the rum had begun to play tricks on her body as well as her head, and it was time to find a ladies' room. The sunset had disappeared, and the only light now came from the blazing tiki torches set all around the terrace. Shielding her eyes against their glare, she carried her empty glass toward the far end of the terrace, where a band was setting up equipment in front of a stage festooned with flowers. She threaded her way among the tables that were being set for dinner, set her glass down on one of the tables, and wandered behind the stage, where she found a little village of grass shacks.

One of these must be a ladies' room, she thought. Better be.

It was dark backstage; the only light came from the open doors of the grass shacks. She stumbled forward and walked tentatively through the first door she came to. "Oops," she said aloud. "This isn't the ladies' room, is it?" She found herself facing a dozen or so strong, handsome men who were smearing glistening greasepaint on their bodies. They looked up and shook their heads. They were wearing authentic *malos*, and nothing else.

"Newp. It may be a lady's dream come true, but it's not the ladies' room. Pardon me, gentlemen." She backed out of their dressing room.

One rule to remember about Hawaiʻi: you don't go backwards in go-ahead sandals. Her foot caught on an electrical cord and she took a spill right in front of a line of hula dancers who were hurrying toward the stage.

They went down like dominoes. "Oh I'm terribly sorry!" June cried. Muttering unpleasantries, the young women scrambled to their feet and rushed on. June got herself to her hands and knees

and tried to get up, but she stepped on the hem of her muʻumuʻu and pitched forward again, this time into the arms of an older man.

"Ye gods," she muttered. Her eyes had adjusted to the dark, and she could see the man's kind face and amused smile. "Have we met yet?" she asked. "I'm June Jacobs, the mai tai princess."

"I'm Keoki Kalama," the man said. "Can I help you find your seat out front?"

"Is there a ladies' room back here somewhere, Keoki? Show me to a little girl's room and I promise to be a good little girl from now on. I hope I haven't done any lasting damage?"

Keoki shook his head. "No worries," he said. "You can use the hula girls' rest room." He pointed to a shack. "Will you be all right? I've got to get out front and handle the lights."

"I'll be fine. Thanks."

While she was in the bathroom of the hula girls' shack, she heard the show begin, with the low, sweet bleat of a conch horn, followed by a driving rhythm of drums and a riff of amplified guitars. June faced the mirror, and the woman she saw there gave her a stern look. "No more mai tais," the face said, and June had to agree. She slapped some cold water on her face and dried off with a paper towel. The world around her came slowly back into focus, and she knew she was lucid again.

She wandered back out into the backstage area and headed toward the light and the loud, driving music, but on the way she stumbled again on another power cord. She caught her balance, but in the process the cord got disconnected, and suddenly the sounds from the stage became muted.

In a brief moment of near silence, she overheard a conversation coming from the dressing room shack she was standing beside.

"Who was that drunk lady?" a woman's voice asked.

"She's one of those detectives Mrs. M hired," said a man.

"Are they going to find out about the movement?"

"They're not interested in the *hui*," the man assured her. "They're just here to make sure the golf course opens on schedule."

"Okay, but if they're snooping around, we're in trouble."

Keoki was on the scene in a flash, carrying a flashlight. "What happened?" he asked. He shone his light at June's feet and found the disconnected cord. He plugged the ends together, and all at once the music was back.

"Come on," he said. "Let me escort you to your seat."

"I don't know where my seat is," June said. "I'm sorry to be such a bother, but when I came back here, we hadn't sat down to dinner yet."

"Come with me," Keoki said. "I know where you're sitting."

He led her out front, steering clear of the spotlights, and escorted her to a long family-style table, where Win sat looking at his watch. June slipped onto her chair beside him, looked up at Keoki, and whispered, "Mahalo."

Keoki bowed and slipped away, back to his post.

June looked about her. She didn't know the other people at her table, except for Win, who was now looking at her with loving concern. She took his hand into her lap and squeezed. "Where were you?" he whispered.

"I ran away to join the circus," she whispered back. "But I had second thoughts. I couldn't live without you, dear."

He squeezed back.

The table was decorated with soft lights and sprays of hibiscus, and plates were piled high with a savory feast of pig and poi, crab legs and shrimp, laulau and mahimahi, chicken long rice and taro rolls, grilled steaks and stir-fried veggies. "You're just in time for dinner," Win said. "And for the show."

"Ladies and gentlemen!" the master of ceremonies boomed out over the crowd. "Welcome to the Sunday night *lū'au* at the Mauna Makai. I'm Ben Kamelele, and the song you just heard is called a *hapa-haole* song, which means half-white and half-native.

It's called 'Hawaiian Hospitality.' And here to give you a special aloha welcome is your gracious hostess, our own beloved Martha Masters."

Martha took center stage and accepted the microphone from Ben. She was dressed in a form-fitting *holomū* of passionate pink. She gave the crowd a dazzling smile, extended her arms in a warm greeting, and said into the mike, "Welcome, dear friends, to our royal grounds. Once upon a time, not too many years ago, this land was part of the ranch of Captain William Brush and his wife Sarah. It was here that they often entertained their good friend, King Kālakaua. We hope to make you feel just as welcome, feed you just as well, and make you all feel like royalty. In that tradition, we have lit the torches, piled high the food, and sounded the conch and beat the drums. Let the *lū'au* begin!"

With that, Martha Masters drifted off the stage, the lights went out, the music started up again with guitar and bass, drums and amplified ukuleles. When the lights came back up, the stage was graced by a line of beautiful hula dancers, their grass skirts swishing, their hand gourds shaking as Ben sang the sassy song, "Keep Your Eyes on the Hands." June stole a look at Win and found his mouth forming a wide-open grin as he gazed on the spectacle of long, shiny hair and lithe, graceful bodies. The young woman at the end of the line was especially magnetic; she seemed to make eye contact with every person in the crowd—especially the men in the audience. She sang as they danced, "*Hana hou, hana hou…*"

When the song ended, Ben encouraged the audience to applaud the dancers. "And that was our lovely Aiulani on the vocal," he added. "Isn't she great? By the way, 'Hana hou' means 'Do it again.' Shall we get these gals to dance some more hula for us?"

The audience whistled and clapped, and the dancing resumed, the women shimmying and swaying to the insistent rhythm. Then into their midst leapt a whirling, nearly nude male figure with a splendid physique. He brandished flaming torches.

"Ladies and gentlemen," Ben called out, "welcome Sonny Apaka, our champion Samoan firedancer!"

The hula dancers retreated and left Sonny in charge of the stage. Grinning ear to ear, he raced to and fro, flinging his torches high into the night air, catching them with casual but energetic grace. He passed the flames between his legs, across his back, around his neck, and over his chest, never flinching, even though the audience could hear his skin sizzle. Faster and faster he spun, until his body was glistening with sweat and firelight.

June was entranced. This was more intoxicating than four mai tais.

"Enjoying the show?" June's reverie was broken by the woman sitting on her left. She looked and found she was next to her employer and hostess, Martha Masters. "He's good, isn't he?" Martha said. "I want you to keep a close watch on him," she added.

June smiled and mumbled, "I'll be delighted."

8. Night Life

The *lūʻau* ended at nine o'clock. The torches went out as if by magic, replaced by soft electric floodlights hidden in the greenery of plumeria trees and palmettos. The guests left the tables, chatting and laughing, dispersing to their tour buses and their rooms.

Win had had a good long nap that afternoon, while June was shopping, and he felt full of energy. Or maybe the energy came from watching those slippery, sinuous dancers. Whatever it was, the tropical night was young and warm, and Win was wide awake and ready for more fun.

"What'll it be?" he said to June. "A walk on the beach? Or a nice, leisurely stroll back to paradise?"

"Paradise?"

"Suite six."

"That sounds heavenly," she answered. "I'm exhausted."

"Not too tired for a nightcap, I hope," said a man who had just joined them. "Hi. I'm Charlie Leong, the hotel concierge. You're the folks from Burlingame, right? Doug Banner's friends?" He offered his hand to Win and a winning grin to June.

Win watched June's yawn turn into a sparkling smile. Shaking Charlie's hand, he said, "Call me Win. Yeah, we're old friends of Doug's. Nice resort you've got here, Charlie."

"It's the best," Charlie agreed. "Come on, join me for a drink at the Barefoot Bar."

"Actually, we're sort of tired," Win said. "It's midnight on the mainland, and...."

Charlie laughed out loud, then winked—yes, winked—at June. Hmmm. "Mainland," Charlie scoffed. "Time to learn Hawai'i time. Come on, folks, let me treat."

"Actually...." Win tried again.

June said, "Sounds lovely. Hi. I'm June."

The Barefoot Bar was on the other side of the main lodge, down close to the shore. A beached old boat lent a castaway feeling. Tables and chairs were set out on the sand here and there. There were shelves for footwear by the entryway; June and Charlie slipped off their flip-flops while Win struggled with his loafers and socks.

"Let's sit here," Charlie said, with a warm smile and a welcoming wave of his arm. The area was softly lit with lanterns and alive with the gentle sounds of strumming ukuleles. A bushy-haired beach boy approached them with a grin and a notepad.

"Aloha! What'll you folks have?"

June said, "I've had enough alcohol for one night. How about a cup of coffee."

Charlie told the waiter, "Give her an iced Kahlua." To June he said, "That's mostly coffee. You won't even notice the alcohol."

That's what I'm afraid of, Win thought. Oh well, "Scotch on the rocks for me," he said.

Charlie ordered a pineapple juice for himself. "So, how do you guys like Hawai'i so far?"

Win said, "Great. Just great. Can't wait to play a little golf, but till then, this is a truly restful vacation." Small talk was hard work. Charlie wasn't paying attention to him anyway; his eyes were on June. Well, Win couldn't blame him. June was a blond beauty, all right. One drink, and then we call it a night.

Then Charlie did face Win, and he said, "Look. I know why you two are here, and I want to assure you that if you need any help from me, you got it."

Win chuckled. "Thanks, but I think we'll be able to handle it. All we want is a little R and R."

The waiter brought their drinks and Charlie signed the tab. Then he raised his glass and said, "Here's to R and R, when the job is done. Look, I know that you guys are hired investigators," he continued in a soft voice. "You're here to keep the golf course on course, and we're very grateful, believe me. I've checked you out on the Internet, and I'm impressed. Jacobs and Winslow, the best golfing sleuths in the business, right?"

"The two and only," June said.

"Yeah, but we're on vacation," Win insisted.

"Don't worry," Charlie said. "Nobody knows who you are or why you're here. But Mrs. M let me in on it, because she wants me to cooperate with you in any way I can. Nobody else knows, okay?"

"Knows what?" said a luscious woman who had approached their table. Win looked up into the lantern-lit smile of a beautiful Hawaiian face. She was a statuesque woman of about forty-five. She looked strong, yet soft, and dressed to kill in a white gown that hugged her hips. "Who are your friends, Charlie?" she asked, putting her hand on Win's shoulder. Win felt the warmth of the gesture all the way down to his fingertips.

"Hi, Sugar. Meet Harry Winslow and June Jacobs. Friends, this is Sugar Boyd. She's our Director of Romance. Nice *holokū*, by the way."

Win said, "I don't know what a *holokū* is, but I'd have to agree." He stood up to offer Sugar his chair, but she had already sidled down next to Charlie.

"A *holokū* is this garment," she told him, tracing a finger slowly along her neckline. "Nice to meet you, June and Harry."

"Call me Win."

June said, "Director of Romance? That's what you do? Sounds like fun. Are you like a matchmaker?"

Sugar laughed, a low confident chuckle. "Not quite. I arrange weddings. Hawaiian weddings are the best, the most romantic in the world. But you have to bring your own sweetheart."

"I don't know about that," Charlie said. "I've seen some strangers fall in love here."

Sugar put a hand on Charlie's and said, "Mostly they fall in love with you, honey." She turned to June and said, "Let me warn you, June, Charlie has a way with the ladies."

"I'll bet he does." June was answering the Director of Romance, but her eyes were on the concierge. "Do you live here in the hotel, Charlie?"

Why would she want to know a thing like that, Win wondered.

"No," Charlie answered. "I live on the other side of the lava field, up in the hills. I'm a mountain flower."

"So, Sugar, you're a wedding consultant?" Win said. "You do flowers and music and hors d'oeuvres and stuff?"

"That's right. And some other special touches. Hawai'i is a very romantic place, and the Mauna Makai has the loveliest weddings of all. Couples come here from all over the world—the mainland, Japan, even Europe. So how long are you two staying? Shall I pencil you in for a ceremony?"

Win glanced at June, who was glancing back at him with a goofy grin. "We're not quite ready for that," Win mumbled.

"I've told him I'll marry him when he can beat me at golf," June said. "As if."

"We're going to have a new specialty here," Sugar said. "Golf weddings, once the Kukuna golf course opens, if it ever does."

"If?" June responded. "I thought it was set to open on Thursday."

Sugar smiled back mysteriously. "Maybe it will. Or maybe not. It's haunted, you know."

"Oh?"

"I think that just makes it all the more romantic. Don't you?"

"Not if it interferes with the golf," Win said. "I hear you're going to have a golf wedding to celebrate the opening on Thursday. Wally's Warriors?"

Sugar shuddered. "What an awful name for a wedding party."

"He's a very famous golfer," Win explained. "Wally 'Whambo' Wood? You've heard of him, of course?"

"Of course," Sugar answered. "A special person. But then, all my grooms are special, just like all my brides. It's going to be a beautiful wedding, you can count on it. Whether the golf game happens or not."

"What could prevent it?" Win didn't know whether he was making conversation or getting into the thick of an investigation. It didn't much matter. Mainly, he was interested in the warmth of Sugar's eyes and the soft melody of her voice.

She shrugged and said, "*Huhū* happens."

"What's *huhū*?" June asked.

Charlie laughed. "What's it sound like?"

Win said, "Well, I just hope the *huhū* doesn't get in the way of the game."

Sugar said, "The wedding will happen either way. And what's more important, golf or romance?"

"I'm not sure," Win answered.

"I'll bet you could teach me a lot about golf."

"And you," June said, "could probably teach Win a lot about romance. I wish you would."

They all laughed as they finished their drinks. "Another?" Charlie offered. "Sugar? What'll you have?"

"I'm on my way home," she said. "I have a thirty-mile drive to Kona, and I have a big day tomorrow." She rose.

Win faked a yawn and said, "June and I are going to retire, too. Thanks for the drink, Charlie."

"Any time, you two."

The four of them left the Barefoot Bar and retrieved their footwear from the entryway. As Win was putting on his socks he felt a warm wind caressing his face.

"The *hulumano*," Sugar murmured. "It comes from Maui. It means the Night Marchers may be coming tonight. The ghosts of Kukuna!"

"Really?" June asked. "Has anybody seen them?"

Charlie chuckled. "Of course. They come for anyone who's done something *kapu*."

"And then what happens?"

"I hope I never find out," Charlie said.

Win said, "Well. Good night, all."

"Mahalo," June added. "And aloha."

Win and Charlie shook hands. Then Charlie gave June a lingering hug, which Win might have minded, but he was enjoying a hug of his own from Sugar.

Hand in hand, Win and June walked slowly back through the gardens and terraces of Mauna Makai, accompanied by the ukulele music that was piped through hidden speakers all over the grounds. When they reached their suite, they found it made up, softly lit, and adorned with fresh flowers and a bowl of fruit. The spread was turned down on their bed, and on the center pillow was another printed legend.

Win took the card with him into the bathroom, where he could read it by better light.

Naupaka, the Saddest Flower

There are two varieties of *naupaka*, one growing near the sea, the other in the mountains. Each bears what appears to

be half of a blossom. When placed together, they form a perfect flower.

According to a Hawaiian folktale, there was once a handsome young man who was desired by the volcano goddess Pele. Pele appeared before him as a beautiful stranger, but he would have nothing to do with her, for he was in love with a maiden in his village by the sea. Enraged, Pele pursued him into the mountains, hurling fiery lava after him. But Pele's gentler sisters took pity on him, and to save him from death they transformed him into the mountain *naupaka*. Then Pele chased the maiden into the sea, but again her sister goddesses intervened, changing the maiden into the beach *naupaka*.

And so they exist today, each blooming as a half flower, never to be united again.

A sad story, Win thought. Who needs sad stories? He threw the pillow legend into the waste basket and brushed his teeth. He gave his reflection his sexiest smile and left the bathroom with high hopes.

But June, the object of his hopes, was already in bed, fast asleep.

9. *Hulumano*

The *hulumano* whooshed and howled across Kukuna. Out on the tenth hole, long, thick irrigation hoses began to move like snakes across the fairway, slowly at first and then rapidly, twisting and turning as if being yanked about by invisible hands....

Sand in the bunkers along the eleventh hole reflected the light of the elusive moon, then went dark like the insides of freshly dug graves....

Beside the twelfth hole, lava rocks took on menacing shapes. A goblin. A gargoyle. Sharks, dragons, serpents. Writhing, yawning, reaching, grabbing...

The flag on the thirteenth green whipped in the wind, then hung limply in surrender, then whipped again....

On the fourteenth hole, white-barked ōhi'a trees waved their graceful limbs and swayed like dancing women....

Shadows emerged from out of the woods, seven-foot-tall soldiers from the distant past. They were clad in brief loincloths, short feathered capes, and beaked helmets. Spears raised, they marched through the night in a disciplined line to the music of piping flutes and the thudding beat of gourds. They chanted as they marched, a stern, insistent monotone....

The *hulumano* winds wailed. The sea slapped the shore. Trees knocked the sides of the buildings of the lovely Mauna Makai....

June awoke with a start when she heard the slam of the screen door that led out to their *lānai*. Wait a minute, she thought, her heart pounding. That's a sliding door.

Then she realized the room was full. She heard footsteps all around the bed. She heard breathing. Loud, rhythmic breathing, like the pant of athletes after a long run, all in unison.

Then she saw them. She slammed her eyes shut. No good, they were still there.

No. Just one. A skeleton walked toward her, his arm outstretched, his fingerbones reaching out to touch her head.

She pulled the sheet over her and burrowed into a ball. "I'm so sorry I disturbed you," she whimpered.

She felt a hand on her shoulder. It began to shake her.

"June, are you okay?"

June opened her eyes as the sheet was lifted off her head. There in the ghostly half light was the smiling face of her wonderful lover.

"You've been having a nightmare," he said. "Maybe one too many mai tais?"

She threw her arms around his neck and clung to his chest. "Oh, Win, hold me!" she cried. "Hold me!"

Win chuckled, happy to oblige.

10. The Wall on the Wall

"You boys should know better."

"Yes ma'am," Sonny muttered.

"Ben?"

"Yes, Mrs. M."

"There's no room for fighting in my organization. Am I completely clear?"

Ben and Sonny both answered, "Yes, Mrs. M."

Martha glared at them over her cluttered desk. "I run a resort, not a grade school. Sonny, I cannot believe that you would intentionally put the wrong motor oil in the mowing machines. I thought you liked those machines."

"Yes, ma'am. I do."

"Do you have something against the golf course, then?" Martha asked, pointing at the framed poster on one wall of her office. "Are you the one who's causing all our troubles?"

"No, ma'am. I love Kukuna."

"Then I just don't understand. You're an excellent mechanic. Sonny, what's this all about?"

Sonny looked close to tears. "I wasn't going to let those mowers out on the course," he said. "I was going to discover the problem and point it out to Ted and then fix it, drain the bad oil out and put in the right kind. I swear. I wasn't going to wreck them machines."

Martha turned to Ben and said, "What's this about turning on

a weed whacker inside the barn? Don't you know how dangerous those things are?"

"Yes, ma'am."

Martha looked each of them in the eye, then stared at the photo of Kukuna's fourteenth hole fairway for a solid minute before speaking. "I'm not going to fire you this time," she said. "There's too much at stake, and frankly, I can't afford to lose either one of you right now. We have the best *lū'au* show on the Kohala Coast, and you two are top-notch performers. Both of you. Besides which, that golf course has to open on time. Has to. We have some very distinguished travel writers and golf writers flying in for this event. So I'm keeping you on, and I want you to work overtime. Ted's not going to like that, but that's the way it has to be, at least until Thursday. If you can prove to me over the next few days that you two can get along together, and that you can do good work, you may stay. But if there are any more squabbles or any more childish pranks, you're both dismissed. Is that understood?"

"Yes ma'am," Ben replied.

"Sonny?"

"Yes, Mrs. M."

"And another thing. I know perfectly well what this is all about. Don't think you're fooling anyone. So let me tell you this: Aiulani is nobody's property, and neither is she a bitch in heat. I want both of you to stay away from her except when you're on stage. You're going to perform for the rehearsal dinner tonight, and then there's the *lū'au* on Thursday. Other than that, no contact with Aiulani. Is that crystal clear?" She waited for an answer. "Well?"

"Yes ma'am."

"Yes."

"Good. Go to your jobs, boys. Make me proud of you."

Martha's next appointment was with the private eyes. Win looked

cheerful and confident as they came into her office and sat down. June, though, appeared a bit pale and shaky. "Are you all right, dear?" Martha asked her. "You look as though you'd seen a ghost."

June's laughter sounded nervous. "I'm afraid I had one mai tai too many at the *lūʻau* last night," she said.

"She mai tai'd one on," Win added. "Gave her nightmares."

"I'll be fine," June said. "Martha, those two young men who were just leaving when we got here, they're the ones in the *lūʻau* show, right?"

"That's right. Ben's the M.C. and Sonny's the firedancer."

"And Sonny's the one you told us to keep an eye on. Why is that?"

"Just a hunch," Martha answered. "There's a movement here in the Islands to win independence and native sovereignty. I know that Sonny is sympathetic to that cause."

"Do you think that might be what's behind these disruptions to the golf course?" Win asked.

"It's hard to say. The sovereignty movement isn't at odds with the tourist industry or the hospitality industry, per se, or the golf business either, for that matter. But at this point I think we need to consider all the possibilities."

"What can you tell us about the sovereignty movement?" June asked.

"Not a lot," Martha admitted. "But I'll get Charlie Leong to give you a briefing when he gets off the desk this afternoon. He's our cultural historian, as well as our concierge."

"We met Charlie last night," Win said. "Nice guy."

"Charlie's a charmer," Martha agreed.

"We also met your romance lady," June said. "She thinks your troubles are all about ghosts."

"Oh, Sugar's very superstitious. Or she pretends to be. She thinks ghosts are good for business."

"Are they?" Win asked.

"Well," Martha said, "since they don't exist, they can't do us a

lot of real harm or any real good. But they've got Ted Tamura and his whole staff spooked, and that's been a big part of the reason the golf course has been such an obstacle course to build."

"You're certain they don't exist?" June asked.

Martha shrugged. "I believe in spirits. Rum, for example. Romance, for another. But ghosts? I've lived in Hawai'i for most of my life, and I haven't met a ghost yet."

"I had the spookiest sensation when we saw Sonny and Ben just now outside your office," June said. "I overheard Sonny saying something to Ben about making sure the golf course opens on schedule."

"It's on everyone's mind," Martha said. "And now their jobs depend on it."

"But I could swear I'd heard his voice before. Using the same words. I just don't remember where or when. It was…unsettling."

After June and Win left her office, Martha got Sugar on the intercom and asked her to come into her office. While she waited, she read over again the hard copy of the e-mail she had received that morning. Then she looked again at the poster promoting Kukuna. There it was, the trademark wall that crossed the fairway. Was that wall built by the ancient people of Hawai'i? Or was it the work of the *Menehune*, the little people, the spirit builders, the…ghosts?

Or was it all a sham after all?

Sugar swept into the office with her usual flair. How does she do it, Martha wondered. Most women don't look that good at forty-five. Hell, most women don't look that good at twenty-five. It wasn't just looks. It was that combination of romance and attitude. Sugar had spice.

"What can I do for you, darlin'?" the romance director asked her boss.

"Have a seat, Sugar. No, sit in this chair. I want you to look at something."

Sugar sat as she was told and smiled. "What's up?"

"That," Martha said, pointing at the photograph on the wall, the Kukuna poster.

"Who built that wall, Sugar? Do you have any idea?"

"There are walls like that all over the Kohala Coast," Sugar answered. "Some people believe—"

"What do *you* believe?"

"The *Menehune*."

"Ghosts?"

Sugar nodded.

"That's what Ted thinks, too," Martha said. "And so does his crew. I wish I could believe it. I'm getting very fond of that wall. And it's become the trademark image of our resort. I don't want anything to happen to that nice wall, do you?"

Sugar said, "You don't have to worry about the wall. If the *Menehune* built it, it will last."

"If."

"Martha, what's worrying you?" Sugar asked.

"I guess I'm just tense. There's a lot happening this week," Martha answered. "For one thing, there's this wedding. This celebrity shindig."

"It's going to be wonderful!" the romance director trilled. "I hear *People* magazine is sending a team to cover the event. Imagine, a genuine sports star choosing the Mauna Makai for his wedding!"

"Sugar, Wally Wood didn't chose the Mauna Makai."

"No? But..."

"His bride chose us. Meg Hartwell. And do you know why?"

"Because this is the most romantic spot in the world?"

"No, my dear. I just learned that Meg Hartwell is the great-great-granddaughter of the sister of Sarah Brush."

"Of the Brush family that used to own this land?"

"Yes indeed."

"How wonderful!" Sugar cried. "How romantic! Isn't that just wonderful?"

Martha Masters drummed a pencil on her desk and stole another glance at the Kukuna poster. "I hope it's wonderful," she said softly.

Martha and Sugar went over the plans for that evening's rehearsal dinner, and when each knew that everything was in place for the whole complicated week's festivities, Sugar left to supervise the flowers that would decorate the rooms and suites of the wedding party and the media.

Alone again in her office, Martha dialed the number of Ted Tamura's cell phone.

"Yeah?"

"Ted, this is Martha. You sound distressed."

"It's a mess," Ted said. "Trouble again. *Pilikia.*"

"What's a mess, Ted?"

"It's okay. We'll take care of it."

Martha knew better than to press her greenkeeper when he was in one of his moods. "Listen, Ted, I've decided to keep Ben and Sonny on the payroll. We need them this week. We've got two shows planned for this wedding, and—"

"It's okay," Ted interrupted. "I need them, too. I've got them out there right now, repairing the mess."

"Ted, what happened? Is it the wall?"

"What wall? Hell no, nothing happened to that damn wall."

That's a relief, Martha thought. "Well then…"

"The King's Trail," Ted answered. "It looks like an army was marching on it."

"Oh, no! Every day it's something new."

"Like I said, *pilikia.* This golf course is nothing but trouble."

"Who do you think did it?" she asked.

"You wouldn't believe me if I told you."

Her next meeting was with Charlie Leong. It did not take her long to get to the point:

"So, Charlie, you'll be meeting the Wood-Hartwell party at the airport later this morning."

"That's right."

"And this is important, why?"

Charlie paused, his grin widening. "This guy, this golfer guy, could really get our golf course off to a great start."

Martha Masters said, "Charlie, look at that poster. That photograph. Yes, that one."

Charlie looked dutifully at the photograph of the golf course. Sweet boy. He said, "Nice wall?"

"Yes, nice wall. Who built it?"

"Well, Mrs. M, I..."

"You're the court historian, Charlie," Martha snapped. "Let's have it."

"There are *pāpōhaku* all over this lava coast," Charlie said. "The ancient native Hawaiians built them. We respect these walls, of course. We preserve them. Why?"

Martha looked at the concierge, right in the eye, and said, "Come on, Charlie. Spill. What's in this particular wall?"

She saw the tic beside his eye when he said, "What are you talking about?"

"Charlie, do you know the last name of this week's bride-to-be?"

"What," Charlie said again, "in the hell are you talking about?"

"She's coming here today, Charlie. Meg Hartwell. Turns out she's a direct descendant of Susan Hartwell, who was the sister of Sarah Hartwell, who just happened to be the wife, and the widow, of Captain William Brush, who owned this land we're sitting on right now. He willed it to his loving wife, whose grandniece sold it to my husband, who willed it to me. That's why this wedding is happening at my resort. And I happen to be your employer, which makes all this laundry list important to you as well."

"Martha, are you okay?"

Martha shook her head quickly, as if to get gnats out of her head. She smiled, confidently. "I'm fine. Really. But the coincidence is a bit much, don't you think?"

Charlie gave her a look that could either be casual or calculating. Martha couldn't tell which. He said, "Do you know something special about that wall?"

Martha picked up the e-mail from Meg Hartwell. Then, after another long look at Charlie's casual frown, she reconsidered. She folded the paper and put it in the top drawer of her desk.

"No," she answered. "Do you?"

Just before lunch she had a brief meeting with Moke Kahoohano, the resort's resident *kahuna*. Dressed in black and sporting a clerical collar, his white hair pulled back in a ponytail, he wore a beatific smile. His whole persona radiated wisdom and dignity.

"Moke," she said, "you're the only one I tell the truth to, and to tell the truth, I'm afraid my resort might fail."

Moke smiled as he reached across her desk and patted her hand. "I think you will do well, Mrs. M. You're a good person. You're a good manager, and you believe in *ohana*—people working together like a family. Mauna Makai will be successful, I know this."

"Was I right to build a golf course?" she asked him.

"We'll see," the old man said. "Madame Pele doesn't seem to have anything against golf."

"Moke, the King's Trail was disturbed last night."

"Oh?" His expression lost some of its serenity.

"Ted and his crew are repairing the damage. Will you bless the site? I think that will mean a lot to the crew."

"Of course."

"And then there's the wall," Martha Masters said.

"Wall?"

"Wall." She pointed to the poster, showing the wall that stretched across the green, green fairway on the way to the four-

teenth hole of Kukuna. "I want you to do a special blessing for that wall."

Martha Masters took her lunch in her office that day. She ordered in from the snack bar: a Chinese chicken salad. As she nibbled, she spread out on the desk the bride's e-mail and read it again.

...and I have reason to believe that wall contains something that belongs to me....

11. Here Comes the Bride

Oh man.

Charlie hated driving this stretch limo. He wasn't born to be a chauffeur.

And what the hell was Martha talking about, all that talk about the wall? Charlie thought of that wall as his. Did she have any idea what that wall was worth? She couldn't possibly. Even if she knew a packet of trinkets was buried in the wall, she'd have no way of knowing what those trinkets were, or what they'd fetch from serious collectors.

Besides, how would she know? It was just a matter of luck and skillful web-surfing that had alerted Charlie to the treasures contained in the Kukuna wall, and Charlie hadn't told a soul.

Still, for some reason Martha seemed obsessed by that wall all of a sudden. "What's in the wall?" she'd said. Maybe Operation Jericho would have to happen sooner than Charlie had planned. Bummer, Charlie thought. But on the other hand, why not? He felt an adrenaline rush. There was nothing to be done right now, with all this hullabaloo over the wedding, but next week, after they all leave...

Meanwhile, here he was driving a limo, shuttling celebrities. This afternoon he was scheduled to give a history lesson to the

lady gumshoe. Writing silly legends and buying drinks for bozos, smiling like a kid till his face got the cramps. This job was definitely getting old. Time to move on. Next week, then, Operation Jericho....

He got to the airport on time, fifteen minutes early, in fact. Which was lucky, because the parking lot was almost full, and he found the reception area swarming with palefaced yahoos, shouting, conferring, talking on cell phones, lugging around cameras large and small. The press. Charlie knew some of these people; they showed up at the airport every time a celebrity flew in to spend time on the Kohala Coast. But this crowd was bigger than usual.

Wally Wood was maybe the most popular golfer in the world today. A big, jovial, handsome young man who'd spent his boyhood as a caddie on Cape Cod, Wally had shown his knack for the game early. According to the profile in *Sports Illustrated*, which Charlie had read only that morning, "Whambo" Wood had been able to drive a golf ball long before he could drive a car. And now "the most eligible bachelor on the green," as the article called him, was finally going to sink his putt.

"Hey, Charlie!" Charlie turned and saw the grinning face of Howie Morse, the star sports writer from the Honolulu *Advertiser*. "So how's it feel to have Whambo and his bride staying at the Mauna Makai? Big-time celebs, huh?"

"Off the record?" Charlie offered.

"Sure, pal. Off the record."

"I'm not a golfer, myself," Charlie said. "I'm a hotel concierge, a simple innkeeper. Celebrities are just guests to me, Howie. But every guest is special at the Mauna Makai."

"They say Wally Wood's worth millions in tour winnings and endorsements. Is it true he wears logos and brand names all over his golf clothes, even his jockey shorts?"

"We all have to make a living somehow, Howie," Charlie said.

"So what's this I hear about the golf course being behind schedule?" Howie asked. "Is it going to open on time for the wed-

ding? I hear you been having some problems. Anything you'd care to tell me?"

"Off the record?"

"Of course, off the record."

"Get lost, Howie."

Suddenly the arrival was announced and the crowd rushed to the gate, where cordons were stretched to give the passengers a clear path across the tarmac. The plane door opened and all at once there they were, the first ones to emerge: the golfer and his bride, a smiling, dazzling couple. They waved from the top step of the rolling staircase, looked up at the blue Hawaiian sky, looked at each other and kissed, then waved again for the cameras as they came down the stairs. They were greeted by cameras and applause, and by Charlie Leong, who formally welcomed them to Hawai'i with orchid lei and a warm smile of aloha.

The whole bridal party clustered around the limo: the groom with three of his "Wally's Warriors" and the bride with her three "Boston Belles." As they were loading luggage into the back of the vehicle, Charlie said to the bride, "No golf clubs for you?"

"Are you kidding?" Meg Hartwell answered. "No-ho way. I do not do golf."

"Nobody's perfect," her fiancé added, laughing out loud. The laughter was echoed by the accompanying wedding party. They all climbed into the limo. Charlie seated Meg Hartwell, the bride, up front with him.

As they pulled out of the airport parking lot and onto the Queen Ka'ahumanu Highway, Charlie got right to the point. "So Meg, I understand you're descended from the Brush family?"

"I certainly am not," Meg replied. "I am a Hartwell. We're a Boston family."

"Oh. I thought there was some sort of family connection that made you decide to have your wedding at the Mauna Makai."

"The Hartwells never could abide the Brushes," Meg said, as

if to explain. "They're Barnstable people, you know. Cape Cod-ders. Whalers. Traders. I like the Cape for summers, of course. But the natives down there are terribly, terribly tacky. Quahogs for breakfast, that sort of thing. There are still a few Brushes left. I think they're in some sort of trade, fish and chips or something."

"So there's no family connection between the Hartwells of Boston and the Captain Brush who lived here in Hawai'i?"

"Well, yes, as a matter of fact there was a family connection. A great scandal, if truth be told. My great-great-I don't know how many greats-aunt ran off with the infamous William Brush. They eloped because her father, my great-great-whatever-grandfather wouldn't allow her to marry a Brush. William had made a fortune sailing trading ships in the South Pacific, but still, he was from Barnstable, and it just wouldn't do. So they ran off and got mar-ried in someplace awful like Provincetown or something. They settled in Hawai'i, right here where we're going, and she was un-happy about it for the rest of her life. Another reason to resent the Brushes, although I suppose we really should forgive them. After all, it's been hundreds and hundreds of years. My great-aunt was right. This really is unpleasant countryside, isn't it?" She wrinkled her nose at the black, black landscape outside.

"This part of the coast is a large lava field," Charlie explained. "But I'm interested in the history of all this. How do you know your great-aunt was unhappy? The countryside doesn't all look like this, you know. We have beautiful mountains and a lovely coast, and—"

"I've got letters to prove it," Meg said. She had to speak loud-ly to be heard over the rowdy laughter bouncing out of the back of the van. The golfers were swapping gross lies and the Boston Belles were shrieking in mock disgust.

"Letters?"

"Sarah Hartwell Brush wrote scads of letters home. Mostly to her sister, Susan, who was my great-great-et cetera-grand-aunt. And I have them all."

"How fascinating," Charlie said. "What a collection that must be. Impressions of Hawai'i in the late nineteenth century. I'm a bit of a history buff myself, and—"

"All but one."

"I beg your pardon?"

"There's one letter missing," Meg said. "But I'm going to get it back. To complete the collection, you know. That's terribly important, don't you think?"

There was more laughter from the back of the limo, and for a moment Charlie thought the Warriors and Belles were making fun of the Brahmin American Princess and her uppercrust accent that sounded like a mouthful of hot marbles. But as the banter went on he realized they were making crude jokes about golf balls. He stole a glance at Meg, who gave him a look of sympathetic disgust. "Golfers," she said, "are so weird."

They reached the entrance to the Mauna Makai and Charlie made the turn and started along the suddenly floral three-mile drive. "Now this is more like it," Meg exclaimed. "Quite lovely, after all. Yes, this will do quite nicely for my first wedding. I think one's first wedding should be beautiful, don't you? Something to remember forever."

"I quite agree," Charlie said, with as sincere a smile as he could muster. "And Sugar Boyd will help you through all the arrangements. She's our romance director, and she's world-famous for her perfect weddings."

"Yum."

"I know she'll want to meet with you and Wally today, as soon as you've had a chance to unpack and settle in."

"*I'll* meet with her," Meg said. "You can forget about Wally. He has no interest in the details of this wedding." She turned to face the folks in the back of the limo. "Hey Wally, do you want to spend an hour or two this afternoon talking about bouquets and hors d'oeuvres?"

"Naw, darlin', that's your department," came the response

from the back, which set off another round of guffaws.

Meg turned to Charlie and said, "See? Like most male golfers, Wally's interested in only two things."

"Golf and—"

"That's right. And he's not getting either one of them till after the ceremony. Those are the rules of this trip." She looked back again and said, "Isn't that right, sweetheart?"

"You make the rules, babe. I just do as I'm told."

"That's a nice groom."

"Well, maybe it's lucky the golf course isn't open yet," Charlie said. "Wally won't be tempted to sneak out on you until after you're married. Oops, I didn't mean it like that. And don't worry, Wally, we will definitely have the Kukuna golf course ready in time for the grand opening, right after your wedding ceremony and brunch."

"Great!" Wally shouted from the back. "I'll see if I can find a foursome."

Wally's Warriors laughed.

"Golfers," Meg said. "Charlie, do you play golf?"

"No ma'am."

"Is it true that you've been having some trouble getting this golf course made on time? That's what it said in *Golf Digest*, Wally told me."

Charlie pulled the limo into the circle and parked it in front of the open-air entrance. "Well, as with any project, things tend to go wrong. But it's all under control now. Don't worry, the wedding day will have its golf game." He turned off the ignition and popped the door releases on his instrument panel.

"Frankly, I don't care much one way or the other," Meg said. "In fact, I may be complicating matters a bit myself."

"Oh?"

She fished in her purse and pulled out a copy of the Kukuna brochure. She showed it to Charlie and said, "See that wall? I'm planning to buy that wall."

12. A Man with a Dream

In the early afternoon, Keoki Kalama stood on his back deck and surveyed his land. Well, it wasn't really his land, but Mrs. Masters had leased the up-country plot to him for life, and he had built the house from the ground up. Although modest, it commanded a sweeping view of the farmland below, and the lava field beyond that, and then between the black stretch and the sea, the Kukuna golf course. With his binoculars, Keoki could barely make out a pair of pheasants perched on the *pāpōhaku* that crossed the fairway of the fourteenth hole. The pheasants obviously felt right at home on Kukuna. Keoki did not feel at home on the golf course, even though his ancestors had lived on the Kohala Coast for centuries before the first pheasants were brought to the Islands.

Keoki had already put in a full day's work as the handyman and jack-of-all-trades for the Mauna Makai resort. He had gotten up at five a.m., as usual, gulped his coffee, pulled on his jeans and work shirt, climbed into his Jeep, and barreled down the mountain by way of his neighbor Ernie's pig ranch, where he had picked up a freshly slaughtered pig for the hotel's *lū'au*. As usual, his drive down the mountain was cheered on by braying wild donkeys, known to the locals as "Kona nightingales." Keoki was fond of these gentle beasts, who had been brought to the island for slave labor and then turned loose to freedom when they were no longer needed. Hundreds of them now lived wild and protected along the Kohala Coast; Keoki saw them as survivors of exploitation, and he wished them the best.

At the hotel, he had delivered the pig to the kitchen, supervised the cleanup of last night's *lū'au*, trucked away the trash, cleaned the grills, swept the stage, and raked the lawn. Then, because there would be another *lū'au* that night, he had prowled the woods and beach in search of new rocks for the *imu*, the *lū'au* pit. He had laid the new stones into it tenderly, then lit a fire from

kiawe wood atop the rocks before going about his regular rounds and taking care of his daily chores. Toward the end of his work day, shortly after noon, he had returned to the fire pit and covered the red-hot rocks with blankets of shreddings from banana plants and large *ti* leaves. He had gone to the kitchen to let the cooks know the fire was ready, and he then had supervised the placing of the pig (stuffed with the sweetest island fruits and sewn with fisherman's wire) onto the bed of hot rocks, where it sizzled and steamed. Then he'd covered the meal with a protective blanket of leaves and burlap bags soaked in seawater, then shoveled it over with sand and dirt. As always, he had been surrounded by tourists, to whom he had explained, in a put-on pidgin accent, the traditional ways of island cuisine.

Ordinarily, his work day would be over by now, and he would go on about his other activities, teaching island children martial arts at the Waikoloa Community Center, and conferring with other members of his local *hui* about their goals to restore sovereignty to the Hawaiian people.

But today there would be no time for that, and Keoki needed a rest, because there was a special *lū'au* scheduled for that night. *Lū'au* were hard work for the team that put them on, and usually there were only two of them each week, with several days between them. But tonight was a special occasion, the rehearsal dinner of the celebrity guests. The whole guest population of the resort was invited, of course, as well as about twenty hand-selected members of the media. *Vanity Fair, People, Sports Illustrated, Condé Nast Traveler, Golf Digest,* and a bunch of other magazines that Keoki never read.

These were hard-working, complicated times. The new golf course was haunted, people said. The hotel was overrun with guests who had little regard for the ancient ways of Hawai'i. The *hui* was getting restless, and Charlie Leong was stirring them up with rumors of hidden treasure. All of these problems preyed on Keoki's mind. And then there was the matter of his daughter, Aiulani.

Such a sweet, strong young woman. Such a beauty, too, and such a fine hula dancer. And she was devoted to the cause. Keoki felt strong pride and love whenever he thought about his daughter. But he worried. He had worried every day since the death of his wife, ten years ago. Was Aiulani growing up too fast? Was she becoming too influenced by modern, western ways?

As if to answer him, he heard the rattle of Aiulani's VW Beetle coming up the road and pulling into the drive in front of their house. He heard the screen door slam, and he heard her call out, "Hi, Dad! I'm here!"

She came out onto the deck, wearing tight jeans, a bandeau top, and a bright smile. She reached behind her head with both hands and gathered her long, lustrous hair into a bunch, which she draped over one shoulder. She said, "You look pretty serious, Pop. What's up?"

"Oh, well, nothing."

"Come on, let's have it."

"Well, I did happen to notice that you didn't spend the night here last night. So I was just sort of wondering...."

Aiulani blushed. "Dad, I'm not your little girl anymore, you know."

He smiled sadly. "So you stayed with Sonny last night? He's a good boy." Of course no boy was good enough for his daughter, and Sonny was a bit dim, but he was loyal. He'd make a good family man, Keoki supposed.

"Actually, I wasn't with Sonny," Aiulani answered. "We're not seeing each other anymore, Dad."

"Not seeing? You don't have eyes? You're on stage together, and he's practically naked, and you're not seeing him?"

"You know what I mean," Aiulani said. "Seeing. You know what that means."

"I don't think I want to know."

"I know it's hard for you, Dad, but times have changed since you were my age."

"That's for sure," he said. "I think I like the old ways better."

"You're not talking about the true old ways," she retorted. "You're just talking missionary morals. If we were back in the times of our ancestors, we wouldn't even be having this conversation. You'd be proud of me."

"Of course I'm proud of you, daughter," Keoki said, a catch in his voice. "And I'm proud of your pride in the old ways. So who were you 'seeing' last night?"

"I was with Ben," Aiulani said.

Ouch. "Isn't he a bit old for you, sweetheart? I know he's a glamorous showman, and a good singer, but..."

"He's also a kind and considerate person, Daddy, and he loves me."

Who wouldn't? Keoki thought. "Have you two been seeing each other for a long time?" he asked.

"No. Well, yes. We've been meeting out on the tenth hole, late at night, for weeks now. But last night was the first time we...spent the night. We went for a walk on the beach after the show, and he told me that he had been fired. He wanted to say goodbye and to tell me that he loved me. We both started crying, and then, well, we spent the night at his place."

Keoki didn't know how to feel. He was sorry for his daughter, but if Ben got himself fired, then there must be something wrong with him. "So Ben's leaving us?"

Aiulani smiled and twirled around on one foot, her long black hair whipping behind her. "No! Mrs. Masters gave him another chance. He's staying!"

"Well, that's good news, I suppose."

"There's only one problem," Aiulani added, her smile fading. "Mrs. M ordered Ben to stay away from me for a while."

"She's a wise woman, that Mrs. M," Keoki said.

"Dad, what do you have against Ben? He's a really, really sweet person."

"But he's really, really not one of us, is he?"

"What are you talking about? Ben's Hawaiian. He speaks our language, he shares our cultures and values, he—"

"But is he in the movement? He's not in our *hui*. Sonny's in the *hui*."

"Ben would be if I asked him," she said.

"You haven't told him about us, I hope?"

"No. I never talk about the *hui* to outsiders. But believe me, Dad, Ben's a thoughtful soul. He cares about our heritage."

"Ben is an entertainer," Keoki said, with what he hoped sounded like authority.

Aiulani's mouth dropped open. "Dad? Hello? I'm an entertainer, too!"

"The hula is more than entertainment," Keoki insisted. "What do you suppose Ben thinks about the concept of private property?"

"I don't know," she answered. "To be honest with you, I'm not sure how I feel about it either. I mean the notion of private property has only been in Hawai'i for a hundred and fifty years, but it's pretty well entrenched, and most of us are okay with it. I mean we don't want a violent overthrow or anything like that, right?"

"No, of course not," Keoki said.

Father and daughter stood side by side on the deck, looking out over the farmland and lavaland and resortland of the Kohala Coast. The spread before them had all been owned by one family, the Brushes, for over a hundred years. Now it belonged to Martha Masters and the Mauna Makai.

"It's true that Hawaiian history since the American takeover has been full of broken promises," Aiulani admitted. "It's true that the whites have prospered while the native Hawaiians have experienced poverty. What used to be our land is now other people's real estate. But I don't feel that way about Martha Masters."

Keoki felt a rush of pride as he admired his daughter's wisdom. "I agree with you, of course. And I certainly don't want a violent overthrow. I just want the world to know that in these islands

where the main industry is hospitality, we Hawaiians are the real hosts. I think Mrs. Masters believes in that. She has me teaching classes in our heritage to our staff. She displays historical and cultural relics in the main lobby. Mainly, she's good to us, and she's fair. But still…"

"Charlie says—"

"Charlie. There's another one I don't trust," Keoki grumbled. "He's not in the *hui*, and yet we always go to him for advice. Why is that?"

"Because nobody on the Big Island knows more about Hawaiian history than Charlie Leong," Aiulani said, "and you know it. Dad, what's eating you today?"

Keoki sighed. "I don't know. I just don't know. Some days I feel like I've been exploited all my life. Other times I think I've been incredibly blessed. It's puzzling, you know? I do know this: I wish I could make just one important statement, sometime in my life, do something that would make a difference. Something to show the world that Hawaiians are to be taken seriously. Some gesture that the world could not ignore. I'd put myself on the line for that."

They stood silently, looking out to sea and listening to the soft calls of birds in the hot afternoon sun. Suddenly the serenity was broken by the cell phone that rang on Aiulani's hip.

Cell phones, Keoki muttered under his breath. We didn't have cell phones when I was her age, and it was a better world.

"Hello?" Aiulani answered. "Hi, Charlie, what's up?"

Keoki watched his daughter's face as she listened to that contraption she held to her ear. What was that expression that grew on that lovely face? Fear? Excitement?

"Okay," was all she said. She snapped her cell phone shut and put it back in its holster on her hip.

"Well, Dad," Aiulani said, "it appears you're going to get your chance." She looked out over the landscape, and Keoki followed her gaze down to the fairway of the fourteenth hole.

She added, "Tonight."

13. He Said, She Said

June felt stronger after lunch. She and Win had eaten by the pool, dressed in swimsuits and shades. They'd shared an enormous platter of hot *pūpū*, exclaiming over every taste of the teriyaki beef sticks, pork wonton, chicken egg rolls, and shrimp tempura. Then they'd walked down to the beach, to settle down on beach towels under a standing umbrella.

Puffy clouds drifted on the distant horizon. A steady, gentle surf offered them a relaxing rhythm.

"This is some life," Win observed. "I could get used to this. Are you sure we get to bill these hours?"

"Actually, I think we'd better get to work pretty soon," June answered, rubbing sunscreen on her bare belly and the tops of her breasts. "But you know what? I have no idea what we're supposed to be doing here. As far as I can tell, the golf course is ready to open now, so what's the problem?" She stood up and dragged her beach towel out from under the umbrella and lay down in the hot sun of early afternoon.

"Well, things keep happening," Win said. "One thing after another. According to the latest from Ted, the King's Trail was torn up last night. The crew had to stop everything and put it back together. It took them all morning."

"Well, so now it's back together. What else could go wrong?"

"Who knows? I think Mrs. Masters wants us to be on hand just in case. Maybe we'll find who's behind all these pranks, or maybe not, but we've got to at least give it a try. So I think we should take Ted up on his invitation to attend the blessing of the King's Trail. We might see something in the faces of Ted's crew. I know he trusts them completely, but somebody's behind all this stuff."

"Maybe not," June said.

"Huh?"

"Maybe nobody's doing these things."

"Just a series of random accidents?" Win responded. "I don't think so."

"I didn't say they were random, and I didn't say they were accidents. That's not what I meant."

"Then what did you mean?"

"I just meant nobody's behind them. No person. No human being."

Win smiled and looked at her over the top of his sunglasses. "Ghosts, huh?" he said.

"Well, why not?"

Win's answer was a snort as he shoved the shades back over his eyes. "We'd better go on back to our room and get dressed for the blessing," he said.

"Okay," June sighed. "Just give me a few minutes more of this heavenly sun." She closed her eyes and stared at the orange nothing, listening to the gentle lap of the waves on the shore.

"There you are!" a voice called.

June opened her eyes and saw a man in a skimpy black swimsuit approaching along the beach with an energetic gait. When he got a bit closer she recognized the smiling brown face of Charlie Leong, the concierge. He plopped himself down in the shade of the umbrella, next to Win, and gave June a grin full of pearly teeth.

"Ezra told me I'd find you two here," Charlie said. "Mrs. M asked me to come and give you a briefing on the Hawaiian independence movement."

Win looked at his wristwatch and said, "That's great, but we've got to be running along right now. Uh, what's so funny?"

Charlie's grin was bubbling over with a friendly chuckle. "Nothing," he said. "Just that we don't see many folks wearing watches on the beach. People here usually don't need to be running along."

"Well, we've got this event to observe," Win said. "We're on assignment, remember? Ready, June?"

June sat up and stretched, feeling the push of her arched body against the cups of her bikini top. "Win, I think you should go attend the blessing. I'll stay here and take Charlie up on his offer. Maybe I can learn something that will shed some light on this problem. Hmmm?"

Win nodded slowly. "Okay, then," he said. "I'll see you in a couple of hours, and we'll compare notes." He checked his watch again, then covered it with his other hand. He stood up, smiled politely, and trudged off in his baggy boxer swimsuit, looking pale and a bit slump-shouldered.

"Nice fellow," Charlie said. "You two are a handsome couple."

She said, "Thanks. We'll look better when we get a little sun."

"You don't want to get too much. Not right at first. Tell you what," he said, pointing up the beach to where several tents were set up to face the sea. "Let's take one of those cabañas. We can sit in comfortable chairs, maybe have Ezra bring us a couple of chi chis, and I'll tell you all I know."

June took a long look at Charlie's small, firm, bronze body and his friendly, cheerful face. "I'm game," she said.

"You're going to think I'm a real drunk," June giggled, when they'd finished their second chi chi. They reclined back on their side-by-side lounge chairs, shaded by their gaily colored pavilion, and stared out at the constant, ever-changing blue Pacific. "So tell me more. Were you born here? Have you always lived in Hawai'i?" *What a stupid question,* she thought. *Of course he has. He's Hawaiian.*

"I'm fourth generation," he told her. "Chop suey."

"Meaning?"

"All mixed up. My great-grandfather came from Canton to work in the sugar plantations. Married a local woman. Their children intermarried also. Lots of different peoples involved. So when it comes to me, I'm Chinese-Hawaiian-Filipino-Scottish.

And maybe some others in there, too. This is a pretty romantic land, you know, and strangers tend to get to know each other very fast."

Talk about fast. "No wonder you're a historian. All that history in your...your body."

Whoa! June thought. *Back to work, before this gets out of hand. I'm working, remember?* "Tell me the history of the Hawaiian independence movement. Native sovereignty, is that what it's called?"

"We had sovereignty once," Charlie said. "But you took it away from us."

"I didn't!"

"I mean you people."

"I'm sorry."

"It wasn't you. I don't blame you personally."

"My people. What did we do?" *And what can I do to make it up to you? Stop that.*

"You locked up our queen, kept her a prisoner in her own palace for eight months. Found her guilty of treason. Sentenced her to hard labor but then decided to take pity on her and just kept her locked up in her own home. That happened over a hundred years ago, and many people feel like they still can remember it."

"I'm so sorry," June said. She put a hand on Charlie's arm. His warm, sinewy arm.

"It was probably our fault," he said. "We were always too trusting of strangers. Too eager to please. We cut down our sandalwood forests to trade for stuff we didn't need."

"Like what?"

"Like trinkets. Corsets. Diseases. It's still going on. Coca-Cola, Nintendo, 'Fantasy Island.'... Our *'āina,* that's our land, got stolen away, our population got almost wiped out, and now our culture's on the verge of extinction."

June squeezed that arm hard. "God, Charlie, no wonder you're pissed off."

Charlie turned his face to hers and took his time with a friendly smile. At last he said, "Do I look pissed off?"

This is going to be so easy, he thought. *They always fall for the guilt trip.* "I know you didn't mean to do it, sweetheart," he said. "Like I said, it was probably our fault. We trust people, and we trusted you. Just as I trust you right now."

This lady detective was sharp. Charlie still wasn't sure whether she was as smart as she was beautiful, but that really didn't matter much to him. She looked great in a bikini, and he itched to get his fingers into the blond curls that surrounded her sweetly smiling face. "I don't want you to feel responsible for the way I live. Actually, I have a pretty good life, I have to admit." He put his free hand on top of hers and stared into her brown eyes. "I meet fascinating people every day."

"So about this independence movement," she said, softly. "Tell me about that. Are you one of them?"

"I'm more of a consultant. They've got the passion, I've got the facts."

"Tell me some facts."

How much do I tell this lady? "It would probably surprise you to know that the native Hawaiians truly value their past."

"That's not surprising."

You have no idea. "Relics, for example. Things you might just throw away like pebbles or broken shells, a Hawaiian might want to treasure as a meaningful link to the olden times of gods and spirits."

"Gods? Spirits?"

"Before Captain Cook came to visit, before all those whalers and before all those missionaries, and long, long before tourists like you, there were spirits everywhere on these islands. Believe it. They lived in the sky, the forest, and the sea. They whispered in the breezes, and they shouted in the thunder."

Charlie had spouted this routine dozens of times, and it usu-ally worked, but he had never seen it have quite this effect. The

little lady's eyes were bright and wide, and she was chewing on that plump lower lip. *Yes. It's getting harder and harder to remember why I'm pitching woo at this lady. Stay focused, Charlie, my man. You're working here, remember.*

"They're still here," she responded, breathlessly. "Aren't they? I believe in them, don't you?"

Hold on. Back off. "Well, who knows? Hawaiian mythology has four major gods. There's Kāne, the creator of man. Ku, the god of war. Kanaloa, the god of the ocean. And Lono, the god of the elements. He's my favorite. He likes a good time. Thunder, you know. Lightning. Crops. Fertility. Sex. I hope this isn't shocking you."

The blonde moved her hand off his arm and onto his washboard belly. "Not one bit," she said.

Shocking? This guy really knows his stuff. "I'm tired of hearing about gods, Charlie," June said softly. "Tell me about goddesses. I could use a little help in that area right now." *What a wise face this guy has. What a thoughtful smile.*

"Well, there's Pele, of course," Charlie answered. "She lives right here on this island, in the crater of Halema'uma'u, up on Kīlauea. She's very passionate. The heat builds up, from far down where it counts, and then it rises...."

Yes. "Yes. Yes?"

"Yes."

My God, I'm hyperventilating. "And do you believe in Pele?" she asked.

"I do."

"So do I. I know exactly how she feels." *Whoo.*

"How does she feel? Tell me. No, show me."

"First I want to ask you an important question."

"Yes?" *Whatever it is, doll, the answer is yes.*

"Is there any way to close the front of this pavilion?"

🌿

Inside the closed pavilion, the air was full of soft colored light which played on their skin. Charlie was all yellow bronze and red bronze and blue bronze; June was a paler shade of yellow and red and bronze; their sweat blended as they kissed with their eyes wide open; and their hands roamed through the slippery colors.

He thought, *My God, she's reaching, and I'm not ready. That's never happened before.* He said, "Sorry."

She said, "For what?"

"It's just that my mind's on something big right now, and—"

"So's my hand."

"I wouldn't say especially big."

"Especially beautiful, then. Would you mind if I were to…"

"Be my guest."

"Thank you, Mr. Concierge. Mmm. You know what?"

"What?"

"'Especially beautiful' is an understatement."

"I could say the same for these."

"Don't say another word."

This wasn't supposed to happen, she thought.

He thought, *This wasn't supposed to happen.*

14. Once More, with Spirits

"So what is a *kahuna*, anyway?" Win asked Ted as they drove out to the fourteenth hole in a golf cart. "Some kind of great surfer, right?"

Ted laughed. "Surfer?"

"Seems to me I've heard the word on Beach Boys albums," Win said. "And in old *Gidget* movies, so I figure it has something to do with surfing. Right?"

Ted's laugh downgraded to a tolerant smile. "*Kahuna* are very

important religious people," he said. "Like priests, but more important. Maybe like cardinals in your culture."

"You mean they play baseball?"

The tolerant smile faded. "You're putting me on, right?"

"Just joking," Win said. "But I would like to know what a *kahuna* is, so I'll understand this ceremony we're going to witness."

Ted nodded. "In ancient days, there were three classes of Hawaiians. You had your *ali'i*, who were the chiefs. They were descendants of the gods. Some of the *ali'i* actually were gods themselves. Then there were the *maka'ainana*. Commoners—farmers, fishermen, soldiers, like that. Then there were *kauwa*. Those were the outcasts, the slaves. They had no rights, and they were the ones usually used in human sacrifices."

"That really happened?"

Ted nodded and drove on. "Then there were *kahuna*. They usually came from the *ali'i* class. In the old days, the *kahuna* were the wise ones. They were the healers, the astronomers, the architects, the experts on farming and canoe building. But their biggest talent, whatever their specialty, was communicating with the spirits. That's still true today. We still have *kahuna*, you see. We keep one on the staff of the Mauna Makai. That's Moke. He'll be doing the blessing. Seems like he's out on the golf course almost every week, blessing this hole or that one, trying to keep up with the problems, and trying to keep the spirits on our side."

"Hasn't seemed to help," Win said amiably. "I mean you're still having all this trouble, right?"

Ted brought the golf cart to a halt and said, without looking Win in the eye, "You might consider what shape we'd be in if it weren't for Moke."

"Yeah, but—"

"Win, if you're going to be skeptical, then I don't think it's a good idea for you to attend this blessing. You know? I don't want any interference from your practical mainland attitude."

"Okay, okay. Sorry," Win said. "Drive on, captain. I'll keep an open mind."

They stood around in a circle, about twenty of them, Ted's whole crew of golf course maintenance personnel, all dressed in clean T-shirts and jeans and tennis shoes. Standing next to Ted, Win could feel a current of energy traveling around the circle, going both ways at once. It was an odd feeling, although Win knew there must be some sort of logical explanation for it. Across the circle, Win noticed Sonny and Ben standing on either side of an elderly Caucasian gentleman in an old-fashioned sailor suit, who was carrying what appeared to be a handmade wooden cane.

Bisecting the circle was the King's Trail, which seemed to be in perfect condition; if it had indeed been torn up the night before, Ted's crew had done a fine job of restoring it. Standing on the well-worn footpath of rugged black lava, in the very center of the circle, stood a smiling, heavy-set man about eighty years old, all dressed up in white ceremonial vestments and wearing a garland of flowers around his head. He held a wooden bowl in one hand, and with the other he reached into the bowl and sprinkled a bit of white sand or powder onto the stones around his feet.

The *kahuna* had a melodious voice, and he spoke with a smile and a song. But since he spoke in Hawaiian, Win had no idea what he was talking about. All he knew was that the old man had nice things to say, judging from the tone of his voice and the smiles on the faces of almost everyone in the circle. The old fellow between Sonny and Ben was not smiling.

Ted whispered to Win, "That's salt. Just a ceremonial token, not enough to hurt the course. Moke is blessing the site now. He's telling us that the spirits are grateful to us for putting the road back together. He says the spirits are sorry they caused the damage, and they will try to be more careful next time."

"That's what Moke says?" Win asked.

"The spirits say that. Moke just translates."

Yeah, right, Win thought. And Ted translates to me, and I'll have to translate to June, who will laugh me off the planet.

"And now," Moke said, breaking into English at last, "Mrs. Masters has asked me to bless the *pāpōhaku*, so we will take a short walk."

The circle broke up and followed the *kahuna* down the fairway about a hundred yards, heading for the ancient wall, the trademark of Doug Banner's masterpiece. Along the way, Win asked Ted, "Who was that old guy on the other side of the circle? The one with a cane? He was standing between Ben and Sonny?"

"Maybe there's hope for those two boys," Ted answered. "It was good to see them standing side by side."

Win was by now getting used to cryptic answers. This was without a doubt the goofiest case he'd ever taken. But how could he complain? Here he was out walking on a beautiful virgin golf course on a bright, clear day without a cloud in the sky. He only wished that he had his clubs with him. And he wished he had June with him. It wasn't that he missed June right now particularly, but if she were with him he'd know where the hell she was and what the hell she was up to…but he decided not to follow that thought. Stay focused, he told himself. I'm working, remember?

Moke stopped about ten yards from the wall and turned around to face his followers. The maintenance crew stopped and waited for him to speak. The old man with the wooden stick had gone ahead and was sitting on the wall. He seemed to be looking directly at Win, and he was not smiling. The blue sky above them was now punctuated by a few large, white cumulus clouds.

Very softly, the old *kahuna* said, "Wait here a minute." He walked over to the wall, where the strange old fellow in a sailor suit was sitting, and the two men appeared to have a quiet conversation. Moke appeared to be offering the old coot some of his salt, and the old salt was shaking his head. They talked for several minutes, if indeed they were talking, and clouds overhead became thicker and darker.

The crew stood still in respectful silence. Win whispered, "Ted, who is that...?"

"Shhh."

So Win waited, wondering if the rest of them were as confused as he was. He felt a raindrop hit his head. He looked up to the sky and felt more rain gently land on his face.

Moke turned around and faced the gathering. His face was wet. He said, softly but loudly enough to be heard above the whistling wind, "I can't bless this wall. It won't let me. The spirits don't want anything to do with this wall. I don't know any more than that." The old *kahuna*'s merry expression had gone south, and his brown, round face was streaked with tears—or were they raindrops?

They were standing in a cloudburst now, their clothes soaked through. Ted told Sonny, "Go get that golf cart back by the King's Trail. I want you to give Moke a ride back to the hotel." Then he walked over to the *kahuna*, who was sobbing out loud, and put his arm around the big man's shoulders. He said to his crew, "That's enough for today. Make sure your equipment's under cover before you knock off."

The gathering dispersed, and Sonny returned with the golf cart. Ted helped Moke into it, and the two shook hands, smiling sadly. Moke said, "I'm sorry, Ted. I couldn't bless that wall. I tried, but I couldn't do it. It's not a true *pāpōhaku*, you know. Did you know that?"

"That's okay, Moke. Don't worry about that. Thank you for blessing the King's Trail."

"That was easy," Moke said. "The spirits were happy to talk to me over there."

With that, Sonny turned the cart around and took off slowly down the fairway. The rain had stopped as suddenly as it had started.

"What do you make of all this, Ted?" Win asked as they walked back from the fourteenth hole to the equipment barn. "I mean,

why was Moke crying back there by the wall?"

"He's an emotional guy," Ted said. "He hasn't been the same since his brother died about ten years ago."

"How did he die?"

"On a golf course."

"What happened? Was he performing a blessing?"

"No, he was playing golf. Shot a hole in one and never recovered."

Win figured Ted was putting him on, so he tried another angle. "Does Moke really believe that the King's Trail was messed up by spirits?"

"Apparently so," Ted answered. "They even told him so."

"And do you believe that?"

"I believe anything Moke tells me."

"Yeah, but spirits? Messing up a trail? What for?"

"They didn't do it on purpose. They just got a little too active, I guess."

"And you believe that?"

Ted said, "Listen, Win, you didn't see the mess. It was a mess. Rocks were scattered all over the whole stretch of the trail that cuts through our golf course. It was a mess."

"Okay, but why do you think it was spirits?" Win wanted to know. "Why not human beings?"

"What human beings?"

"That's what June and I are trying to find out."

Ted shook his head. "Didn't you hear the wind last night? The *hulumano*?"

"So you're saying the wind blew the stones around?" Win asked.

"Of course not," Ted answered. "Some of those stones are pretty heavy."

Win was getting nowhere, and they were almost back at the equipment barn. "Okay," he said. "One more question. Who was the old sailor?"

"Who?"

"The old guy sitting on the wall. The one Moke was talking to?"

"I have no idea what you're talking about," Ted answered. Then his face brightened and he said, "Look!" He pointed out over the golf course behind them, where a double rainbow stretched across the sky, like a giant welcoming arch.

"What do you make of that?" Ted asked.

Win whistled. "Very nice. Beautiful. An omen? Good luck?"

Ted stuck out his hand and smiled broadly.

"For once we agree."

15. Call to Arms

The Monday evening party began with a loud, melodious blast of the conch.

Nearly naked men ran about the terraces, the gardens, the paths, and the beach, lighting torches as they weaved in and out among the assembled guests and tourists and media people. The crowd hushed to hear their chanting, and then, when the torches were lit and as the sound of ukulele music drifted out over the party, the conversation rose again.

June held onto Win's arm and plucked a taro chip from a passing tray. She had decided to stick to ginger ale this time. The night before had been a disaster. Tonight she wanted to stay focused. She didn't want to make a fool of herself in front of Charlie. Speaking of whom...

Where was Charlie?

There was a huge crowd tonight. June guessed there must be at least three hundred people milling around the terraces, the gardens, and the beach, all of them decked out in colorful, casual finery, all of them laughing and shouting, chatting in their main-

land accents, munching tasty tidbits, and sipping or gulping their fruity cocktails.

And not one of them was Charlie. How come?

Meg loved it. Flashbulbs popping, all these shrieking socialites throwing their arms around her and Wally, wishing them a wonderful wedding—it was a woman's best dream come true.

She had gotten separated from Wally, but who cared? He and his buddies were no doubt laughing and drinking and swapping lies about their golf games, but she'd let him get away with that tonight. Tonight was her night. She didn't really need Wally. He was just the groom.

Meg looked great and she knew it. She had spent two hours and two thousand dollars—Wally's money—in the hotel boutique that afternoon, and it was worth it. Her pure silk "sundress," a frothy ankle-length but bare-shouldered Dolce & Gabbana number, clung to her like a shadow, as comfortable to her body as a second skin. The dress suggested peaches and mangoes, and peachy-keen she knew she looked.

"Miss Hartwell?"

She turned and faced a pasty-faced young couple dressed in black. The man carried a notepad, and the woman was lugging a camera bag. "We're from *Rolling Stone*," the woman said. She pointed and shot, and the flash went off and red spots danced before Meg's eyes. God this was cool! The man said, "Could we have a minute of your time?"

"Why of course," Meg laughed. "Anything for *Rolling Stone*."

"Miss Hartwell?" another voice called from behind her. "I'm from *People*."

Meg turned her back on *Rolling Stone*. "*People!*" she cried. She sang, "People who read *People* are the luckiest people in the world...."

FLASH!

A voice drifted out over the loudspeaker. "If I may have your

attention," it said, "I'd like to welcome you to our resort and to our *lūʻau*."

The crowd hushed, and Meg joined all her well-wishers in listening to their hostess, who stood on the stage at the far end of the terrace, across the pool, speaking into a microphone.

"Aloha!" Mrs. Masters said. "We at the Mauna Makai are thrilled to have you all here on this beautiful full-moon night, and we bid a special aloha to Meg Hartwell from the world of Boston and Wally Wood from the world of golf." A cheer rose from the party, and the smiling hostess waited for it to die down before she continued. "I want to propose a toast to their romance, to their wedding, to their happy marriage forever after!" She raised her glass and the cheer rose again.

This is the greatest, Meg thought. Just the greatest.

She turned back to chat with the *People* people, but they had mingled away. Hey, no fair. She frowned as another flashbulb went off in her face. "Who are you?" she asked.

"*Vanity Fair.*"

"Oh?" Meg turned her frown into a dazzling smile and leaned back against a palm tree. "Well let's try that shot again, shall we?"

Moke took the microphone from Martha's hand and smiled into it. It was as if his beatific smile were carried by the public address system over the party. The people out there on the terraces and the beach hushed to listen.

He felt the warm breeze in his flowing white hair. He adjusted his flame-red toga and began to chant softly into the microphone.

He knew they did not understand what he was saying. It didn't matter. He did not really know what he was saying either. It did not matter. He was going into his blissful trance, feeling the happiness and love of the crowd before him. His voice rose and fell. The breeze rose with his voice.

He stopped, and with a huge grin, he nodded at the *lūʻau* pit.

In a trice, two burly island boys pounced on the pit and shoveled the dirt away. The aroma of roasted pig reached Moke's nostrils as the main course was lifted out of the pit and placed on a giant wooden platter.

The hushed crowd began to murmur as the fragrance drifted abroad in the air.

Backstage, Ben stood in front of the girls' dressing room hut and waited for Aiulani to appear. When she came out through the door, he caught her arm and said, "I've been thinking about you all day."

Aiulani gave him a tentative smile and gently pulled her arm away.

"What's wrong, honey?" Ben asked.

"We're not supposed to talk to each other. That's what you told me."

"It's showtime now. We can talk to each other now. In fact, I think we should have a kiss for good luck, what do you say?"

He reached for her, but she stepped back. "Not tonight, Ben," she said.

"We'll be out there singing love songs in a few minutes, baby," Ben complained. "How am I supposed to sound happy if you treat me this way?"

"Ben, please."

"What?"

"I don't want to be confused right now."

Sonny joined them. He was ready for work, with glistening greasepaint rubbed all over his massive bare chest. He nodded at Ben, who nodded back. He said to Aiulani, "You ready?"

Aiulani held her hand out to Sonny, and Sonny took it in both of his. They stared into each other's eyes. She turned to Ben and said, "Ben, I have to talk to Sonny alone for a minute. Do you mind?"

After checking backstage to be sure all the wiring was in place for the sound and lights, Keoki went out front and crossed the terrace and climbed the stairs to the control booth over the kitchen. Looking down through the plate-glass window, he had a full view of the whole party and of the stage. He sat down before his bank of buttons and switches and checked his watch.

At exactly nine o'clock, he flipped a whole row of switches, and the electric lights went out all over the terrace. The scene glowed with torchlight, but the stage was dark. Keoki punched on the CD player and listened to the canned music that filled the air. He adjusted the sound slightly—a little less volume, a little more bass—and then he slowly brought up the stage lights, revealing the Hawaiian musicians in their places.

The drummers began pounding along with the recorded music. Keoki gradually phased out the CD as the on-stage musicians took over, and then he adjusted the mix of the sound so that the ukuleles were loud enough to be heard over the steel guitars.

Ben Kamelele strutted out onto the stage, wearing formal black shoes, tuxedo trousers, and a bright, flowery silk aloha shirt. He wore a white orchid lei and a *haku* lei of leaves around his head. The locals and the guests who had seen Ben the night before cheered and whistled for the star, and the applause was quickly picked up by the rest of the wedding throng.

The showman grinned as he took the microphone from its stand. He bowed, and bowed again. Then, with no further ado, he began his first number, "The Hawaiian Wedding Song."

He's good, Keoki thought. Yes, Aiulani's right. Ben's a good singer, a good showman, and a good fellow, too.

Ben finished his song, thanked the audience for their applause, welcomed them to the *lūʻau*, cracked a few jokes, and then said, "And now, the treat you're waiting for."

Keoki adjusted the lights and remixed the sounds from the instruments on the band. On came the line of hula dancers, one after another, swaying to the provocative strains of island music.

The last dancer onto the stage was his daughter, the light of his life. She was radiant, as always. No, she was more radiant than ever. A woman with music in her soul and hope in her heart.

The future of Hawai'i in her graceful hula hands.

Keoki checked his watch again.

Aiulani looked across the stage in one direction and saw Ben waiting in the wings, an intense frown on his face. Her heart ached for that man. She let one arm stray away from her dance and send him her love, but he didn't seem to catch it.

She looked back into the wings on the other side of the stage, and there was Sonny, the firedancer, ready to bound out into the spotlight, grinning and prancing on the balls of his naked feet.

She had spent last night with Ben. Her body still tingled from the memory.

Tonight, Sonny would be her soldier.

This wasn't going right. There was definitely something wrong here.

Martha Masters mingled among the tables, whispering cheerful greetings to the guests who were enjoying their meal and their show. The guests were all having a great time, she could tell. They had no idea that the show they were watching was sloppy, out of order, somehow just...off.

The drums were beating a different rhythm now, more warlike and insistent. The dancing was faster than usual, and more athletic. The song Aiulani was singing had a new tune, and Martha had never heard these words before. She didn't know the Hawaiian language well enough to understand the whole message, nor did she know the language of the hula, but she knew there was something happening on that stage that she should worry about.

It's okay, Martha told herself. It was an innkeeper's dream come true: the hotel was completely booked, the bar was making

a killing, the guests were having a wonderful time, and the place was crawling with reporters and photographers from all the most important media from the worlds of travel, golf, and society.

What more could an innkeeper want?

Only one thing.

Martha Masters wanted to know what in the hell was going on.

Sugar Boyd was uneasy, too, but she knew better than to show it. She glided among the diners, leaning down to kiss their cheeks and share their laughter. But even as she laughed her way across the terrace, noticing how happy her party was, she knew something was wrong.

Sugar had arranged dozens of weddings and she knew her business well, but this one was wilder than most, almost out of control. This Whambo fellow seemed completely uninterested in the wedding itself; all he wanted was a game of golf. He did seem utterly smitten with his bride-to-be, which Sugar found a bit touching, since Miss Hartwell seemed to think of him as a necessary but not particularly desirable accessory.

Well, every couple was unique. Even when it came to weddings, rites of passage where people dressed and spoke their lines according to established rules, people showed how different they could be. All Sugar could do was give them the romantic party of their dreams and wish them the best, the happiest future they could imagine.

This evening was out of her hands now. Wally was guzzling beer with his buddies, and Meg was telling her bridesmaids, once again, the story of her great-great-great-aunt and her crazy husband with that crazy wall.

What was that all about?

Win saw her coming their way during the show's intermission. She was like a goddess on the waves, her pastel mu'umu'u teased by the evening breezes. What a lovely presence!

He stood up and called, "Sugar! Over here!"

She turned and flashed him a bright smile and walked their way. As Win sat down, he said to June, "That's Sugar. The romance lady. She's coming over here."

"So I see," June remarked. "How could I not?"

"Hello, you two," Sugar bubbled when she reached their table. "Are you having a good dinner?"

"The best," Win said. "Will you join us?"

"I'm sure Sugar's busy, Win," June said.

"I'll sit for a minute," Sugar answered.

Win stood up and held a chair for her and she sat down. "That feels good," she said. "I've been on my feet for hours. How's the dinner?"

"It's all delicious," June said. "Whatever it is."

Win asked Sugar, "Tell us what we're eating." He didn't much care what they were eating, but he loved the melodious sound of this woman's voice.

She smiled and said, "This is *moa*, morsels of chicken cooked in coconut milk." She pointed at another dish and said, "*Lomi*, salmon marinated in lime juice and spices. And that's *lawala palula*, little baked yams."

"Yum," June said.

Win thought, yum yum.

"By the way, Sugar," June said. "Have you seen Charlie?"

"Isn't he here? He usually comes to the *lū'au*."

"I haven't seen him," June said. "I was just wondering."

The lights on the patio darkened and the drumming began again. Sugar rose to go, but Win put his hand on her arm. "Sit with us, won't you? We need you to translate for us, tell us what these songs are saying."

"Okay," she answered. "I could use a bit of a rest. I've been on my feet all day."

"As you've already mentioned," June said.

What's eating her, Win wondered. But he didn't have much

time to ponder, because the atmosphere exploded with the energy of Sonny's fire dance. And once again Win could see that June was transfixed by the spectacle of muscle and heat.

When Sonny's performance ended, the hula dancers came swaying back onstage, and Aiulani took the microphone from the stand. She was one gorgeous young thing. Win readjusted himself in his seat and sighed. This was the life.

"We have a new song for you tonight," Aiulani said, a sparkle in her voice. "A song of welcome, so that you wonderful visitors can know how we islanders feel about you, and how we welcome you to our land. So sit back and enjoy...."

Win looked to Sugar, expecting to hear her whispered translation as Aiulani sang and danced the song. But as Aiulani sang, Sugar's face took on a look of horrified surprise.

Waiters scurried around the room, blowing out the hurricane lanterns on the dining tables. Around the terrace, one by one, the torches were being extinguished also, until the only light left was the spotlight on the stage.

"Romantic," Win said. "Is this one of your tricks, Sugar?"

"It's romantic, all right," June added. "I can't even find my raw fish."

"Sugar, what's going on?" It was the voice of Martha Masters, who stood beside their table, looming like an angry shadow. "Is this in the script?"

Sonny stood in the wings, watching Aiulani dance and listening to her song of battle. His heart was filled with passion, a strange cocktail made of love for his childhood sweetheart, love for his native islands, and the adrenaline that comes before the dance, before the game, before the fight.

Aiulani was brilliant tonight. She vamped, she swayed, she did the 'uwehe. She did a *hula mānai*, kneeling on the stage, keeping time with a stick. And a *hula honu*, imitating the graceful motions of a sea turtle. She did a *hula Pahua*, a dance increasing

to a frenzy. And to every song played and sung by Ben and his trio, she did the usual *kāhea*, the reminder call to the musicians of the next verse to be danced. And then she did the dance to the song none of them had rehearsed but all of them knew.

Sonny had known that tune all of his life. It was adapted from an old Christian hymn that the missionaries had brought to their islands back in the 1800s. But the islanders had added their own words, and those were the words Aiulani was singing now. If only those haoles knew what those words were telling them:

> *Aloha means many things.*
> *Hello. How are you? I love you.*
> *It also means goodbye.*
> *And goodbye is what we say to you now.*
> *Goodbye. Go home.*
> *Get a life, a life*
> *Get a life of your own*
> *Go home, go home*
> *Go back where you came from*
> *Take your wealth with you.*
> *Leave us in peace.*
> *Go. Go now.*
> *Let our beloved islands be as they were before you came.*
> *Aloha....*

"What's all this about, Sonny? I want an answer, and I want it now."

Sonny turned and faced his rival. "The time has come," he said. "Are you in or out? With us or against us? You have to choose."

"Who's involved?" Ben asked.

"Most of us. Waiters, cooks, busboys, beachboys, bellboys..."

"Where does Aiulani stand?" Ben asked.

"Can't you tell?"

"I'm in. So what's next?"

"When the lights go out, we run."

"Where?"

"We're meeting at the maintenance barn."

Up in the control booth, Keoki watched as his daughter rallied her troops. The audience had no idea. They were hooting and whistling in the dark, like a bunch of drunken sailors egging on a hootchy-kootchy dancer.

But Aiulani was in control of it all. "And now," she said, smiling like a sly little girl, "I would like to dance a special *mele* my mother wrote for me. It's about the home I grew up in."

She turned to the band and nodded. "This Old House."

Keoki swelled with pride. His daughter. Her mother would be proud.

In dance, she told of the mountains. *Mauka!*

And of the number of rooms in the house. Just a shack, really, but full of love. Aloha.

She let her hands and hips tell of her favorite room, the kitchen. And of the hole in the roof. And of her bedroom, which she shared with a younger sister.

And then she moved outdoors, to tell of the rain. The flowers.

And finally, for the last verse, she broke into song:

"*Pāpōhaku!*" she sang. "*Pā-pōhaku, Pā-pōhaku, Pā-pōhaku!*"

That was his signal.

Keoki hit the lights. The whole bank of switches.

Darkness everywhere.

Silence.

Gradually the light of the full moon took over, and the murmur of conversation again filled the terrace.

16. Operation Jericho

Twenty-three strapping young men crowded into the dimly lit equipment barn. They talked in whispers, but as their excitement rose so did their voices, until Keoki had to take charge. "Quiet down," he ordered in a soft but forceful voice. "Quiet down and listen up."

The chatter ceased.

"Okay, men, here's the deal. First, I want to thank everyone for making it. We've had our parties and our meetings and our fun, but tonight we have our work. You guys all ready to work?"

He listened to their mumbled assent. These were good boys.

"Anybody not here to work? If anybody doesn't want to do this thing, now's the time to get out."

"Question?" It was Ben Kamelele with his hand up. Odd, Keoki thought. Ben wasn't part of the *hui*.

"Yes, Ben?"

"What thing are we doing?"

"That's a good question," Keoki admitted. "Anybody know the answer?"

"Something about the wall," Sonny said. "That's what Aiulani told me."

"That's right," Keoki said. "Something about the wall. That *pāpōhaku* out on the fourteenth hole. That wall's coming down tonight. Sonny, did you put gas in the trucks and clean out the truck beds?"

"Yup. Changed the oil, too."

Ben said, "Put in the right oil this time?"

"Shut up."

"Just kidding."

"Shut up anyway."

"Both of you shut up," Keoki barked. "And all of you listen good. Okay, here's the plan. We're working as a team. A sweep.

We've got both trucks out back here, and we're going to pile in and drive out to the fourteenth hole. Ezra, you're driving one truck, and Russ, you're driving the other. Charlie's shotgun in the first truck, I'm shotgun in the second. Everybody else climbs in back. We're staying on the maintenance paths all the way until we reach the fairway out there and then we'll cross over to the wall. Then I want everyone to take a position by that wall, equally spaced, and we're going to take that wall down, stone by stone. Got it? We pass those stones along and put them in the back of Ezra's truck. Quietly. When Ezra's truck is full, he drives the load up to Ernie's pig farm and dumps the rocks. There are a few guys up there waiting to help him unload. Meanwhile, the rest of us are filling up Russ's truck. Ezra brings his truck back down, Russ takes his load up to Ernie's. We do this till the job is done. I figure it'll take about four loads. It's got to be done before dawn. Any questions?"

Ben raised his hand again. "I'm new to this group. I guess I need to know why we're doing this. I mean Ted's really going to have our ass for tearing up his golf course, and we'll probably get fired, and that's okay I guess, but I need to know why I'm putting myself on the line."

"For independence, man!" Sonny blurted out. "For the sovereignty of our people."

Keoki nodded.

"Okay, I'm all for independence," Ben said. "But tell me, how does tearing down the wall on hole fourteen help the cause? Just curious."

Keoki didn't have an answer for that one. He turned to Charlie and said, "Can you explain it?"

"The wall is a sacred thing," Charlie said. "It's spiritual. It's a part of our heritage. It was built by the *Menehune* long before our ancestors were even here. The *haoles* have no right to exploit something so important to us. It's on all their posters, all their brochures, now it's time for us to take it back."

"But take it down?" Ben persisted. "Do we have a right to do that? I mean if the *Menehune* built this wall, do we have the right—"

"We don't have time for a debate," Charlie snapped. "It's time for action. You're in or you're out. Which is it?"

"I'm in."

"Okay. let's go."

Charlie walked back and forth along the row of workers, shining his big red flashlight on their hands as they removed stone after stone from the wall. The job was going quickly, but not quickly enough to suit him. They had been at their chore for over an hour, and so far they had filled only one truckload. That truck had left for Ernie's pig farm, and the men were now filling the second truck. The wall was still three feet high.

The men were chanting a work song, backed up by the moaning wind. A full moon shone over them, flooding the fairway with ghostly light. There was enough moonlight, in fact, for the guys to see their work clearly, but Charlie still kept the flashlight going as he strode back and forth, shining his spotlight on the wall and watching it come apart.

"Hey, Charlie," Ezra called. "I hope you're not getting too tired doin' all that walking."

"Yeah," added Tony, a burly busboy that Charlie had never particularly liked. "Or getting too cold by not doing any of the work."

"Don't get a hernia carrying that flashlight," another guy mumbled.

"Keep working," Charlie said. "I'm doing my job here."

"What are you, the overseer?" Tony said. "Cracking the whip in the canebrake?"

Charlie didn't answer that one. He just kept moving along, aiming his light at every inch of wall as it came apart. The boys were working hard, he had to admit that. They were passing the

stones along and piling them high in the back of the truck. And he knew it was hard work. Getting harder, too, as the wall got lower and they had to stoop farther to lift the stones.

"It's going to be done soon," he told them. "Keep it up, you guys. You're doing great work."

But the next time he passed by Ezra and Tony, the two of them straightened up to their full height and glared at him. The singing stopped. So did the work. Charlie felt all eyes on him.

"What?" he said.

"We don't want no more boss man," Tony said.

"You're not even a member of this *hui*," Ezra added. "What makes you the boss man?"

Charlie shone his light into Ezra's sweaty face. "Get back to work," he said.

"Turn that light off."

"Get back to work."

Tony said, "This is bullshit. Either you work with us, or we're walking."

Carl, one of the beachboys, added, "Either the concierge gets his hands dirty for a change, or he gets his nose rearranged. What's it gonna be, boss man?"

"Boys!" barked Keoki. "Let's keep working. It'll all be done soon enough."

"Hey! What's this?" Sonny called from down the line. "I found something weird here."

Charlie rushed to Sonny's side and snatched the package out of the big man's hands.

"Hey, gimme that," Sonny protested. "I found it."

"Where?" Charlie asked, breathlessly.

"What do you mean where? In the damn wall. Buried under some stones. Give it back. What is it?"

His whole body trembling, Charlie held the package in one hand and used his other hand to shine light on the treasure. Here it was, the gift of a lifetime. Even wrapped in sturdy tapa cloth,

the whole package weighed less than a pound; and Charlie knew that once the tapa cloth was removed, what was inside would weigh only a few ounces. But ounce for ounce, this was the greatest treasure Charlie had ever held in his hands....

"Gimme that," Sonny growled.

Charlie tucked the package into his windbreaker. He shone the light on his own face and showed the whole crew his grin.

"Boys," he said, "we can quit working on that wall. Job's finished."

Keoki stood before Charlie and said, "Explain that, friend."

"Okay, I take it back," Charlie said. "You're right. Finish the wall. And I'll leave you alone. I've caused enough trouble around here. Sorry. I'm outa here. Adios. Aloha. Whatever." He turned to go.

Keoki said, "Walk if you want, but first hand over that package, whatever it is."

"You don't want this," Charlie stammered, patting his windbreaker. "It's nothing of value."

"Hand it here."

Charlie felt the sweat break out all over his body as he watched the entire crew approach him and surround him. He couldn't make a break for it now. He now faced the crisis of his career as a collector. And the climax of conscience. He had to choose. Was it all for him, or was it all for native sovereignty?

Charlie was a selfish man. He knew that about himself. He was proud of his selfishness. He had worked hard, all his life, at taking care of number one. But sometimes you have to do the right thing.

He pulled the package out of his jacket. He had dreamed about this treasure for months, and now he had to give it up.

"Let's take the truck up to Ernie's," he said at last. "Unload those stones and then get inside Ernie's house where we can examine this in good light." He spoke up so all could hear. "Guys, this package is worth a fortune. This is the best thing to happen

since the sovereignty movement began. And you guys discovered it. Good work! You all deserve a medal. Now let's go to Ernie's and we'll have a look."

"What about the rest of the wall?" Keoki asked.

"Screw the wall," Charlie answered, holding the package high above his head. "This is what we came for."

Ben Kamelele stepped forward. "You mean to tell me we risked our jobs for that bundle of crap?"

"It's not a bundle of crap. I keep telling you…"

"Whatever it is," Ben insisted, "I put my job on the line, and so did all these other guys, so that you could walk away with that. Am I right?"

"Look," Charlie said. "I'm turning it over to you. Relax, man. This is for the good of all of us."

"Wait a minute," Sonny said. "What about the wall?"

"What about it?"

"We can't just leave it half-done like this. It's a mess."

"So?"

"Ted's going to be furious. He's going to fire us."

"I'm not so concerned about Ted," Keoki added. "What about the *Menehune*? They're going to be mad, and that's no good. It's their *pāpōhaku*."

Charlie responded with a loud guffaw. "*Menehune*! They had nothing to do with this crummy wall," he said. "This wall was built by Captain William Brush, in 1884. And I can prove it."

Charlie heard the uproar of the entire crew of workers, blending with the howling wind. He saw them closing in on him fast, and he felt Sonny's meaty hands under his armpits. Suddenly he was hoisted above their heads, then passed along like a sack of potting soil, then thrown into the back of the truck, where he landed heavily on the pile of rocks. He still held the package tight in his hands.

"Boys," he cried. "Wait a minute!"

"The hell with that," Ben shouted. "We're taking this load on up to Ernie's and we're dumping it. And whatever's on top in the truck is going to end up on the bottom of the pile."

This is it, Charlie thought. I'm dead. It was worth a try, but it didn't work out.

"Wait!" It was Keoki's voice.

The rumble quieted down.

Keoki approached the side of the truck. "Charlie, give me that damn package."

Charlie did as he was told. Easy come easy go? It was hard as hell.

Then Keoki turned to the gang and said, "That's it for tonight. You guys go on home. I'm taking Charlie and these rocks up to Ernie's. I'll get the other crew to unload the rocks, and send them home, too. Charlie and I will have a talk about this package, whatever it is, and I'll let everyone know in the morning."

Charlie watched the workers shuffling away from the truck. He grinned to himself. Still in the game.

"With all due respect," Sonny said, "that sucks. I want to come along and make sure this little mongoose doesn't jump out of the back of the truck."

"Okay," Keoki said. "Climb in."

Sonny did as he was told, and he sat down on Charlie's body. Charlie felt the wind go out of him. He was being crushed between a rock and a hard butt.

He heard Keoki say, "Ben, you get in the cab. You're coming, too. I want to talk to you."

Keoki drove fast. This evening had been a fiasco. Charlie had taken them all for a ride, and twenty-five people would probably be fired. He hit potholes and bumps along the road to the pig farm, and he hit them as hard as he could, knowing how heavy Sonny was and just where Sonny was sitting.

"Ben," he said, "I'm sorry you got roped into this. You weren't

part of our *hui*, and you don't deserve the consequences. I know why you came along, and I'm sorry. It wasn't your fault."

"I'll find another job," Ben said. "That's not what I'll miss."

"I know," Keoki said. "I'm sorry."

Keoki turned into Ernie's dirt road and bumped toward the house. The light was on in the house.

"Uh-oh," he said.

The other truck was parked in front of the house. It was still full of rocks. Full to the top.

Parked beside it were two empty SUVs marked with the Mauna Makai logo.

"Ben, my friend, there's going to be hell to pay."

17. Hell to Pay

Win had never been to a piggery before. He had always been a city person. A suburbs person, actually, whose only experience with country living had involved well-tended fairways and greens. It was true that he had seen his share of poverty and human waste in the grungier parts of the San Francisco Bay Area, but he had never before encountered anything like the smell that had met his nostrils when they drove into the farm. Luckily the wind was blowing away from them now, and the inside of the simple farmhouse was quite pleasant, the only aroma being good coffee brewing on the stove.

They sat around the kitchen table: Martha Masters, Ted Tamura, June and himself. Ernie, the farmer, had gone to bed, mumbling about the trouble he'd been through already that evening. Martha had sent the ragtag crew of hotel and golf course workers home before they could unload all those rocks from their truck.

"Here they come," she announced when they heard the

rumble of the other truck approaching outside. "How are you doing, Ted?"

"I'm going to shoot them," Ted answered. "Or fire them. Maybe both."

"Stay calm. Don't fly off the handle," Martha told him. "And I'll try to stay calm too." It was clear to Win that she was on the edge.

The footsteps on the porch outside were heavy and slow. The screen door opened, and in walked four sweaty, dirty men looking sheepish and frightened. Keoki Kalama came first, with a package under one arm. Then Ben Kamelele. Then Sonny Apaka, who had a vise-grip on the upper arm of Charlie Leong. Once they were all inside they shuffled to a stop, and three of them stared at the floor. Charlie, the concierge, gave Martha Masters a hopeful, boyish smile.

"Well, gentlemen," Martha said, "what do you have to say for yourselves?"

"Good evening, Martha," Charlie said. "Glad you could make it."

"Don't give me that, Charlie. Where are the rest of your crew?"

"I sent them home," Keoki answered. "What about the guys I had working up here?"

"I sent them home," Martha answered. "So we're even on that score. Now let's see how many other scores we can even up. You can start by giving me some information."

"What do you want to know?" Keoki asked.

"I want to know the names of all the people who were in on this plot. Don't tell me now, but have a complete list on my desk first thing in the morning."

"And if I refuse?"

Martha sighed. "Keoki, I have hired a very fine team of private investigators. I believe you've met Mr. Winslow and Ms. Jacobs? These people can find out who was involved. They special-

ize in that sort of thing. But don't put them to the trouble, okay? Second, I want to know, right now, what the hell this is all about. Right now, Keoki. Or should I be asking you, Charlie? Well?"

There was silence until Sonny piped up. "How did you know we were up to something?"

Martha sighed again. "Because I'm a rocket scientist, Sonny. Good lord. The lights and the music all went down at the same time, and by the time Win here got the power going again, half my male staff had deserted. That was a bit of a clue, wouldn't you say?"

"How did you get the power going?" Keoki asked Win.

"I had seen you going up into the control booth before the show started," Win explained. "I figured you needed help, so I went up there with my pocket flashlight, and when I found the room empty, I just started flicking switches till I got the place lit up and I put a CD on the PA system. No biggie. Meanwhile, June went into the kitchen and helped them get back on track with the desserts. The guests never knew what hit them. They thought all that darkness was part of the show."

"The full moon helped," June added. "The whole effect was kind of romantic, actually."

"That's a relief," Ben said.

"Damn right," Martha said. "Considering all the media there reporting on the event. It could have been a disaster. Anyway, things were barely under control when I got a frantic call on my cell phone from Ted."

"You guys are going to pay big for this," Ted growled. "I was at home watching Monday night football, and all of a sudden the golf course started yelling in my ear, calling for help. So I phoned Mrs. Masters and told her to meet me at the equipment barn. But on my way there, I saw one of my trucks going up the mountainside, full of rocks. I followed it and when I saw where it was going I called Mrs. M again. She was here in five minutes, along with her detectives. You guys didn't have a chance. Your ass is grass." Ted turned to June and said, "Pardon my language."

"I've heard worse," June said.

"Okay," Martha said. "Back to basics. What's going on? Sonny, do you want to clue me in here?"

Sonny puffed up and said, "I don't think we should talk in front of these outsiders." He gestured toward June and Win.

Keoki said, "Sonny, the time has come to cooperate."

"Not in front of them," Sonny insisted.

Martha said, "Listen, my friend. I have hired these world-famous detectives to help me get to the bottom of my golf course problems, and they're going to do their job whether you cooperate or not. But it will go a lot better for you and for all your friends if we get to the truth right now. That is a fact. Do you understand? Win, you take over."

Win nodded. Very gently, he said, "Sonny, outside this house there are two pickup trucks. One of them is full of rocks. Is the other full of rocks also?"

Sonny nodded, shifting from foot to foot.

Win continued, "Keoki, where did those rocks come from?"

"From the wall on the fairway of the fourteenth hole."

"You guys had no right to damage my golf course!" Ted shouted.

Martha said, "Ted, hush. Win?"

Win turned to Ben, who was staring at the floor. "Ben, have you fellows removed the entire wall?"

"No, sir. About half of it's still there."

"Why did you stop?" That question was for Charlie, who merely smiled and shrugged.

"Can the wall be rebuilt?" Win asked Keoki.

"I suppose so. It only took us a couple of hours to take half of it down, and the stones are still in the trucks. We can rebuild the wall tomorrow." Keoki turned to Martha and said, "You want us to?"

"Of course I do," Martha said. "But there are two more things I want. I want to know who was the ringleader of this prank, and I want to know exactly what this is all about. Sonny?"

Sonny mumbled.

"Speak up."

"Native sovereignty," Sonny answered, with a choke in his voice. "Hawaiian independence. Something you wouldn't understand."

Martha wiped a tear from her eye. "Haven't I treated you people well?"

"You have," Keoki answered. "You're a fair person, and you're a good boss."

"Then why…"

Keoki seemed ready for tears also. "The time has come, Mrs. Masters. I want to see sovereignty in my lifetime."

"But how would destroying my wall help you with that? What's the wall got to do with Hawaiian independence? What gives you the right to destroy private property?" The tears were gone now, and Martha was speaking fiercely.

"We didn't used to have private property," Keoki answered.

Martha nodded. "Well, supposing we call that wall public property, which would be fine with me, what purpose did it serve to tear it apart?"

After a long silence, Charlie finally spoke. "Martha," he said, "I did this for you. For you and the hotel. I'll take full responsibility, because once you learn what this was all about, you'll thank me. I'm sure of that."

His three companions gaped at him with transparent surprise, and Martha Masters said, "I'm all ears."

Charlie turned to Keoki and said, "Let's open the package." He held out his hand, but Keoki did not give him the package.

Martha said, "What is that, Keoki?"

Sonny said, "Don't let her have it."

Charlie said, "Come on, Keoki. Work with me on this. We open the package and everybody wins. Trust me."

Martha stood up and said, "Keoki, you may have my seat. Please sit down and let's see what you have under your arm."

Looking like a man with no options and no pride left, Keoki

sat down and laid the package on the kitchen table. He un-
wrapped the tapa cloth, and out came an oversized envelope, still
in perfect condition, stamped and bearing the address: "Miss Su-
san Hartwell, 14 Beacon Street, Boston, Massachusetts, U.S.A."

Ted handed Keoki a pocket knife, and he slit open the enve-
lope. He withdrew a handwritten letter and a number of trinkets.
Win watched Ben and Sonny and Charlie draw near for a close
look. Ben and Sonny looked curious, but Charlie had a look of
combined lust and pride.

"Look at those beauties," Charlie breathed. He reached a
hand out toward the table and Martha slapped it back.

"What are these things?" Martha asked Keoki.

"Damned if I know. Charlie?"

Charlie said, with a knowing smile, "Read the letter."

Keoki stood up and handed the letter to Martha, who sat back
down at the table and read:

Kohala, Hawai'i
November 1, 1884
My dear sister Susan,

How I miss you! But I want you to know I am having a
most interesting life here with William on our ranch in the
middle of the Pacific Ocean. Why just the other day we
entertained a king. Imagine that! Actually, King Kālakaua
comes to visit fairly often, whenever his responsibilities
bring him to this island. Of course he lives most of the time
in the capital city, Honolulu.

William is a marvelous host, and he always throws lavish
parties in His Majesty's honor. The king always comes with
a large entourage, and it is quite a sight to watch them
climbing up the mountain to our ranch by torchlight. They
all dance the hula and sing. The king often joins in, as he is
very keen on hula dancing, which he has brought back into
favor. Our well-intentioned missionaries banned the dance

for years, but it's now popular again. It's quite a spectacle, I must say!

It's a good life here, Susan. It's very different from Boston, and I know you and the rest of our family think I've made a poor choice, but I want you to know that I'm happy. I miss Boston in the winter and Cape Cod in the summer, and most of all I miss you, but this is my home now. I regret that I cannot have children, but I grow my roses and I also run a small school here, teaching English to the children of our ranch hands. They are sweet youngsters, quite eager to learn. I am a fulfilled woman, Susan. Believe me, I am.

I am enclosing some gifts for you, some Hawaiian souvenirs that I hope you will find interesting. Here is a dog tag that was worn by Harriet, my beloved spaniel, who died last year. I thought you might like to have the tag, since you were so fond of her. Harriet wore it proudly. The wooden token is like a substitute for money. Sometimes the government runs short of metal, and the sugar plantations make these wooden coins to fill in the gap in the economy. But I'm sending you some metal coins, too. The penny is the largest, for some reason. It has the head of our previous king, Kamehameha III. He had been dead for several years before I came to Hawai'i. The little silver coin has the head of our friend, King Kalākaua. Isn't he handsome? As for the other coins....

Martha looked up from the letter. Her face was twitching. "My God, Charlie, this letter is priceless!"

"You're damn right," Charlie answered with a proud smile. "Just think how those coins and tokens will look in the glass case in the lobby of the Mauna Makai. And you can frame that letter for the wall, and—"

"What's going on?" Sonny shouted. "That's our stuff, Charlie. What are you doing, giving it all to her?"

"It doesn't belong to you, Sonny," Martha said. "It doesn't belong to me either. It belongs to Meg Hartwell. That's why she was so interested in the wall. Somehow she knew about this package. How did she know, is what I want to know. Charlie, any ideas?"

"A lot of people know about it," Charlie said. "It's known as the 'missing letter from Hawai'i.' The existence of this letter first surfaced when the Hartwell family donated facsimiles of the Brush-Hartwell correspondence to the Massachusetts Historical Society three years ago. It doesn't have much monetary value, but you could probably sell it to Meg Hartwell for quite a price. She seems anxious to complete the collection. And those trinkets, they're valuable on the antique Hawaiiana collector's market. I might as well tell you, you've got a little gold mine there on that table."

Ben said, "I get it now. You wanted this stuff for yourself. You got caught, so you're willing to let it go to the hotel to save your own ass. But you never had any interest in our cause. You were using us." He advanced on Charlie with clenched fists.

Keoki was openly weeping. "Mrs. Masters, I am so ashamed. I have made a huge mistake in judgment, and I dragged my friends in on it, too. I will hand you my resignation tomorrow morning."

"You certainly will not," Martha snapped. She turned to Charlie and said, "Ben has it right. You were in it for yourself. Personal greed. Correct? Well?"

The confident grin was gone from Charlie's face. He stared at the ceiling for a moment and let out a huge breath before he spoke. "Okay," he said at last. "I haven't been entirely straight with any of you about all this. It is true that I was tempted by these things here. I learned about them on the Internet, and when I realized that they were right in my backyard, so to speak, I somehow just had to have them. It wasn't for the money. I'm a collector. It's kind of an addiction, like gambling or drugs. I have this problem when it comes to Hawaiian antiques. Maybe there's a twelve-step program for it."

He glanced around the room, but seeing no smiles, he continued. "So I used my friends," he said. "Keoki, Sonny, Ben, I'm sorry. I used you. I'll never forgive myself for that. But Martha, I want you to know that tonight I was fully intending to put these things in your possession, so you could display them in the lobby for all your guests and all your employees to enjoy. I swear to God."

"Why should I believe that?" Martha asked. "Why should I believe anything you say? If these things are so valuable, why would you give them to me?"

"It's because of something that happened to me earlier today," Charlie said, stealing a glance in June's direction. "I had a talk with one of the guests," he continued. "I was telling her about Hawaiian history, and she seemed so genuinely interested, so honestly moved by the whole thing, that I realized that she had a right to see these treasures on display. I had to share them with her, and with the rest of the guests. And with you guys too," he said, nodding to Sonny and Ben. "These treasures are for all of us, not for me."

Win glanced at June, and saw that she was blushing and had tears in her eyes. All these tears, Win thought. This was getting out of hand.

"Well, Martha, now you know why Meg Hartwell was so interested in that wall."

"Yes. And it seems to me that if anyone has a rightful claim on all this stuff, it's her," Martha said. "In the meantime, I'll hold onto it." She reached across the table to gather the Hawaiiana treasures into her hands.

"Not so fast," Sonny said. "I figure I'm fired anyway, so I might as well speak my piece. If all that stuff is so valuable, Mrs. Masters, what gives you the right to just take it like that? Maybe it belongs to that Hartwell woman, and maybe it belongs to the hotel, or maybe it belongs in a native Hawaiian museum. But who are you to make that decision? And why should we let you

keep it in the meantime? By the rules, those things belong to me."

"What rules are those?" Ted asked.

"Finders keepers," Sonny answered. "Not very fancy *haole* rules, but they make sense to me."

Charlie said, "May I make a suggestion?"

All eyes turned to the concierge, who was wearing his most sincere smile. "I think Moke would know best what to do with all this material. He's our spiritual leader, and he's the wisest person I know."

Keoki nodded. So did Sonny. And Ben. And Ted.

Martha too. "Very well," she said. "I'll call him into the office first thing in the morning. Meanwhile…"

"Meanwhile," Charlie continued, "I suggest you let Win and June be the caretakers of this package. They're not interested parties, their reputation is at stake, and I trust them."

"Charlie, you amaze me," Martha said. "That's a fine suggestion. June, how do you feel about this?"

"Charlie amazes me, too," June said. "I'll be glad to hold onto the package until Moke decides what should be done."

"How do you guys feel about this arrangement?" Win asked Sonny and Ben.

They both nodded. "Okay, I guess," Ben said.

"Keoki? Ted?"

"Sure."

"Why not?"

It seemed as if everyone in the room sighed together in relief.

Martha said, "Well, this may turn out for the best, and we may even get some good publicity out of the discovery of those treasures. I have to admit, though, that I'm still upset. Keoki, Ben, Sonny, how could you boys do this to me? Well, I don't have time for hurt feelings right now. I still have a hotel to manage and a wedding to host and a golf course to open in front of the entire world. That has to happen on Thursday morning, on schedule.

Boys, I want that wall rebuilt and ready for Thursday morning. Is that clear?"

"Yes ma'am," Keoki said.

"I'll supervise," Ted said. "I want everyone in your gang at my equipment barn at two p.m. tomorrow. You hear me, Ben? Sonny?"

"Yes, sir."

"Put that wall back the way it was," Martha went on, "and you're all forgiven. If you don't, you're all fired. Oh, and Charlie? Don't bother to get your hands dirty by helping with the wall."

"I'll be happy to help," Charlie said.

"I want you in my office tomorrow morning. Actually, I guess it's already tomorrow. Anyway, come by my office in the morning so I can give you your severance pay. I want you to clean out your office by noon."

"But..."

"Get out of here, Charlie."

Charlie looked around the room, his face red and grim. He turned and left the farmhouse, slamming the screen door behind him.

The meeting was over. Martha, Ted, Win, and June stood up from the table and followed Keoki, Sonny, and Ben out onto the porch. The wind had picked up, and it had reversed its direction. Win was reminded, forcefully, that he was on a pig farm.

"Uh-oh," Ted said. "Bad wind."

"Smells pretty awful," Win said.

"The smell's okay," Ted said. "Just pigs. But I don't like that wind."

"The *hulumano*," June said. "It gives me the creeps."

"It gives me chicken skin," Keoki said.

18. Not Playing Golf

When Win awoke on Tuesday morning, he found that June was already up and dressed. He pulled himself out of bed and stumbled naked into the large room of their suite, where she was sitting at the table reading the letter from Sarah Brush to Susan Hartwell.

"That was quite a wind last night," he said. "Did you have more bad dreams?"

She shook her head and smiled. "I had beautiful dreams," she said.

He loved her smile. "Come on back to bed," he said. "I'll make those dreams come true for you."

"I'll take a raincheck on that," she answered, putting the letter back in its envelope. "Where do you think we should hide this thing?"

"There's the safe in our closet."

"Oh, right."

"Do you have the key, or do I?"

"It's in my purse."

"Are you sure? Remember, Martha warned us not to lose it...."

"Win, have I ever lost a key? Have you ever known me to lose anything?"

"No, of course not. You're right." Win put his hand on her shoulder. "You sure I can't interest you in an early morning siesta?"

She shrugged his hand off and said, "Go take your shower. I want to get to the dining room before they stop serving breakfast."

Win said, "You go ahead. Have breakfast by yourself. I'll just grab a piece of fruit from the bowl here."

"Okay. What'll we do this morning?"

"I'm going for a walk," Win said.

"Want some company?"

"Not really. I need to get out on the golf course and take a good long walk. I haven't played golf since Friday, and I'm feeling a little antsy."

"The golf course isn't open yet. You can't play golf today."

"I can still take a walk, can't I?"

"Touchy touchy," June remarked.

"Maybe," Win admitted. "Since there's no feely feely."

Win felt better once he got out onto the golf course. Something about an expanse of well-tended green lawn stretching out to goal after challenging goal did wonders for the golfer's spirit. That and the feel of turf under his soft spikes and the heft of the golf bag slung over his shoulder. Win felt like a man again, a man whose company he enjoyed.

Yes, he was carrying his clubs. Why not? Call it a hunch or maybe just an eccentricity, it felt like the right thing to do. This was his work, right? Keeping an eye on things, doing whatever it took to keep the golf course out of last-minute danger. Win had a right, even a duty to be out there smelling the new-mown grass and feeling the rise and fall of terrain as he strolled his way along the pristine, virgin course. Carrying the golf bag was important. It wasn't as if he was actually playing golf.

No doubt about it. Doug had done a beautiful job with this course, playing with the contours of the land, throwing in water here, sand there, providing an emerald highway through what had once been a forbidding field of black lava rocks.

When Win reached the green of the third hole, he took a short detour and walked through a grove of *kiawe* trees to the open scar of lava rock that Ted had shown them on Sunday. There it was, the remarkable display of petroglyphs. In the interim, somebody had put a small fence in front of it and had erected a sign pointing out this archeological treasure and asking visitors not to touch or disturb it.

But something was different. Win stared at the carving of the

man wielding a stick and found that his stance had shifted. Win was sure, positive, that this figure had held the crude golf-club-like stick above his shoulders, as if poised to begin a swing. Now the club was halfway down the swing, about level with the figure's waist, and there was a new bend at the hips, as if the ancient golfer were throwing his weight into the action.

Odd. Well, it was still an interesting carving, and Win supposed he just hadn't remembered it correctly.

When he got back out to the green, he was surprised to find that he wasn't alone. There was another golfer walking the course, another man dressed in Bermuda shorts and a golf shirt, as if for a game, also toting a golf bag. And not just any man. Not just any golfer.

Win felt shy in front of this famous person. But it was his job to keep tabs, and so he approached him and said, "Hi, I'm Harry Winslow."

The other fellow smiled broadly and put out his hand. "Wally Wood. How ya doin', Harry?"

"Call me Win. I'm doing great. How about you?"

"I've got the jitters, to tell you the truth," Wally said. "I'm getting married in two days. I've never been married before. You married?"

"Nope. I've been living with a woman for a couple of years, but I'm not sure I could handle marriage."

"Same here, and me neither. And now my bride-to-be has decided we're not even living together, in the biblical sense, if you know what I mean, until we get married. I know that's only a couple of days away, but I'm getting pretty tense."

Win chuckled. "Join the club."

"Speaking of clubs," Wally said, "it always calms my nerves to hit a few golf balls around. I see you've got your clubs. What do you say we knock a few balls in the air?"

Win felt honored, thrilled, to be invited to play with the most famous golfer in the world. But it was out of the question. "Damn.

Wish we could, Wally. But the course isn't officially open yet, and golf is off limits till after you get married."

"Yeah, I know. I shouldn't have mentioned it. But at least we could do a little putting." He reached into the side pocket of his golf bag and pulled out a couple of balls and dropped them on the green. "Top Flight for me. Ultra for you. What do you say?"

Win laughed. "Well, that certainly couldn't hurt." He pulled out his putter as he lay his bag outside the green.

Five minutes later, Win and Wally had each sunk several putts. From good distances, too. Not one miss for either one of them. Win expected as much from Wally Wood, but he himself had never putted this accurately before. It seemed as if the cup had a magnet in it. Win felt great.

"Hey, I'm doing pretty good here," Wally said. "You too, pal. Too bad we can't chip a few balls up the next fairway. I'm not talking long drives or anything. Just some seven-iron stuff."

Win scratched his head. "I can't see how that would do any real damage to the course," he said. "As long as we don't get caught. I haven't seen any of the greenkeeping crew so far this morning."

"The're not the ones I'm worried about," Wally said. "It's those damn reporters and photographers who won't leave me and my fiancée alone. But so far it looks as if I've lost them. So let's play while we can."

The conspiracy seemed to give them an instant friendship, as if they'd been golfing together for years, all over the world. They walked out onto the fairway of the fourth hole and laid their golf balls on the grass. "Seven irons only," Wally said. "Strictly pitch-and-putt. We're not really playing golf at all, right?"

"Makes sense to me," Win said. "Give it a whack."

Wally, also known as Whambo, grinned at Win, addressed the ball, pulled his seven iron back, and swung through the ball. The ball lifted as if it had life and wings to fly. A beautiful shot landing just a short hop away from the green.

"Nice going," Win commented. "I'm afraid I'm going to slow us down. I'll never get that far with a seven iron."

"Give it a try."

Win did. *Shhhoook!* His ball lifted too, and it sailed like a happy bird, and it landed right in front of Wally's ball. In front!

"Holy cow!" Wally said. "You're good!"

Win couldn't answer that one. To agree would be boastful. To disagree would be absurd. Either way would be bad luck. He just grinned and said, "Let's go see what happens next."

What happened next was a simple pitch for each of them, landing within inches of the cup. Gimme gimme.

They walked out onto the fairway of the fifth, and it went as well as the fourth. The sixth was even better. Every time Wally hit a winner of a stroke, Win followed with a stroke just as fine.

"I have the feeling this can't last," Win admitted, as they landed their balls on the ninth green. "I've never played like this before. What if we get caught? But we can't stop now, now that we're doing this well. I mean you probably play this well all the time, but... Forgive me. I'm rambling."

"Win, I got a question for you," Wally said.

"Yes?"

"Do you drive this well also?"

"Wally, I'm trying to tell you, I'm really not this good."

"I bet you drive like a champ," Wally said.

"Are you suggesting...?"

"Listen, pal. If we stick to seven irons for the second half of this course, it's going to take quite a while. I know we're playing well, but still. If we were to allow ourselves a drive—only one at the beginning of each hole, mind you—we'd be done a lot sooner, and that would be better for everyone concerned. And we'd be less likely to get caught, either by the greenkeepers or the newshawks. Am I right?"

"Wally, my friend, I've spent a lot of time dealing with the criminal mind, and I like the way you think. Tee up, sir."

Wally took his stance, surveying the fairway of the tenth hole with the calculating stare of a professional golfer, and casually, elegantly, let his drive rip. Far, far away the ball soared until it plummeted to a landing, smack in the middle of the fairway.

"Nice shot," Win commented.

"Thanks." Wally leaned on his driver, awaiting Win's turn.

Saying a silent prayer that he wouldn't blow it, Win too connected with the sweet spot. He watched in amazement as his drive matched Wally's distance.

Having given up their seven-iron-only rule, Wally chose a wedge and Win a nine-iron. Both approaches came to rest an easy one putt from the hole.

They proceeded to hole eleven. Here again, Win matched Wally stroke for stroke. He had great difficulty not whooping with joy. "I've never played like this before," he confided. "Never. Maybe it's your skill rubbing off on me."

Wally looked back at him and said, "I've never played like this either. On the one hand, I'm glad there are no other people around. But who's ever going to believe we had a game this good?"

Hole thirteen. Par five. *Thwack. Wham!* Their second shots landed them both on the green. They both sank their putts. They were both too amazed to talk or even grin. They shook hands. There were tears in Wally's eyes.

"I don't believe that really happened," he said, finally. "I've only seen one double eagle before in my life. And this was a double-double."

"Who's dreaming?" Win asked. "You or me?"

When they got to the tee for the fourteenth hole, Win stared in shock down the fairway. "My God," he said. "Do you see that wall?"

Wally chuckled. "Don't let a little wall bother you, buddy. I've seen the way you drive, and you'll clear that wall by a mile."

"I know, but the wall's all the way across the fairway, and it's a full four feet high."

"So? Don't worry about the wall. That's the trademark of the course, by the way. They use it on all their posters and brochures. My fiancée's obsessed by that wall, for some reason."

"I know, Wally, but can't you see? It's all in one piece. There's nothing wrong with it."

Wally said, "Tee off, my man."

Win shook his head in wonder and teed off. *Thwack!* It was the best golf shot he'd had all morning. No. Make that all year. He watched his ball become a white dot in the sky, then land with a bounce only a few yards from the distant green.

"Ever thought about going pro, sir?" Wally said. "I could use you as a friend, but I'm not sure I want you as a rival."

With that the golf star teed up and teed off. *Wham!* Wally's ball bounced onto the green itself. "The eagle soars," he whispered. "How in the hell am I going to keep this a secret?"

They carried their bags down the fairway toward the green. Win marveled again at the wall, which was in perfect condition, as if nothing had ever happened to it. Was last night just a dream? Or was he dreaming right now? And where were Ted and his crew? Maybe it all made sense after all. Maybe the crew didn't all go home last night. Maybe they came here in the middle of the night, repaired the wall, and were now sleeping off the adventure. But...

He shook his head. Well, whatever. With his golf game this good, why ask questions? They strode on till they reached Win's ball, which he easily pitched up onto the green.

When they stepped onto the green of the fourteenth hole, they found all three balls lying within a few feet of each other.

Wait.

Three balls?

Three?

"I don't get it," Win said.

"Get what?" Wally asked.

"I believe that's my Strata," said a third voice. The voice had a rough Scottish burr.

Win spun around and found himself face-to-face with a withered old man in a sailor suit. He was the same person Win had seen the day before, still carrying the same wooden cane; but on closer inspection, Win saw that the cane was really a handsome, handcrafted golf club.

"Mind if I join you?" the old man said.

"Well, the golf course isn't really open yet, so we're not exactly playing."

"Och, I've been playing this course for over a hundred years. My name's Angus, by the way."

"I'm Win. And this is Wally." Win turned to introduce his friend, but Wally was intent on sinking his putt and paying no attention to the newcomer.

"Hey, you guys!"

"Uh-oh," Wally said. "We're busted."

They watched the utility cart coming at them at top speed. Ted Tamura was at the wheel, shouting curses louder and louder as the cart got nearer. *"Get the hell off my golf course. This course is not open yet. You're trespassing! I could have you arrested!"*

Ted brought his cart to a halt beside the green, and he climbed off and strode up to the golfers. "Mr. Winslow, you know perfectly well this course is off limits."

"Morning, Ted. Meet Wally Wood. Wally, this is Ted Tamura, the greenkeeper. I'm told he's the best in the business."

"I know who you are, and I don't care," Ted said to Wally. "You may be a big star, but you still have no right to play on this course until Thursday. If I let you play, then I have to let everybody play, and the course isn't ready for that, and neither am I. And another thing…"

"Wait. Ted, hold on," Win said. "We weren't really playing. We were just walking the course."

Ted nodded slowly, squinting his eyes. "Right. Sure. Well

then you won't be needing your golf clubs, will you? Why don't you two just give me your bags right now, and I'll drive them back to the hotel for you. That way you won't have so much weight to carry around while you're not golfing."

Well, there was no way around it. It was the end of the best morning of golf Win had ever experienced. He shoved his putter into his golf bag and placed the bag on the back of Ted's cart. Wally did the same.

"I'll take your golf balls, too," Ted said, pointing at the two balls resting on the green.

Wait.

Two balls? Where was the Strata?

Win turned to Angus, to see if the old Scot was going to surrender his wooden club, but the old Scot had vanished.

There was no explaining the events of that morning. Win did not even try. He said, "By the way, Ted, your boys did a great job of repairing the wall. You can't even see that any damage was done."

Ted looked back down the fairway at the wall. It was in perfect condition.

Visibly shaken, Ted hopped back onto his utility cart and turned on the motor. "Do you guys want a ride back to the hotel?"

"No thanks," Wally said.

"We'll walk," said Win.

"I have to warn you," Ted said. "There's something strange about this golf course. I guess it's safe, but it's a little strange. I just hope it starts acting normal by Thursday morning."

"Ted, my friend," Wally said, "this here course is the best course I've ever played, even if I wasn't really playing it. Don't change a thing."

After Ted had driven off, Win said to Wally, "I wonder what happened to Angus?"

Wally answered, "Angus who?"

19. *Vanishing Act*

Win whistled as he crossed the terrace by the swimming pool. For a day that had started out on a sour note, this had turned into perhaps the luckiest day of his life, and he planned to push that luck. He couldn't wait to see June; he knew her mood would change when she heard what a game he'd had.

Arriving at suite 6, he cleared his throat and rapped happily on the door.

No answer. He tried the door and found it locked.

Win didn't have his key with him, but fortunately there was a housekeeping cart across the courtyard, and the maid was happy to unlock the door to his suite. She was a handsome young Hawaiian woman with a big smile and a nametag that read "Blossom."

"I haven't cleaned your room yet," she told him. "Would you like to wait while I do it now, or do you plan to go out again?"

"Give me fifteen minutes to freshen up."

"*Mahalo,*" Blossom said.

Win took a quick shower and changed into fresh shorts and a Hawaiian shirt. He wanted to write a note to June, to tell her he was in a much better mood and couldn't wait to tell her about his walk on the golf course, but he put that pleasure off, knowing that Blossom was waiting for him to leave. He needed to get to the snack bar anyway. It was almost two o'clock, and he hadn't eaten anything yet that day, other than half a papaya for breakfast. Besides, maybe he'd find June at the snack bar. This was going to be her lucky day, too: she was going to hear the golf story of the century.

He put his room key in his pocket and waved across the courtyard to Blossom, who waved back.

He left the door unlocked for her.

Martha Masters had had a frustrating morning. She'd been unable to reach Moke by phone, although she'd tried several times, whenever she could get a few minutes' rest from the duties of managing a hotel full of golfers, media, and wedding guests. Before she knew it, it was lunchtime, and she just had to get out of the office to stretch her legs and air out her brain. She was finishing her lunch as Win came into the snack bar. "Thanks again for all your good work last night," she told him.

"Our pleasure," he said, smiling. "Have you seen June?"

"Not today. By the way, Ted called me and said you and Wally Wood were out on the golf course this morning."

He smiled shyly, like a little kid caught taking an extra piece of candy. "We weren't really playing," he said. "Just sort of walking the course. I wanted to keep an eye on things."

Martha patted his hand. "I hope you had a few good shots," she said. "Have a nice lunch."

She left the snack bar and returned to her office, where she found Sonny Apaka waiting for her.

"Hi, Sonny. Come on in. Ted phoned me and told me that you boys put the wall back and it looks as good as new. Thanks for taking care of that so quickly."

"It wasn't me, Mrs. M. Must have been some other guys. I thought it was going to be done this afternoon, but I'm not working this afternoon."

"Oh? Why's that? Aren't you feeling well?"

"I feel terrible, if you want to know the truth."

"What hurts?"

"Mrs. M, I gotta quit my job. I been thinking it over, and it's not working out."

"Oh, Sonny, please! Tell me what's bothering you. I know there are some problems around the native sovereignty issue, but maybe we can work on them together. I do want to help your cause, if I can. You know that."

Sonny nodded sadly. "Yes ma'am. I know that. That's not the problem."

"Then?"

"It's Ben," he answered.

"Ben's been giving you a hard time?"

"No ma'am. I was giving him a hard time, but now I've decided he's a pretty good guy. Thing is, I'm in love with Aiulani and she's in love with Ben. I'm not supposed to know that, but I do. It breaks my heart to work with Ben all day, and it breaks my heart worse to dance with her at night. This sucks, Mrs. M, and I gotta get out of here before I go *pupule*."

Martha nodded. "Listen, Sonny. Please stick around until after the wedding is over. I'm going to need all the help I can get to survive this event. Take the rest of today off, but please stay with us until the end of the week. Will you promise me that? If you do that, I'll do all I can to help you find a good job at another hotel. Okay?"

"Yes ma'am. *Mahalo*."

"Aloha, dear. Now go take a swim in the ocean and cool off."

After Sonny had left, Martha called Sugar and said, "I need your help. We've got a romance problem that's poisoning the staff."

"I'm awfully busy right now, Martha. As you well know."

"It'll wait till after the wedding, but then I want you to talk to Sonny."

Sugar chuckled through the phone. "It's always a pleasure to talk with that fine specimen."

Martha had no sooner hung up the phone when the intercom buzzed and her assistant announced that Meg Hartwell would like to see her. "Send her in," Martha said, thinking, Hoo boy, how did I ever get into this business?

Meg Hartwell was a pretty young thing, but she looked tough and all business as she strode through the door and took a seat across the desk from Martha.

"Is everything going okay?" Martha asked. "I hope your accommodations are comfortable?"

"Yeah. This place is great. You're so lucky to get to live here. If I lived here I'd spend all day on the beach, every day."

"I'm afraid the job keeps me too busy for that," Martha laughed. Too busy for small talk, too, she thought. "What can I do for you?"

"There it is," Meg said, pointing at the poster on the wall. "That wall. I want to talk to you about that wall."

Martha nodded. "We're very proud of our *pāpōhaku*. The designer of the golf course was going to tear it down, but then he decided to keep it, and it appears he made the right decision. That wall has brought us a lot of good luck. That particular photo, and others like it, have shown up in every important golf magazine over the past year. The wall is what people recognize about our new golf course and even our resort. Corporate imaging, they call it."

"Yes, that's all very well and good, but there's a problem," Meg said sweetly. "I don't mean to be difficult, but I need to have that wall taken apart."

"You too?"

"What do you mean?"

"Maybe you should tell me what *you* mean."

Meg sat back and crossed her legs. "Okay. Here's the deal. I come from a very well-established Boston family, okay? I mean we go back to the *Mayflower*. I'm not a snob or anything, but you mention the Hartwells in Massachusetts, and people know who you're talking about. And we're very proud of our family history. Why? Because it's all we have left."

"I'm afraid I don't follow," Martha said. Oh brother. Looney tunes.

"The Hartwell family are right up there with the Cabots and Lodges. I've had all kinds of ancestors in the Senate and the House, two Harvard presidents, you name it. We're not as famous as the Kennedys, thank God, but we're nicer. Trouble is, we're broke. That is, until Thursday morning. On Thursday morning

I'll be Margaret Wood, but that's another story. At that point I'll be able to afford whatever I want, and I want that wall, Mrs. Masters. I hope you don't mind, but I would like to buy that wall, and if you don't want to sell it to me, I'll be wealthy enough to hire a very good lawyer."

The two women stared across the desk at each other.

"Just what is it about that wall that you want so much?" Martha asked.

"It's a long story, but I happen to know there's a Hartwell family heirloom buried in that wall."

"Not anymore."

"What?"

"You're talking about 'the missing letter from Hawai'i'?"

Meg blinked at her. "You know about that letter?"

"I've read it," Martha answered.

"When?" Meg stammered. "Where?" She stood up and walked over to the poster and put the palm of her hand on the image of the wall. "You mean to tell me the letter isn't in this whatchamacallit, this Popocatapetl?"

"*Pāpōhaku*," Martha said. "No. Not anymore."

"Where is it, then?"

"I don't know exactly. But I can assure you it's in safe hands."

"Yeah, well I want it safe in my hands."

"I'll see what I can do. Give me until Thursday morning. Perhaps we can give you and your husband a nice wedding present."

"That would be so kind of you. You see, Mrs. Masters, my husband and I will not be leaving Hawai'i without that letter. I need it for our family archives." Meg stood up and said, "Well, I'll let you get back to work. I think you people are doing a lovely job with my wedding."

After Meg left, Martha took a deep breath and read, for the third time, with a mixture of regret and relief, Charlie Leong's resignation letter.

Win returned to suite 6 fully satisfied, having had a teriyaki burg-
er crowned with pineapple slices, washed down with two Primo
beers. He let himself in with his key and was pleased to see that
the room had been cleaned and made up, and that the bed had
been turned down and made ready for the evening. There was
even a new legend on his pillow.

"Honey?" he called.

No answer.

Too bad. It was siesta time, and Win could have used some
company for one more round of exercise before his nap. Oh
well…

He shuffled off his sandals, sat down on the bed, and
stretched out. Moving the pillow legend to June's side of the bed,
he rolled over and drifted off to a happy dream of golf balls sailing
into a warm blue sky.

"Mrs. M, can I talk to you a minute?"

Martha looked up from her desk and saw Keoki poking his
head inside her door. "Of course, Keoki. Come on in. Just don't
tell me you want to quit. I've had enough of those already today."

Keoki walked in looking sad and sat down.

"What can I do for you?" she asked.

He sighed deeply. "I'm so ashamed," he said. "I was disloyal to
you last night. I think I should leave this place. You are too good
an employer to deserve this kind of treatment."

"Oh, don't be silly," she said. "I couldn't run Mauna Makai
without you, Keoki, and you know it. You made a mistake. We all
make mistakes. All's well now."

"It's not, though," Keoki said. "You see, if I stay with you, I
might feel I'm being disloyal to my people."

"The sovereignty issue?" Here we go again, she thought. "Ke-
oki, what can I do to prove to you I'm on your side? I won't give
you my hotel, because my husband and I worked hard all our
lives for this. But if there's anything else, please let me know. How

about a contribution to your movement? How about we offer classes to tourists and guests in native Hawaiian culture? I'd be happy to have you pass out literature about the cause to all the guests. Would you like to start a museum of Hawaiian history right here in the hotel? I can't afford to lose you, Keoki. Name your price."

Keoki was a proud man, she knew that. That's why it moved Martha so much to see him once again on the verge of tears, unable to speak.

"Keoki, let's try this for starters. Let's get Moke in here and have him resolve this issue of what's to be done with the package you uncovered last night. I've been trying to reach him. I'll try again right now."

Keoki nodded.

Martha picked up the phone and punched Moke's number.

"Aloha," said the kind old voice on the other end.

"Moke, this is Martha Masters. I've been trying to reach you all day."

"Hello, my friend. I was meditating this morning. I heard the phone ringing, but I was listening to other voices at the time. Aloha, Martha."

"Aloha yourself. Listen, Moke, would you be willing to come to my office and help us out with a little advice?"

"Of course. When would you like me to come?"

"How about now?"

"If my old Ford wants to be my friend today, I'll be there in half an hour."

"You're an angel."

"Maybe, but sometimes that Ford can be a devil."

Martha hung up and told Keoki, "Go to the Barefoot Bar and have a beer. Put it on my tab. Calm down, my dear. Then come back." She looked at her watch. "Meet Moke and me here at four forty-five."

Keoki stood up. "Thank you, Mrs. M."

"I think by now you could call me Martha."

Keoki nodded and left, and Martha lifted the phone again. The front desk answered, and she said, "Please ring suite six for me."

Win awoke and caught the phone on the first ring. "Hello?"

"Win, this is Martha Masters."

"Oh. I mean, hello."

"You sound disappointed."

"No, of course not. I just thought it might be someone else. What can I do for you, Martha?"

"Would you and June come on over to my office? I'd like to have a meeting. And please bring that package. You know the one I mean."

"Right now?"

"In fifteen minutes. Is that convenient for you?"

"Yes, of course. I'll be right there. But I'm afraid I don't know where June is, and she has the only key to the safe. So I can't bring the package."

"Well, perhaps you could leave a note for her to join us?" Martha suggested. "And have her bring the package with her?"

"Okay. I'll see you in a few minutes."

He hung up, sat on the edge of the bed, and took stock. He needed to write June a note. Okay. He reached for the nearest piece of paper, which happened to be the envelope containing the pillow legend on June's pillow. He picked it up and grabbed the pen by the bedside phone.

There was already a note on the face of the envelope.

Dearest Win,
 Don't wait up for me.
 I'm terribly sorry.
 J.

What was that all about?

Win went to the bathroom to splash some cold water on his face. June's toothbrush was gone. Her hairbrush. Her cosmetics case.

Then he went to the dresser and opened up the top drawer, where June had put her T-shirts and underwear. He checked the other drawers. Zilch. Her side of the dresser was empty.

He checked the closet. June's clothes were gone.

All of her stuff was gone.

Win knelt before the safe at the back of the closet and gave the door a tug. To his surprise the door opened easily.

Win swallowed hard. He felt inside the safe to make sure.

Empty.

20. *Love in the Afternoon*

"How in the world do they do it?"

"Do what?" Charlie asked. He stood close behind her, his arms around her waist.

"Make sunsets like that," June murmured. They stood on his balcony, gazing down over the mountainside and out to the giant display of brilliant color that filled the sky over the ocean. "Is there a god in charge of that?"

"It's a committee," he told her. "That's why it's never the same two nights in a row. Would you like another mai tai?"

"No, I've learned my lesson about mai tais. Besides, I really have to be going."

Charlie nuzzled her ear. "Oh, don't say that. Don't spoil our perfect day."

"It has been a perfect day, hasn't it Charlie?"

"Thanks to you. Without you this day would have been a disaster."

June turned in his arms until they were face-to-face, and she kissed him tenderly on the lips. "Will you be all right now?" she asked.

"If you'll stay with me," he said, smiling boyishly.

"You know I can't do that," she answered. "Poor Win must be going crazy."

"It will do him good to worry a little bit. He doesn't appreciate you enough."

"Win's sweet," June protested. "He's just not very romantic, especially when there's a golf course in the neighborhood. But really, I must..."

"One more drink," Charlie pleaded. "Watch the rest of the sunset with me."

She smiled. "A weak one." She shivered a bit in the newborn breeze. "Can you bring me something to throw over my shoulders?"

"Coming right up."

While Charlie was inside, June dismissed Win from her mind by remembering the afternoon she'd spent with Charlie. He had found her by the pool in the late morning and had begged her to come with him for a drive up the coast. He had just emptied out his office and was feeling an attack of anxiety coming on. "I need company, June. I need *your* company," he'd said. "Please. I'll show you a Hawai'i you'll never find on maps or postcards. I want to share something special with you. And I want you to hold my hand through this horrible day. Will you do that?"

She had done just that. And he had shown her a beach and a forest and a mountain path and a waterfall beyond belief. They had swum naked in a sapphire pool and had made love on a bed of soft moss, under a gentle shower of warm rain. He had sung her songs of island love and woven spicy flowers in her hair. At the end of the afternoon, he had said, "Come have one drink with me. There's a place I know."

The place turned out to be the *lānai* of Charlie's condo, where June now stood in the early evening breeze, with her hands

on the rail, watching maroon clouds darken to black and the first few stars blink on.

She felt him return behind her, heard him place their drinks on the glass table, felt him wrap a shawl around her shoulders. They stood side by side, with her head on his shoulder and his arm around her waist.

They kissed, and Charlie gestured to the chairs beside the glass table. They sat down and he lit a hurricane lamp. The lamplight glowed on his smile.

"Thank you for this lovely day," she said.

"You made the day lovely, June. I was just along for the ride."

"You needed a nice day, after what Martha did to you."

"I don't blame Martha for letting me go," Charlie said. "I wasn't really open with her. I never let her know what I had in mind for the hotel. I never really trusted her, I'm afraid, and perhaps I was right not to. So I did things my way, without letting her in on what was happening. So I suppose she had a right to suspect that I was motivated by selfish reasons."

"But you weren't, Charlie. It's so unfair. You were only trying to do what was best for everyone concerned." June felt tears well up in her eyes. How could Martha Masters have mistrusted this beautiful man?

"Perhaps it's all for the best," he said. "She has her little trinkets, which she can lock up in a glass case, and I have my freedom. And you."

"Oh, Charlie, don't get carried away. You don't have me. But it was a beautiful afternoon, wasn't it?"

"I'll treasure it forever."

"Are you going to be all right?"

"I'll land on my feet."

"What'll you do?"

"I'm thinking of going to the mainland for a while. Get out on my own a bit. I have contacts there in the import-export business."

"Where on the mainland?"

"San Francisco."

"No!"

"No?"

"But that's practically my backyard," June said. Suddenly she realized that one of the things she had enjoyed so much about her heavenly afternoon with Charlie Leong was the feeling that it would never happen again. But now...

"You'll have to show me around," Charlie said. "Take me to Mendocino and give me a walk in the redwoods."

June pulled the shawl tighter around her shoulders. This second mai tai was certainly no weaker than the first one. June became aware that she needed her brain right now, as much as she needed her heart. "Charlie," she said, putting down her glass, "I have to go. You have to drive me back to the resort. I'm sorry, but this has to stop while it's still beautiful." She stood up.

He rose, too, and stood before her. "Stay with me tonight," he said.

"No. No, really,..."

"I'll cook you a simple Hawaiian dinner. I'm an excellent cook."

"I'm sure you are, but..."

"This wasn't just an afternoon fling for me, June. Was it for you?"

June thought a moment. Was it? "I have to go to the bathroom," she said. That was practically the only thing she knew for sure.

"Of course. Use the one off my bedroom."

She left the *lānai* and walked across Charlie's living room to the bedroom. She was pleased to see that he kept his bed made and his room neat. In the bathroom, she flipped on the light and faced herself in the mirror.

She saw an intelligent woman looking back at her. An ex-cop, a successful investigator, a sensible, rational person. This was the

face of a responsible adult. And also the glowing face of a woman infatuated. A woman who couldn't stop smiling.

And she saw that she was wearing her shawl. Not just a shawl, but her shawl, the shawl she had brought with her from Burlingame, California.

And there, beside the sink, June saw her toothbrush. Her comb and hairbrush. Her cosmetics case.

When she was finished in the bathroom, she stormed out into the bedroom, where she found Charlie changing into white slacks and a fresh aloha shirt. He grinned at her.

"You little skunk," she said, grinning back. "Where did this come from?" She held the toothbrush and shook it at him like a teacher with a ruler.

"The Mauna Makai resort," he confessed. "Suite six, to be exact."

"And how did it get here?"

"Your room maid is a friend of mine," he said.

"And do you have any more surprises for me?"

"I do indeed."

"Oh, Charlie, damn it, I…"

He hushed her with a kiss.

21. A Spoonful of Sugar

Win juggled golf balls on the flagstone terrace that stretched from the *lānai* outside suite 6 to the beginning of the beach. He had not eaten; he wasn't hungry. He hadn't had a thing to drink; he wasn't thirsty either. He was a mess.

Juggling golf balls was a meditation for Win, but this wasn't relaxing him a bit. The four balls rose higher and higher before his face as his tosses lost control, and he had to rein himself in to keep them from flying out of orbit. He tried to slow the beat of his

heart, but it wasn't working.

Juggling golf balls was what Win did when he had a serious problem to solve. Things often seemed to fall into place and make sense when he forced his brain to focus on the golf balls instead of the problems at hand.

But this wasn't working. Nothing made any sense at all. Everything sucked, and Win felt like a lost little boy.

"Wow! What talent!"

It was that low melodious voice that reminded Win of crème brûlée. Keeping the balls in the air, Win pivoted to face Sugar, who was walking across the flagstones toward him. She looked like a comforting angel in the gentle light, and she seemed to float to the strum of the ukulele music.

"You're really good at that," she said. "We should get you to perform at our *lū'au.*"

Win lost it. When she was within a few feet of him, and he could smell her plumeria scent and almost feel the warmth of her body, he fumbled and let one of the golf balls drop and bounce on the flagstone. The other three followed, and he was surrounded by bouncing balls. He grabbed at them, but they were bouncing all over on the uneven surface.

Sugar laughed gently and helped him retrieve the golf balls. As she handed them to him, their fingers touched, and he shied away. He dropped the balls into his trouser pockets.

"Um, thanks," he said.

"Win, are you okay?"

He turned his back on her and looked out across the beach to the sea and the night sky. Little stars winked at him, mocking him. "Yeah," he said. "I'm fine." He pulled a golf ball out of his pocket and hurled it as hard as he could out at the sea. It fell short and landed on the sand. "I'm just fine." He hurled another ball. "Fine and dandy." And another. And the last.

They all fell short. He couldn't even throw the damn golf balls as far as the damn water.

"Okay, my friend," Sugar said from behind him. She placed a hand on his shoulder, and his shoulder recoiled, but she kept the hand there until it felt comfortable, even comforting. "Tell me what's wrong."

Win opened his mouth but couldn't speak.

"Hmmm?"

"I feel so alone," he said after a long pause.

"Where's June?" Sugar asked. "Or is that the wrong question?"

Win shook his head. "Unfortunately, that's the right question."

"I see."

"You do?" Win said. "Because if you do, please explain it to me."

Sugar stood next to him and took his hand. They faced the sea and listened to the gentle lap of waves.

"What happened?" Sugar asked. "Pardon me for being nosy, but I care about you. Did you two have a fight or something?"

"No. Not really."

"An argument, a misunderstanding?"

"I can't talk about it."

"You can, too. And you should. Do you want to go for a walk on the beach? Let's walk, Win. Let's go get those golf balls before one of our turtles mistakes them for marshmallows. Then we'll go for a nice long walk and you can tell me all about this. I can help you, pal. Romance is my business. Come on. Take off those shoes and socks."

Win did as he was told. He slipped out of his loafers and pulled off his black socks, set them by the front door of suite 6, then followed her across the terrace to the sand.

The fact was, he really couldn't talk to Sugar, or anyone else, about all this. Martha had made him promise to keep his mouth shut until they found out where June had gone, and where she had taken the priceless package, and why. Martha had threatened

to call the police, and Win had begged her not to do that. She had given him twenty-four hours to find the woman, find the package, pack their bags, and leave. If the package wasn't on her desk by five p.m. Wednesday, there would be an all-points bulletin and a warrant for June's arrest.

Meanwhile, the matter was hush-hush. It was a mystery that Win had to solve all by himself, without talking to anyone about it. How was he supposed to do that?

Strangely, he knew that June would come back. She would bring that package back and lay it on Martha's desk herself. June would never steal anything. June would never break the law. June didn't even jaywalk. June was a good person. She would never break the law. Would never break…

She was breaking his heart, that's all.

"Talk to me, Win."

Fingers interlaced, they walked on the sand toward the ocean's edge. They picked up the four golf balls and Win slipped them into his pockets. They walked slowly on the hard-packed, cool, wet sand.

"Talk."

Finally he did. He said, "What do you know about this guy Charlie?"

"So that's what's bothering you? Charlie?"

"Yes."

"June's off spending time with Charlie?"

"Maybe. I don't know. What do you think? Would Charlie do that sort of thing with a guest?"

She squeezed his hand, but it was not a reassuring gesture. "I'm afraid he might," she said. "I mean to say, yes, that's Charlie for you."

"He's a slimebag," Win muttered. "How could any self-respecting woman fall for a phony like that?"

"He has a lot of charm. Many women who come to Hawai'i are primed for romance, and that's Charlie's department."

"I thought that was your department," Win said.

Sugar laughed. "Maybe so, but I don't romance the guests. Charlie does. And I'll say this, the women are always grateful for the experience. He's got his talents."

"Sounds to me like you've had some experience with him yourself."

"Honey," she chuckled, "this old dame's had a lot of experience with men, including Charlie, and I'd rank him pretty high."

"Great," Win mumbled. "That's just great news." He stopped walking and sat down on the hull of an overturned dinghy. He put his elbows on his knees and his face in his hands.

He felt the dinghy rock as Sugar sat down beside him. "Win," she said, "you've got great talents, too. I can tell that just by looking at you. The way you walk, the way you smile, I just know you're a wonderful lover."

He looked into Sugar's face as her right arm went around his shoulders. Her smile was warm and compassionate. Her left hand caressed his cheek.

"I don't know," Win said.

"I do." Sugar leaned forward and kissed him on the mouth. A soft, easy kiss.

"Thanks," Win said. "Thank you, Sugar. You're one kind lady."

She slapped him gently on the chest. "I'm no lady, and that wasn't out of kindness." She kissed him again.

This time he kissed back. Hungrily. And without planning or plotting, he found his hand resting on Sugar's bountiful breast.

She let it rest there a moment before she carefully extracted herself from his embrace and stood up. She smiled down at him and said, "Win, you're going to be all right. June will come back to you, I promise you that. I know she's a smart person and a good person. She knows how important you are, and how sexy. She's just a little crazy right now. It happens sometimes. She'll come back to you, and she'll owe you a lot of special favors."

"Oh?"

"Make sure you take advantage of that. Claim those special favors. You deserve to be treated like a sultan. Now I'm going to leave you here, because I have another appointment. Will you be all right?"

"I think so. *Mahalo*, Sugar."

"Aloha, my friend."

22. *Meeting in the Moonlight*

"It's a mystery," Ted said for the tenth time that day. "How did that wall get fixed?"

His wife, Miyoko, sat down beside him on the bed and took his hand. "The important thing is, it's fixed. Now you can stop worrying about it. Okay?"

"I guess, but still, I wonder...."

"Ted, what's to worry about? You've done a great job. Who cares how the wall got fixed? Maybe Keoki's boys did it, maybe the *Menehune* came and did it, maybe the rocks decided to walk down the hill and go back to bed. Speaking of which, are you ready to turn out the light?"

Ted smiled and kissed his wife. He switched off the lamp and they stretched out side by side.

"Well, honey, I think we're in pretty good shape. I walked the whole course this afternoon, and I gotta say my guys have done great work. There's nothing more we can do. If I do say so myself, Kukuna is one beautiful golf course."

"Of course it is, darling."

"Tomorrow I'll go over it one more time with fingernail clippers...."

"Ted, will you do me a favor?" Miyoko whispered. "Will you massage my temples?"

"Why? Do you have a headache?"

"No. I just want you to think about something besides that damn golf course for a few minutes."

Out on the golf course, the moon, just past full, was flooding the fairway of the tenth hole. Aiulani wore a light cotton sweatshirt and walked briskly toward the green. There he was, waiting for her in the moonlight. She felt in the pocket of her jeans for the note he had passed to her that afternoon: "Meet me at our place at ten tonight. I have something important to tell you."

Ben always had something important to say. How beautiful she was, how much he loved her, how this, how that, and it had always made her feel like a butterfly, or a waterfall, or a simmering volcano, or sometimes all of the above.

But no more. It had to end. Aiulani was determined this time to face the facts, and Ben had to face them, too. She would speak her piece before he had a chance to charm her with his sweet talk. What a lovely man he was. What a shame she had to break it off.

Quickening her pace, she rehearsed her speech: *Listen, Ben, this can't go on. You're a city boy, I'm a country girl. You're ten years older than I am, Ben. You're an entertainer, and I'm an artist. I'm involved in a political movement, and I have to stay focused. And besides, I'm promised to Sonny. Yes, I know he's kind of dumb, but he's good-looking and he's sweet, and, well, maybe I don't really love him, but he loves me, and yes, I know you love me too, but Ben, oh Ben....*

Ted sat up in bed.

Miyoko said, "What now, honey?"

"The golf course is crying," he answered.

"You're having a bad dream," Miyoko said. "Go back to sleep."

"How can I be dreaming when I'm wide awake?"

"Ted, golf courses don't cry."

"The golf course is crying," Ted insisted.

Miyoko sighed. "Maybe it is. But there's nothing you can do about it. Would you like me to rub your neck?"

Round and round Ben marched, playing tag with his shadow as he circled the fringe of the tenth green. He and Aiulani had met here at this spot so many times over the past few months that it felt like a home. It was the place they had shared their dreams. At first he had told her his dreams and she had told him hers; later they had made up dreams to share. The tenth green was a land of dreams that Ben would always love, even if he knew he would never return here after this night.

It was time to face the truth, and Aiulani would have to face it, too.

Aiulani, I am too old for you. I am too old for myself. I'm almost thirty, and if I don't hurry I'll never make it to the big time. I want to go to Honolulu, maybe even Los Angeles. Maybe even Las Vegas. Can't you see? I could be a rock star, or at least a lounge act. You don't want that kind of life, late nights in smoky saloons. You need to stay here and devote yourself to the hula and to your people and your land. You're such a fine dancer, Aiulani, you don't want to waste that on my kind of music. And your cause is so noble, it deserves all your attention. Sonny will be a better husband for you. He's true, he's handsome, he's simple. You deserve so much better than me. Go to Sonny. He's true, he's simple.... He is so simple....

Ted got out of bed and pulled on his trousers.

Miyoko sighed. "Again?"

"I can't help it," he said. "The golf course is in distress. I don't know whether it's angry or heartbroken or both."

"How do you know these things?"

"I don't know. But when the golf course is in distress, I have to go."

"It couldn't wait till morning?" Miyoko asked.

"I can't sleep anyway when there's trouble out there. It'll be better after the course is officially open, I promise. But right now I have to be sure everything's okay."

Miyoko pulled herself out of bed and stood up. She put her hand on her husband's shoulder and said, "I'll put on the coffee."

They met beside the green and held each other's hands. She could feel the magnetic pull of his arms and his body, but she held herself back.

She was so lovely in the moonlight. He wanted to enfold her in his embrace, to kiss her lovely mouth and feel his fingers combing through her long, thick flowing hair. But he controlled himself.

"Aiulani, I have something I have to say."

"Stop, Ben. Before you talk, I want you to hear me out."

"But if I hear your voice, I'll weaken."

"I'm the one who feels weak."

"This is the hardest thing I ever had to do," he said. "Let's go sit down."

They walked to the bunker and sat down on its edge, with their feet in the sand. He reached for her hand, but she pulled it away. Then she reached back and took his hand fiercely. "Ben," she said, "listen to me."

"Okay. Speak."

She opened her mouth, but words did not come. *Listen, Ben, this can't go on....* She tried, but she simply could not talk. She stood up and walked out into the middle of the sand trap. She felt her hips begin to sway. She tried to dance a hula of goodbye, but her body would not move like that. She knelt on the sand and wept into her cupped hands.

Ben walked across the sand and knelt in front of her. He put his hand on her head, feeling the strands of her hair slide through

his fingers. She raised her face, and he leaned forward to kiss the tears from her cheeks.

"Maybe we don't need to have this talk right now," he said. "Things are so crazy right now. Maybe after the golf course opens and the wedding's over and things get back to normal, maybe we can talk then."

She nodded, smiled shyly, then fell against his chest and held him tight. "Ben," she whispered, "wherever you go, if you'll let me, I'll follow you."

"If you want to stay here, Aiulani, as long as you'll have me, I'll stay with you forever. I don't have any dreams more important than that."

"Is that what you came here to tell me tonight?"

"Apparently so. And you?"

"I've forgotten what I came to say," she said. "But I know I've just spoken the truth."

Ted finished his coffee and reached across the kitchen table for his wife's hand.

"You're smiling," Miyoko said. "Are you okay?"

"The golf course is feeling much better," he said.

"What do you mean? How do you know?"

He shrugged, and his smile grew. "I just know. The golf course stopped hurting. It's happy."

"So you don't have to go?" Miyoko said. "We can go back to bed?"

"Let's do that," Ted said. "But I've just had all this coffee. I'm not sure I can sleep."

"We'll think of something," Miyoko said, squeezing his hand. "I'll rub your back or something."

Ted squeezed back. "Or something."

23. Firedancer

Poor Sonny!

Sugar quickened her pace as she walked along the beach toward the Barefoot Bar. Her chance encounter with Win had made her late for her appointment. She hoped Sonny would still be there. That boy needed help.

As Martha had said, the kid was lovesick. His ego was whipped. For weeks now he had been alternately mournful and angry. Martha was concerned for the hotel and the golf course, naturally; they couldn't afford to lose their firedancer or their best mechanic, and Sonny was both of those. But mostly Martha was concerned for Sonny himself. And Sugar shared her concern. They all loved Sonny, the sweet kid.

Only two years ago, Sonny had been captain of his high school football team. His life was every teenage boy's dream: he was a football star, he had a hot car that he had rebuilt himself, and he was going with the prettiest girl in his class, the girl he had loved since childhood. Now, at nineteen, he still was a star when he did his fire dance, and he still had vehicles to tinker with, but the third part of his happiness had vanished.

Sugar was an expert on romance, but it didn't take an expert to know that Aiulani was in love with Ben Kamelele, and Sonny Apaka didn't stand a chance. She didn't know what to tell him, or how to make him get over the heartache, but she had promised Martha that she would have a talk with the kid and try to give him some sort of comfort and maybe restore a little of his self-confidence.

The Barefoot Bar was loud and busy by the time she got there, with extra tables and lanterns set out for an overflow crowd that reached almost to the water's edge. It was a boisterous gang of young folks, shouting and laughing, drowning out the live ukulele trio. Sophisticated media people mingled with the hip and

wealthy from the wedding party. Guests table-hopped and laughed and shouted at one another, while cameras flashed like fireflies. Every table was full, and the waiters and waitresses were scurrying around delivering drinks and munchies.

Sugar looked over the scene, trying to spot a lonely boy in the midst of all this noisy fun. It was not a good place for a lonely boy to wait all by himself, and Sugar was sorry she had suggested this spot for their rendezvous.

No lonely boys to be seen. It looked as if he had given up on her and left. Too bad. But then Sugar heard her name called from across the party. "Sugar! Come join us!" She weaved her way among the tables to the source of the voice, a small table, where a young Hawaiian man sat with three gorgeous blondes. One of the blondes, the one who had called her name, was Meg Hartwell, the bride. "Girls," Meg chirped, "this is Sugar, the romance director I told you about. Sugar, meet Mitzi and Taffy, my best girlfriends from Boston." Mitzi and Taffy both flashed dazzling smiles, and Meg continued, "And of course you probably know this hunk here."

The hunk looked up at Sugar with a sheepish grin.

"I certainly do," Sugar said. "Sonny and I are old friends."

"You may be an old friend," Taffy laughed. "But Sonny's a young stud, it seems to me."

Sonny's grin grew out of control.

"This guy is so cool!" Mitzi exclaimed. "God, Sugar, how can you stand having such a cute guy around? How do you get any work done?" She reached across the table and pinched Sonny's bright red cheek.

Mitzi was a smart-looking lady in a classy yellow silk blouse. Taffy looked a little less classy; in fact she looked endearingly tacky, in too much makeup and a bright red halter top that barely contained a playful explosion. Both women looked friendly and ready to frolic. Taffy said, "Old friends, huh? I hope we aren't trespassing."

"Naw," Sonny said. "Sugar's my counselor. She's going to give me lessons on how to be cool with girls."

The trio of blondes laughed. Mitzi said, "Honey, that's the last thing you need."

Meg stood up and said, "Sugar, you can take over my seat. I've got to go find my future husband and keep him out of trouble." She ruffled her fingers through Sonny's hair before she left, and Mitzi and Taffy roared with laughter and clinked their glasses.

Sugar sat down. She turned to Sonny and quietly asked, "Are you doing okay?"

"Yeah, I guess," he mumbled, still unable to control the smile on his face.

"Then maybe I should move along and let you enjoy yourself. I don't want to intrude."

Taffy said, "Aw, stay, Sugar! Maybe you could give us some pointers on how to be romantic."

"You already got some pretty good pointers," Sonny said, nodding at Taffy's chest.

Taffy snorted and playfully slapped his arm. "Smooth talker," she chided.

A waiter appeared beside the table to take drink orders. Taffy and Mitzi ordered refills on their rum punches, Sonny asked for another Coke, and Sugar ordered a glass of iced jasmine tea. The waiter wrote down the orders, smiled, and disappeared into the crowd.

"So Sugar," Mitzi said. "You're a romance director. What does that mean, exactly?"

"Part social director, part wedding consultant," Sugar explained. "A lot of people come to Hawai'i to get married."

Taffy said, "Sonny, you're not getting advice from her because you're getting married, I hope?"

"Nope," Sonny said. "I'm too young to get married. I'm only nineteen."

Mitzi licked her lips. "Nineteen. I love it."

"I sure hope you're not getting married," Taffy continued. "That would just break my heart. Well, I guess you can get married if you want to, but wait till after Friday. Wait till after I go home, okay? You got a girlfriend?"

Sonny glanced at Sugar, and Sugar gave him a tiny shake of the head.

"Nope," he answered. "Not so far tonight anyhow." The grin was back on his face.

Taffy reached across the table and clasped Sonny's thumb in her dainty fist. "Let me be your girlfriend. Till Friday. I need to have some fun."

"Hey!" Mitzi protested. "I saw him first."

"Bull. We both saw him first," Taffy said. "There he was, practically naked, dancing with fire. You were gorgeous, sweetie."

"Thanks," Sonny said. "I mean, yeah, thanks. Um…okay, thanks."

"You're welcome. So Mitzi looks at me, and I look at Mitzi, and we're like, 'He's the one.' So we flipped for who would get to…"

"And I won," Mitzi said.

Sugar was beginning to feel outraged and a bit protective of her young friend. "Just a minute," she objected. "Doesn't Sonny have something to say about this?"

Sonny shrugged and said, "Whatever. I mean like, either is fine I guess. Don't make me choose. I'm just a mechanic."

"I'll bet you are," Taffy cooed.

Both blondes laughed. Mitzi repeated, "I won the toss."

Taffy said, "Let's flip again. Best two out of three."

"Double or nothing?"

"Forget about nothing," Sonny said. "How about just double?"

Ye gods, Sugar thought. Watch it, kiddo.

Mitzi and Taffy exchanged a wicked look and cracked up laughing.

"Sonny, you be careful," Sugar said. "You're playing with fire here."

"I'll be okay," Sonny answered. "Playing with fire is what I do."

The waiter brought the drinks to their table and Mitzi signed the tab. Before the waiter could take away their empty glasses, Taffy plucked the little bamboo and paper toy umbrellas and put one behind each ear.

"Lovely," Mitzi commented. "Such class."

They sipped their drinks and Taffy said, "Sonny, I want you to teach Mitzi and me to dance with fire. Will you do that for us?"

"No, I better not do that," Sonny answered.

"Awww, please? Why not?"

"You'd ruin your clothes," he explained. "To be a firedancer you have to take off your clothes and cover your body with oil. It's not easy."

Once again the blondes grinned at each other and cracked up. "We might be able to manage that," Mitzi said.

Taffy sucked the last of her fruit punch through the straw, then took the little umbrella and twirled it in her fingers. "I've run out of ears," she said. "What am I going to do with this thing? It's so cute. I know...." She placed the stem between her breasts so that the umbrella sat like a brooch on the top of her halter. "Is that clever or what?"

Mitzi snorted. "The word is 'cleavage,' babycakes."

"I think it's cute. Do you think it will keep me dry?"

"I doubt it seriously."

"You don't do anything seriously."

"Touché."

Sugar finished her jasmine tea and stood up. "Well, young-sters, I've had enough partying for tonight. Have fun. And ladies? Please be gentle with my young friend. Sonny, remember you have an early morning tomorrow." She bent down and kissed the top of his head.

"Thanks, Sugar," Sonny said. "*Mahalo.*"

Sugar walked away from the party along the beach. When she got far enough away that the sounds of laughter and music were drowned by the gentle lapping of the waves on the sand at her feet, she stopped and stared at the moonlight on the water.

Poor, sweet Sonny.

She chuckled. Poor Sonny, my eye.

24. Close Call

Charlie awoke Wednesday morning with the first light of dawn. Careful not to disturb his guest, he rose from the bed, slipped on a robe, and tiptoed out of the room, closing the door softly behind him.

He walked into the kitchen and started Mr. Coffee. Checked the fridge and the fruit bowl. Set the table. He was going to make June a breakfast she'd never forget. But first, while the coffee brewed, there was time to catch a wave or two.

He walked into his study and switched on his Mac. When the machine had booted up, he opened Netscape and checked his e-mail. He hadn't checked his e-mail in almost two days, and there were twenty-four messages. There wasn't time to respond to them now, but he looked down the list of senders and recognized several of his favorite paying customers. What a great business he had, selling antiques by the side of the Information Superhighway. And the best part was, he could take the business anywhere in the world without disrupting a thing. Speaking of which…

He pulled down his bookmarks menu and selected "cheaptickets.com." He checked on his reservations for three that afternoon, and printed out the confirmation. Two one-way tickets to San Francisco. California, he hummed, here I come. Open your golden gate. He plucked the confirmation from the printer and folded it and put it in the pocket of his bathrobe.

Then, because he couldn't resist, he pushed his chair back from the desk and opened the top drawer. There it was, the treasure that made it all possible. He gently slid the contents out of the envelope and held them in his hand. A few scraps of paper, wood, and metal, light as a small handful of jewels, and twice as valuable. Charlie held his future in his hand.

With his other hand, he returned to the bookmarks menu and selected a folder labeled "Numismatics and Philately."

"Hi."

The voice behind him was soft and sleepy, but it startled him so that he almost dropped the treasures onto the floor. He quickly poured them back into their envelope, dropped the envelope into the open top drawer, and slid the drawer shut as he spun around in his swivel chair and grinned at the beautiful woman standing in the doorway wearing nothing but a smile.

"Good morning," she said. "Whatcha doin'?"

"A little early-morning surfing. How are you?"

"Fine." She strolled across the room and peered over his shoulder. "What's numismatics?"

"It's a technical term in my business. Are you ready for breakfast?"

The breakfast was indeed wonderful. Pineapple and mango juice, Kona coffee, bagels spread with macadamia nut butter, and strawberries with powdered sugar. June wore a silk kimono from Charlie's closet, and on her lips she wore a satisfied, sugary smile, which she daintily wiped with a napkin when the last strawberry was gone.

"That was incredible, Charlie," June exclaimed. "Do you serve a complimentary gourmet breakfast to all your conquests?"

"What do you mean, conquests?" Charlie retorted.

"Don't tell me this hasn't happened before."

"Well maybe," he admitted. "But not like this. This is special."

June smiled tenderly. "It feels special to me, Charlie. But why

does it feel special to you? What's the difference from all the other times?"

Charlie chuckled. "Well, for one thing, I no longer work for the hotel. So it's not a casual fling between a concierge and a guest. This is more. You believe that, don't you, June?"

"I want to believe it."

Charlie pulled the plane reservation confirmation out of his robe pocket and handed it to her. "Happy Wednesday," he said.

June unfolded the paper and gasped. "Charlie! This is my name!"

"That's right."

"This is for today!"

"Right again."

"But I can't do that, Charlie. I just can't. I mean, this is so sweet, but this is impossible. Really, Charlie, I can't just…"

"Yes, you can."

"No, I can't."

"Why not?"

"Well," she sputtered, "what about Win?"

"What about him? Let him stay in Hawai'i and play golf. He'll be all right."

"But, I mean, how about all my stuff? My clothes?"

"What clothes?"

"All the clothes I brought with me. The things in my hotel room. My jewelry, my shoes, my, my swimsuit, my…my *clothes*, Charlie!"

Charlie chuckled. He stood up and offered her his hand. "Come with me," he said. She stood up and he led her back into his bedroom and opened a closet. On the floor of the closet were two shopping bags from Mauna Makai gift shop. They were full of clothes. Charlie lifted them out of the closet and set them on the unmade bed. "Check it out," he said. "You travel light. I like that."

June gasped as she pulled garments one by one out of the

bags. "My blouses. My slacks, my shorts, my swimsuit, my other swimsuit…Charlie, what's going *on?*"

"You don't need to go back to the Mauna Makai, babe. Everything's here. We're set to travel." He put his arms around her and whispered, "I love you, June. Please don't back out on me. I need you."

June backed out of his arms. "Just what do you need from me, Charlie? I want to trust you, but I need to know what you have in mind. Just what is it you want?"

"I want only you. Your support. Your love. Your company. You."

"And that's why you stole all my things?"

"I didn't steal them. I brought them for you."

"You mean your girlfriend, the maid, brought them for me."

Charlie shrugged and smiled. "She's not my girlfriend."

June did not smile back. But she didn't frown either. She said, "Charlie, leave me alone for a little while. I want to take a shower and then put on some of my clothes, which you kindly brought for me. I need to think. Okay?"

"Of course." He kissed her lightly on the cheek and left the bedroom, closing the door behind him.

He went back to his study and back onto the Net. He answered some of his e-mail, quoting prices and confirming orders. He sent out his updated want list to all the suppliers on his address list. He processed a few credit card numbers. Then he got back into the numismatics file.

When he had been working at his computer for about half an hour, he heard a soft knock on the door behind him. He swiveled around, and there she was. She was not smiling, still. He held his breath.

"Okay," she said simply. "Let's do it. Let's run away together."

Charlie hopped out of his chair and caught her up in his arms, but she held him a few inches away. "I need to tell Win," she said. "I can't just leave without saying goodbye."

"I don't want you to weaken," he said. "If you go talk to him he'll try to win you back. He'd be a fool not to."

"I won't go there," June said. "I'll phone him." She walked over to the desk and sat down on his chair and lifted the receiver of his telephone. "What's the number of the hotel?"

He told her the number and she said, "Leave me alone with this, Charlie. I need the time to myself. This isn't going to be easy. So please leave and close the door behind you."

Charlie did as he was told. He went to the kitchen and washed the dishes. Ironic. He didn't really have to wash the dishes. This afternoon he would walk away from it all and let other people clean up his mess. But it gave him something to do. When he was finished with the dishes, he went into the bedroom. He showered and shaved. He dressed in his traveling clothes: tight tan slacks and his best green aloha shirt. He made the bed. He sat and waited.

When at last he could stand the wait no more, he returned to the study and gently opened the door and peered inside.

June's face was streaked with tears.

"It was rough, huh?" he asked. "Believe me, June, it's going to be all right. You're going to be a happy woman. I'll make you happy, I swear."

She shook her head at him.

"How did he take it?" Charlie asked.

"I never called him," June replied. "I didn't have to call him."

"What do you mean?"

"I mean this." She opened the top drawer of Charlie's desk and pulled out the envelope containing the letter from Sarah Brush to Susan Hartwell, the coins, the dog tag. "You're a god damned thief, Charlie Leong. How could you do this?"

"What were you doing rummaging in my desk drawer?" Charlie demanded. "I thought I could trust you."

"You thought *you* could trust *me*?"

"Wait a minute, June, calm down. I can explain this."

"Oh. What a relief. Good. You can explain it. Okay, explain."

"I told Blossom to bring me all your things. I didn't know she was going to bring that package, too. I meant to return them, of course."

"Is that why you wrote this e-mail to the American Numismatic Society, requesting the latest prices on these very coins?" She pointed at the computer screen, and there it was, his latest query.

"Have you been snooping in my e-mail? What's going on here, June?"

"What's going on is that you're stealing things that don't belong to you. And no, I wasn't snooping in your e-mail. This letter happened to be on your screen. I bumped into your mouse and the screensaver disappeared, and there it was, as big as a pile of horse manure but smelling a lot worse."

"June, honey, I was doing this for you," Charlie pleaded. "For *us*. Just think of what this could do for us. It will set us up in business together. It will—"

"Get out of my way, Charlie. I'm walking."

"Where are you going?"

"Out of this condo, to start with. Then I'll find the nearest phone booth and call for a cab."

"How can I convince you that I love you?"

"You can't. You don't. I know what you're up to. You suggested to Martha and Keoki that Win and I should be the ones to keep these valuables. That's because you knew you had the duplicate key to our room safe and could get your maid friend to steal them for you. And you wanted to take me with you so it would look like I was the one who stole them. And after you sold these coins and made your bundle you were going to drop me like a hot rock, so that I could crawl back to Win and beg for his forgiveness."

"June..."

"And I almost fell for it, because you're pretty good at this kind of thing. But next time you try to con a dumb blonde, pick a

dumb blonde, Charlie. You had me charmed for a while, but I'm not a dumb blonde. I'm an ex-cop. Out of my way." She walked past him, out of the study and into the bedroom, where she picked up the two shopping bags and headed for the door.

Charlie said, "Stop."

She stopped and turned.

"Okay," he said. "I'll call you a cab. Also, I want you to take all these goodies with you. Come here." He led her into the kitchen, where he emptied the contents of the ancient envelope onto the table. One by one he counted the coins, and the dog tag, and the letter, and put them into a clear plastic food storage bag. Then he folded the envelope and placed it in the garbage can under the sink. He handed the transparent bag to June, who had tears in her eyes.

"Charlie, I can't figure you out," she said softly.

"Nothing to figure out, June. I love you. I want you to go to San Francisco with me. You would rather break my heart."

"I can't steal, Charlie. Don't you understand that?"

"Take those trinkets and go, June. I don't want them any-more."

"I'll take them to the hotel," June said. "I'll turn them over to Martha Masters. Then I'll call you. Okay?" She stuffed the valu-able package into the side of one of her shopping bags.

"Let me call you a cab. I would drive you down there myself, but I'm not welcome on the premises."

He made the phone call, and then they waited in silence seat-ed at the kitchen table. When the doorbell rang, they were hold-ing hands. They stood up, and shared a passionate kiss.

Then June broke away, picked up her purse and shopping bags, turned, left the kitchen, and walked out through the condo front door.

After the door closed behind her, Charlie let out a long-held sigh of relief. He rushed to the garbage can under his sink and pulled out the envelope and flattened it carefully on the kitchen table.

25. Pushing the Envelope

The taxi dropped June off in front of the lobby of the Mauna Makai, and she paid the driver with a twenty-dollar bill and told him to keep the change. Carrying a shopping bag with each hand, she rushed into the building and across the lobby to the desk of the receptionist who guarded the back offices. She told the receptionist that she needed to see Mrs. Masters right away.

"She's in a meeting right now," the young woman said. "Would you like to have a seat and wait?"

"Will you just let her know I'm here?"

"Please have a seat."

"I'll have a seat," June said, "if you'll just let her know I'm out here waiting."

"Her line's busy right now. I'll call her as soon as she's off the phone."

June found a chair and sat down, but she couldn't sit still. She stood up and paced the lobby, still dangling a shopping bag from each hand. She stopped before the glass cases, where for the first time she took a long look at the treasures on display: a conch shell, an old leather-bound prayerbook, a piece of orginal sheet music in Queen Lili'uokalani's handwriting, a fish hook made of human bone, a portrait of Pele, and a montage of grainy photos of the heyday of the ranches. Each item on display had an explanatory note written by Charlie Leong, the hotel historian.

"Miss Jacobs?"

June spun around to find the receptionist standing right behind her, a grim look on her face. "Yes?"

"Mrs. Masters would like to see you right now. Would you like me to hold your bags for you while you—?"

"No." June sped past the receptionist and through the door to the back offices. She went straight for Martha's office, opened the door, and marched in.

Martha was sitting behind her desk. Directly across from her was Meg Hartwell, who turned around in her chair and watched June enter the office. There was no smile on the young bride's face. The room felt charged with energy, like the still air before a hurricane hits.

Martha stood up, walked around her desk, and pulled another chair up close. "Sit down, June," she said.

June did as she was told, placing the bags before her on the floor. Martha returned to her chair behind her desk.

Meg said, "I see you've packed your bags."

June ignored her. "Martha, I have to show you something," she said. "There's something I need to explain to you."

"You have a lot of explaining to do," Martha agreed. "You can start by telling me where you've been. No. Forget that. I don't care where you've been. You can save that explanation for Win, who's worried sick. I only want to know one thing."

"Yeah," Meg said. "Where's my stuff?"

"Your stuff?" June replied. "*Your* stuff?"

"Miss Hartwell feels that she is the rightful owner of the contents of the package that was discovered in the wall on Monday night," Martha explained.

"It's not something I feel," Meg said. "It's something I know. What I don't know is where it is." She turned to June and said, "That's the sixty-four-dollar question. Do you know the answer? If so, it might save you from either a lawsuit or a jail sentence. Or both."

Martha said, "Calm down, Miss Hartwell."

"Don't tell me to calm down."

"June, can you tell us what happened yesterday?"

June took a deep breath. "I went for a drive with Charlie Leong. He was feeling upset over being fired, and I was worried he might do something rash, so I agreed to spend the afternoon with him. And the afternoon turned into an evening, and the evening became the night. I don't know what happened, but I guess I got

screwed, to put it bluntly. I'm really ashamed. I feel like a high-school kid who's been seduced. I'm really sorry about this."

"Charlie can be a charmer," Martha said. "He was valuable to this business in a number of ways, but I'm glad he's gone. No resort needs to have a staff Lothario. I hope you haven't been too hurt."

"I'll be all right," June said, wondering if that was the truth.

"I don't care if you caught double pneumonia, and nobody cares about your sex life," Meg Hartwell said. "And besides, you didn't get seduced. You packed your bags for an overnight stay, to say the least."

"I did not."

"That's not what I heard," Meg insisted. "I heard you took everything you own, plus some things that I own, and took off like a thief in the night."

"It was broad daylight," June snapped back. "And I didn't take anything more than my purse. All the rest of this stuff was stolen from my room."

"And you stole it."

"I did not."

"You've got it, don't you?"

June turned to Martha and said, "All my clothes and jewelry and toilet articles were taken out of my room by a hotel maid. She brought it all to Charlie's place while Charlie and I were out driving in the countryside. I had no idea this was happening."

Martha nodded. "I believe you. That explains why Blossom quit her job this morning. She said she had other plans for the rest of her life."

"You mean my family heirlooms are in the hands of some, some *chambermaid*?" Meg stormed. "Where the hell is she? I want her arrested."

"Oh for God's sake," June said.

"Don't you oh-for-God's-sake me."

Martha rapped her desk with her knuckles. "Both of you be

quiet and listen to me," she commanded. "First, June I think you did a terrible thing by running off with Charlie. I don't care what your motive was, you've hurt Win terribly. That's none of my business, but I had to say it anyway. What is my business, although Miss Hartwell seems to feel it's *her* business, is what happened to the contents of the package that Sarah Brush meant to send to Susan Hartwell back in 1884. If you can answer that question, perhaps we can get beyond all this bickering."

Meg said, "I'm not bickering. I just want what's mine. And my lawyer is only a phone call away...."

"Oh shut up," June said. "Here." She reached into one of the bags and brought out the clear plastic bag and placed it on Martha's desk. "Will that help?"

A smile bloomed on Martha Masters' face. "Thank God," she said. She reached for the bag and gingerly took out each item: the letter, the copper and silver coins, the wooden token, and the dog tag. "It's all here," she said. "I'm so relieved. Thank you, June."

"Just a minute," Meg said. Her face was a furious red.

Martha smiled at her. "Miss Hartwell, please take this letter. I would like to keep the coins and the dog tag, because I think they'd be of interest to our guests and to our staff. But I believe the letter should go to you. It was written by your ancestor, and it was supposed to have gone to another of your ancestors. It belongs in your family." She handed the folded letter across the desk.

Meg snatched the paper from Martha's hand, unfolded it, glanced at it, refolded it, and pitched it back across the desk. "Where's the envelope?"

"I beg your pardon?" Martha asked.

"Who wants a stupid letter?" Meg said. Then she passed her hand over the coins and said, "And this is a bunch of worthless junk. You can keep it. It's not worth more than a few dollars. Maybe a couple of hundred, tops." She turned to June and said, "Give me the envelope."

"I don't know what you're talking about," June replied.

"Do you mean the tapa cloth the letter was wrapped in?" Martha asked. "We threw that away."

"No, not the tapa cloth. Who wants a bunch of old tapa cloth?" Meg snarled. "You two are in this together, aren't you?"

"Miss Hartwell, I have no idea what you're talking about."

"You two are either both very stupid or both very sneaky," Meg said. "But that envelope belongs to me, and you're going to either hand it over or pay me what it's worth."

"And how much is that, dear?" Martha asked.

"Don't call me dear. I won't settle for less than a million."

June and Martha exchanged a look of astonishment. June remembered seeing the envelope going into the trash can under Charlie's sink. By now it might be in a Dumpster somewhere, or even in landfill.

"Would you like to explain?" Martha said.

"Well, as if you don't already know, the only thing about this whole stupid package that's worth a hill of beans is the stamp. A two-cent stamp from the Kingdom of Hawai'i, printed in 1851. It's called the Missionary Issue. It's one of the rarest stamps in the world. In good condition it's worth over eight hundred thousand dollars. And my stamp, the one on the envelope that these things came in, has never been cancelled. That's good for a cool million, ladies. Now hand it over." Meg Hartwell turned to June with a scowl on her face and held out a trembling hand.

"I…"

Meg snapped her fingers.

"I don't have it," June stammered.

Meg leaned over and picked up one of the shopping bags, then turned it over, dumping its contents out on Martha's desk.

"Wait a minute!"

But Meg was already rifling through June's underwear, her skirt, her swimsuits.…

Martha lifted her phone and barked at the receptionist, "Call

the police. We have an emergency here. Put me on when you get them on the line." She hung up.

"You don't need to do that," June said. "Miss Hartwell, if you'll just calm down…"

"She's not calling the cops on me, Miss Jacobs," Meg said. "We're having *you* arrested. Now let's see what's in that other bag."

"Nonsense," Martha snapped. "I'm calling the police to have them catch Charlie Leong before he escapes with that stamp."

"He has a three-o'clock plane reservation," June said.

Martha checked her watch. "It's one-thirty now. Not much time."

June removed everything from the other shopping bag and showed Martha and Meg that she didn't have the envelope or the stamp. "You know, Charlie may not have known the stamp was valuable," she said. "I mean, he wasn't a complete heel. I believe he cared for me. I mean, look, he did give back those other things. He probably wasn't aware that the stamp was worth…"

She stopped speaking. She could tell that the two other women didn't buy it, and she didn't buy it either. That envelope was not in a Dumpster.

"I've been had," she said.

Martha's phone buzzed and she lifted the receiver. "Yes? Thank you officer. This is Martha Masters at the Mauna Makai. I would like to report a theft."

26. Men in Uniform

Plan B.

Charlie had Blossom drive him to the airport in his car. June was out of the picture, and good riddance. She took the coins and the token and the dog tag and the letter. Fine. Everyone concerned would think the matter was closed. What a flock of pi-

geons. And in a little over an hour, Charlie would be aboard a United Airlines plane, bound for San Francisco and a new life. A wealthy new life. Solo.

"Can't I come with you, Charlie?" Blossom whined. "I quit my job. I'm free. I could help you out a lot. Besides, Charlie, I love you. You know I do. Let me come with you. Please?"

"Not this time, baby," Charlie said. "I had a really hard time getting this one ticket. The plane's full. And I don't know what I'll be doing when I get to the mainland. I'll set things up, and then I'll send for you. Okay?"

"Aw, Charlie…"

"Besides, babe, I need you to take care of things here. Clean out my apartment, put my stuff in storage, sell my car…"

"Sell your car?"

"Tell you what. Why don't you sell *your* car, and then you can keep my car? This is a much better car than yours, and you can have it."

"I don't want your car," Blossom whimpered. "I want you."

"You got me, baby. I just have to work out the details first. I'll send for you, I promise." God this was difficult. Thank God they were almost at the airport.

"I was afraid you were going to run off with that *haole* woman."

"Are you kidding?" Charlie laughed out loud. "I just needed to get those rare coins that she had in her room. Thanks to you, I have them. You were great, honey."

"So now what happens?"

"So now I go to the mainland, sell the coins, get a business partner, get a place to live, and send for you. Like I told you."

But Blossom didn't let go. "She spent the night, didn't she?"

"She insisted, and I let her stay, yes," Charlie said. "But nothing happened."

"You didn't sleep with her?"

"Of course not. I slept on the couch, let her have the bedroom."

"I still don't know why you had me bring all her clothes to your place. You're not telling me everything, Charlie."

"That was for Plan B," Charlie said. "We might have had to kidnap her for a few days. But luckily we didn't have to do that. Now she's out of the picture. She took all her clothes and I sent her back to the hotel in a taxi."

"But you kept the coins?"

"They're right here, babe." Charlie patted the briefcase on his lap. "Okay. Here we are."

Blossom slowed down and made the turn off the Queen Ka'ahumanu Highway into the parking lot of the Kona airport. She found a parking spot and turned off the engine. By the time she had the key out of the ignition, Charlie had his seatbelt off and was opening his door.

"I'm going to miss you, Charlie," she said.

"I'll miss you too, baby. But it will only be for a few days." Would this conversation never end? They both climbed out of the car and walked around to the back. Blossom opened the trunk for him and he pulled out his carry-on suitcase. He kissed the tears off Blossom's cheeks, then kissed her lips. He gave her a hug and squeezed a buttock and whispered in her ear, "Better go now, honey. That'll make it easier for both of us."

Blossom backed out of his arms, slammed her way back into the car, and drove off. Charlie let out a huge sigh of relief and took off across the parking lot, carrying his briefcase with one hand and towing his rolling suitcase with the other.

When Charlie was about halfway to the open-air counter of United Airlines, a man in uniform suddenly appeared before him and stood in his way. "Mr. Leong?" the man said.

Charlie nodded. "Who are you?" he asked.

"I would like to have a word with you."

"I'm in a hurry," Charlie said. "I have a plane to catch."

"This won't take long, sir. Would you come with me, please?"

"Listen, I really don't have time. I'm late as it is."

The man in uniform shook his head. "Your plane doesn't leave for another fifty-seven minutes."

"Well, maybe so," Charlie said, "but I have things I need to take care of before I board, and...what's going on here?" His voice trailed off as he became aware of six more men in uniform approaching from all different directions. Unlike the first fellow, who was rather small, these guys were big. Their uniforms were serious business. They were armed, and they looked ready for a fight. They formed a circle around Charlie and the small man. "Okay," Charlie said. "I'll cooperate. What do you want?"

"I'd like to have a look inside your briefcase," the small man said. "Open it up for me please, sir."

Charlie did as he was told. He balanced the briefcase on top of his suitcase and popped the snaps. "There," he said. "It's empty, as you can see."

"May I ask why you're carrying an empty briefcase?"

"That's my business, isn't it?" Charlie responded. "Is there any crime in carrying an empty briefcase?"

"I suppose not. What do you have in your suitcase?"

"Clothes."

"Open it for me please, sir."

"Here? On the tarmac?"

"Yes, sir. If you don't mind."

"But I do mind," Charlie protested.

"That was a figure of speech, Mr. Leong. Open the suitcase."

The six armed bruisers each took a small step forward, tightening the circle. Charlie looked around and saw people moving to and fro across the parking lot, but nobody was paying the slightest attention to him or to this huddle of men in uniform. There was no way out of this without making a scene, and the last thing Charlie wanted was to call attention to himself.

He squatted down and unzipped the suitcase, opened it up, and took out his clothes and offered them, bundle by bundle, to

the big guys, who did not accept them. They stood with their arms crossed over their broad chests and showed no emotion whatsoever. So Charlie had to lay all his good clothes on the tarmac. When all the contents were piled up on the hot tarmac, the small man took his wooden stick and probed the corners of the suitcase. He squatted down and peered inside all the zippered compartments. "You were right," he acknowledged. "There wasn't anything in your luggage but clothes and a few toilet articles."

"Whaddaya know?" Charlie quipped. "Now, if you don't mind, I have a plane to catch."

"It looks as if we'll have to search your person," the uniformed gentleman said.

"I'm sorry, but that's out of the question," Charlie answered. "You have no right to search my person. I'm not carrying a weapon, and I'll be glad to walk through a metal detector to prove it, but your behavior is way out of line. If you'll just drop this nonsense, I won't make a fuss."

"Come with us, Mr. Leong."

"What?"

"I would like you to come with us."

"Where?"

"To my office."

"And where's that?"

"You'll see when we get there," the old man said. He had an obnoxious Scottish accent. "Now don't protest, sir. You really have no choice in the matter."

The circle of warriors closed in until Charlie could smell the sweat from their nearly naked bodies. They wore only *malos* and cloaks. They wore beaked helmets. They wore no shoes and didn't seem to mind the burning surface of the parking lot. They carried short swords. They breathed like rusted machinery.

"Okay, okay," Charlie said. "Let me just put this stuff back in my suitcase...."

"That won't be necessary," the old man said. "You won't need it again."

"But I can't just leave my suitcase open like this, my clothes spread out all over the parking lot."

"I beg to differ," the old man in the sailor's uniform answered. He pointed with his wooden cane in the direction of the Queen Kaʻahumanu Highway, and the clutch of bruisers began to move.

Panic time. Plan B. Charlie opened his mouth and screamed, "Help!"

A few people glanced in his direction, but nobody paid much attention.

"Help me!"

This time nobody even turned to look.

"Don't make a public spectacle of yourself," the old sailor told him. "As long as we're surrounding you, nobody can see you. Nobody can see us either, for that matter. Keep moving, please."

"You guys are ghosts right?" Charlie said, his throat constricted with fear. "So I could just walk right through you, right? And then people could see me?"

The old man chuckled. "I suppose you could do that," he acknowledged, "and then everyone could see a raving lunatic who's dumped the contents of his suitcase onto the parking lot. I expect nobody would be terribly concerned except for those fellows." He pointed with his wooden stick at three police cars that were speeding into the parking lot with their colored lights flashing. "I have a feeling they're looking for you."

"Christ," Charlie muttered.

"Don't worry," the old man said. "As long as you're with us, you're safe. Now let's get moving. We have a long walk ahead of us."

27. *Waiting for Win*

June drummed with a pencil eraser on the teak table and glanced again at the glowing red numbers on the clock by the bed.

Five o'clock.

She had been waiting for over three hours now, pacing the two rooms of suite 6, during which time she'd gone through a whole catalog of chilling emotions, beginning with remorse and regret.

She longed to get outside and stretch her legs. Make a run for it.

But she had to stay and wait. She had to be there when Win returned. She owed him that, and she owed it to herself, too. The prospect frightened her, but if there was any chance at all for their relationship to survive the ravages of indiscreet romance, she had to sit and wait and nervously prepare for the scolding of a lifetime.

When she had first entered the room, a little before two, she was relieved to find it empty. As much as she wanted to face Win and beg for his forgiveness, she was as nervous as a first-time criminal, and she was glad to have the place to herself so that she could collect her thoughts. She was also glad to see that the room had been made up, so that she wouldn't be interrupted by room service. And when Win returned, they would have the room to themselves.

She set the shopping bags on the bed and put her clothes away, back into the closet and the drawers of the dresser. As she placed her toilet articles back in the bathroom, she decided to take another shower. She was hot and sticky with nervous sweat.

She stripped and took a cool shower, trying not to rehearse, over and over, her apology. The long shower cooled her down and softened her up, and when she finally stepped out and dried herself off, she felt relaxed enough to face Win. In fact, she hoped

that perhaps he had come in while she had the water running. Perhaps he was out there in the room now. She timidly opened the bathroom door and stepped out into the bedroom, wearing a blush and a hopeful smile.

No such luck.

Fine, June thought. More time to relax. She dressed in shorts and a T-shirt from Pebble Beach, one that she knew Win liked. No bra; Win liked that, too.

She put on her dark glasses and picked up her guidebook to Hawai'i, then slid open the glass door and went out onto the small private *lānai*. She sat down and opened the book and stared at the same page for several minutes before she gave up the futile effort to read.

It was hot outside, and she didn't want to get sweaty again. Not before she could get sweaty with Win. She walked back into the room and closed the sliding door behind her. She lay down on the bed and closed her eyes. Perhaps a nap.

Not a chance.

At four o'clock she opened the refrigerator and found herself a ginger ale. She walked over to the teak table in the living room and looked at the bowl of fruit. Nothing looked appetizing, even though she hadn't eaten since her late breakfast at Charlie's place. Charlie's place. What a fool she had been.

That's when she discovered the note.

Most people wouldn't have noticed the note. Most people would have just seen a note pad with blank paper. It had the logo of the Mauna Makai at the top, and there was a pencil lying next to the pad. The paper had no writing on it.

But June was a private eye, and every private eye knows that a blank note pad often carries a message. She gently ran her finger over the surface of paper and deduced from the texture that a note had been written on the sheet above this one. That sheet had been removed, but this one still bore the slight impression of handwriting.

She picked up the pencil, and using the side of the lead, she gently began to rub the graphite over the surface of the paper. She took her time, careful not to add any new lines or any new texture. As the paper gradually darkened, sure enough, the message emerged, white and clear, in Win's careful handwriting.

Sugar,
 I've gone for a walk on the golf course. Will I see you when I get back? I sure hope so. I hope that tonight we can pick up where we left off.
 Love and aloha,
 Win

June smiled. Wasn't that sweet? Win was ready to forgive her, even if she didn't deserve it. It was so good of him to write her a note, even if he didn't leave the note for her to read. He must have had second thoughts about the message, but the important thing was that he had felt affectionate and ready to forgive. June still felt remorse and regret, of course, but mainly she felt the light feeling of relief.

It was lovely that Win, who could often be so stiff and formal, could sometimes be romantic and demonstrative. He hadn't called her "Sugar" in years.

Come to think of it, Win had never called her "Sugar." "Honey," yes. "Sweetie," sometimes. "Sugar"? Never.

Sugar?

Now it was five o'clock, and June sat at the teak table, drumming an angry tattoo with the eraser of the pencil.

The sticky nervous sweat was back.

The remorse and regret were still there. They had never left.

But the feeling of relief was gone, replaced by a new one.

White-hot jealous rage.

28. Angel of Mercy

Nine o'clock, and all's crazy. What a week this had been. Thank heavens it was almost over.

After a light dinner, Sugar went down to the Barefoot Bar to check in with the partying horde. What a crowd. Between Wally and his golfing entourage, Meg and her society friends, and the newshawks and paparazzi, there had been very little peace or sanity at the bar all week. Well, this was the last night of foolishness. Tomorrow morning the wedding would happen, the golf course would open, the game would be played, the guests would go on their way, and the Mauna Makai would once again become a haven of gentle romance.

She spotted Meg, who was wearing a grim face, not at all the face of a young woman on the eve of her wedding. Was she nervous? It was hard to imagine that this tough young woman could be nervous about anything, even her wedding. Sugar decided to have a talk with her, to give her whatever support she might need at this moment. But as she crossed among the tables, she heard her name called from the bar.

"Sugar! Over here!"

She changed her course and walked over to the bar, where she found Win sitting on one of the wooden stools, a cocktail glass in one hand and a lopsided grin on his face. He wore Bermuda shorts and a golf shirt, and he had a cotton sweater thrown over his shoulders. His eyelids were drooping just a bit, and his eyebrows were straining up into his forehead.

"Hiya, Shug," he said. "I been waiting for you."

Sugar patted his shoulder. "Hello, Win. Are you feeling okay? No, don't get up."

Win swiveled on his stool and leaned back against the bar. "I'm feeling great," he said. "Super dooper."

"That's good."

"Super-dee-doo-dah. Did you get my note?"

"Yes, thanks. How was your walk on the golf course."

"Wonderful," Win said. "I always like to walk on a golf course when I've got something important to think about. Clears the brain." He rattled the ice cubes in his drink and chuckled. "What's left of it."

"So what did you think about?" Sugar asked.

"You."

"Oh, give me a break," Sugar laughed.

"It's true. I tried thinking about golf, but I couldn't stay on the subject. I tried thinking about all the problems the resort's been having, but my mind got lost in the loop. I kept coming back to thinking about June, and that wasn't any fun, so I thought about you." He shrugged and added, "You're a lot more fun to think about."

Uh-oh. "Win," Sugar said, "about last night..."

"I've been thinking a lot about last night."

"You shouldn't."

"Last night I took a walk on a tropical beach with a woman who would never make me suffer. You wouldn't make me suffer, would you, Sugar? Hey, do you want a drink? Bartender!"

"No, I don't want a drink, thanks. And no, I wouldn't make you suffer. But..."

"You're the queen of romance," Win said. He turned to the bartender and said, "I'll have another one of these."

Sugar said, "Win, I think you should get back to your room. I happen to know that June has come back."

Win nodded and shot her a naughty smile. "I know she's back. She's in our room. Sweet sex. I mean suite six. I saw the light on when I went there to take a shower after my walk."

"Well? How did she seem? Did you two..."

"I don't know. When I saw the light on, and I knew she was back, I decided I didn't really need a shower, so I came here instead. I been eating hors d'oeuvres and drinking scotch and feel-

ing fine ever since. And I'm so glad to see you, Sugar. Less go for a walk, what do you say?"

The bartender set Win's new drink before him, and Win said, "Did I order this?" He shrugged and signed the tab, then said to Sugar, "I don't need this. I've already drunk half the scotch in Hawai'i. Do you want it?"

"No thank you."

"Good. I'll drink it." He did. "Let's go for a walk."

That was the last thing Sugar wanted to do at that moment, but she felt she was duty bound to separate Harry Winslow from the bar. She took his arm and helped him slide off the stool and stumble away from the crowd and toward the shoreline. They walked along the water's edge, away from the noise, until they reached the overturned boat where they had sat the night before. "Do you want to sit down?" she offered.

"Don't mind if I do. I don't seem to be much good at standing up," Win said.

Sugar sat down on the hull of the boat and gazed up at bright stars. The moon wouldn't rise for another hour or so. She was exhausted. This Hartwell-Wood wedding had been an enormous job, and she looked forward to getting back to her hotel room, her bed away from home, which she kept for nights when she had to work late.

Win plopped himself down and threw his arm around her shoulders. "You're my pal, huh, Sugar?" The arm slipped down to her waist and started to give her a gentle tug.

She stood up. "Come on, pal," she said. "I'm taking you to that cabaña up the beach there. Can you stand up?"

"For an offer like that, I could fly." Win wobbled to his feet and offered her his arm, which she took to keep him from falling over. They weaved their way along the shore to the cabaña.

"What is this place?" Win asked.

"It's the massage hut," Sugar answered. "Come on in." She led him into the cabaña and lit the lantern. It was a small room

with a large massage table taking up most of the space. There were shelves on the back wall, and on the shelves were bottles of oil and large beach towels.

"Would you like a massage?" she said.

The grin was back on Win's face. "A massage?"

"A back rub."

"Do I have to take off my clothes?" He asked, already fumbling with his belt buckle.

"Just your shirt. It's only a back rub." Win peeled off his shirt and handed it to her. She placed it on a shelf and said, "Lie down on your stomach."

Win did as he was told. Sugar squeezed some oil out of a bottle and into the palm of her hand, then rubbed her hands together until the oil was warm. She leaned into Win's back and shoulders and said, "You're hard as a brick."

"I don't think so," he said. "Not after all that scotch."

"I mean your back muscles. Your shoulders. Your neck. Wow, your neck. Tight. You're tense, aren't you?" Then she said, "Breathe. No really breathe. Breathe deeply."

Win breathed.

"Again. That's better. There. Feel that come loose there in your shoulder? You're going to be all right, Win."

"Am I? Are you sure?"

"Positive. I know you're sad right now, you poor man. You're dealing with anger and grief, and nervousness and fear. And tomorrow you'll be hung over and probably feeling guilty as hell. But I just want you to know you're going to be all right. It will work out."

She kneaded his shoulders. She poured more oil into her hands and got them warm and slippery, then went to work on his back. As her hands worked their way down the strong muscles that flanked his spine, she felt him start to tremble. "Keep breathing." His breaths became little whimpers. "You're in pain, I can tell," she murmured. "But you're going to get through this, my dear friend. I promise you." The trembling grew and the whimpers

turned to groans of anguish. "You may cry," she told him. "Go ahead. Cry, Win."

Win bawled. Sugar reached for the Kleenex box and placed a few tissues in his hand. She continued to rub his back, up and down, as he cried aloud. When finally he could catch his breath, he mournfully said, "Jesus, I love her so much."

"Love her, Win. Do. She wants to come home to you. Take her back and let her know you love her. And forgive her."

"But will she forgive me?" he cried.

"For what? Breathe. What have you done?"

"I don't know. Whatever made her run off with that jerk. I must have really pissed her off. Maybe I was just too much of a wimp. I don't know. I just want her back."

"It will work out, Win. Breathe. That's nice. Breathe. Good."

Sugar's kneading softened to a gentle touch as Win's breathing became slow and regular. She gently massaged his scalp with her fingertips, crooning a Hawaiian lullaby. Within a few minutes he was snoring.

She covered his body with a beach towel, kissed his head, blew out the lantern, and left the hut.

The stars were ablaze in the sky, and the ocean sweetly lapped the shore. Now it was back to the bar for one more round of greetings and goodnights before she retired for the night.

Big day tomorrow.

29. That Sinking Feeling

Charlie guessed it was a little past midnight. The waning moon had risen over the mountains in the east and was casting a pale glow on Kukuna's sixteenth hole. The old sailor looked strangely fierce in the ghostly light.

This was not good.

Charlie had been in jams before, and he had always managed to work, worm, charm, or squirm his way out of trouble. But this time it looked bad. Definitely bad.

His feet burned from the thirty-mile march from the Kona Airport, and his body was so full of fear and adrenaline that he could hardly stand still. But he had no choice. Standing still was what he had to do. Just stand there in the middle of a sand trap, face to face with a devilish little thug whose raspy breathing was enough to give a grown man chicken skin.

No escape. Even if his feet weren't all blistered and sore, he wouldn't have been able to run, because the bunker was surrounded by dozens of giants in helmets and dark cloaks, their arms crossed over their massive chests. They, too, breathed like the rumble of thunder.

"What's up?" Charlie asked, trying to sound as confident as possible. "What do you guys want from me? Because if there's anything I can do for you, I have some influence around here, and maybe I could pull a few strings...."

The old man shook his head. "Give me your shirt."

Charlie said, "Forget it, man. I'm not giving you the shirt off my back."

"Take your shirt off, Mr. Leong."

"I will not. It's too cold out here." Charlie was chilled all right, but the chill was not from the night air. In fact the night air was warming up, like the still, hot air that precedes the *hulumano*. But nobody, dead or alive, was going to get their hands on Charlie's shirt. Charlie had paid good money for this vintage 1950s Hawaiian beauty, and he was keeping it. It meant the world to him.

"One more time, Mr. Leong. Please take your shirt off and give it to me."

"Go to hell."

"I might just do that," the old man chuckled. "But you first." He took his wooden stick and waved it in the air, as if he were

conducting an infernal orchestra. The night marchers responded, stamping their feet as they began to march in a circle around the outside of the bunker, a heavy march that shook the earth. They started a moaning chant as they picked up the pace, and the *hulumano* wind joined the chorus with a high howling crescendo.

Charlie felt the sand beneath his feet give way as he started to sink into the trembling trap. He tried to lift his feet, but he was already embedded halfway up to his knees. He struggled left and right, but that made him sink deeper, and his whole body was shaking in the grip of the sinking sand.

The marchers marched and chanted, and the wind howled on, and Charlie, buried to his straining, aching thighs, screamed out, "Okay, okay! Okay, stop it! I'll give you the goddamned shirt!" He ripped the shirt from his body, the buttons flying like fleas, wadded it up and threw it at the old man, who scooped it out of the air with his stick and carried it to the bunker's edge.

The old man came back and faced Charlie, who was now embedded to his waist. He had to look up to see the old man's face in the moonlight. The face was grinning now, and the wind was whipping the little man's sparse white hair.

"Why?" Charlie cried, clawing with his hands, trying to dig his way out of the sucking sand. It was no use. "Why are you *doing* this to me?"

"Because you destroyed my wall," the old man answered. "I built that wall, and you took it down, and now I'm taking you down."

"But the wall's back up now. I'm sorry about the disturbance, but I had my men repair that wall. Come on, help me out of this...." By now the sand had covered Charlie's shoulders and he could no longer wave his hands.

The little man's laugh was high and shrill and not one bit funny. "Mr. Leong, you didn't have your men repair the wall. I had *my* men repair the wall."

"Okay. But the wall's in one piece right now, so..."

"No. There's a piece missing."

There was no reasoning with this little maniac. And now that Charlie was up to his chin in sand, the little maniac looked like a giant. "What's going to happen to me?" he sobbed.

"The earth beneath you is hollow," the old man explained. "There's a cave under there, and the sand is sinking into it. And so are you. It's like a drain, and you're going down. You will drop to the floor of my cave, and all the rest of the sand in this bunker will pour down on top of your head. Tons of it."

"This isn't fair!"

"I don't suppose it is."

"Why aren't you sinking, too?"

"Because I don't weigh anything, Mr. Leong."

Charlie tried to respond, but the sand had covered his mouth.

He pressed his head back to keep his nose in the air, and the sand filled his ears, muting the howl of hell.

The last thing Charlie saw before the sand scraped over his eyes was a little old man in a sailor suit disappearing like mist in the moonlight.

30. The Blessing

What a beautiful morning for a wedding, Martha thought. The weather was gorgeous, with a crystal-clear sky from the mountains to the sea. A fresh warm breeze gently played with the festive garlands and garments of the crowd assembled at the tee of the first hole of Kukuna. What a lovely-looking bunch, from the bride and groom in their white finery, to the gaily garbed attendants, to the hip, chic media newshawks and shutterbugs, to the hotel staff and golf course groundskeepers who had been invited to attend the celebration. They all formed a large circle, buzzing with happy chatter.

"Aloha, friends," Martha said, and the party hushed to hear her greeting. "It is my great pleasure to welcome you to this double ceremony. We of Mauna Makai feel especially honored that Margaret Hartwell and Wally Wood have chosen our resort for their wedding, and especially fortunate that we can combine the launching of their happy marriage with the launching of the Kukuna Golf Course, of which we are so proud. May the marriage and the golf course both last forever, full of beauty, pleasure, and fair play.

"Before we begin, let me give you a quick rundown of the events of the day. We'll start by having our resident *kahuna*, Moke Kahoohano, bless the golf course." Martha nodded at the handsome sage, who beamed back through the gentle applause. "Then the golf game will begin." A cheer went up from the groom's side of the wedding party—Wally's Warriors, as they were known in the golf world. "We are especially grateful to Wally and his entourage for being willing to initiate this brand new course. The golfers will walk the course. The rest of you may walk if you wish, but we'll also have plenty of golf carts to take everyone to the fourteenth hole, where the golf game will stop."

"Awww," the Warriors cried in mock disappointment.

"The golf game will stop *temporarily*," Martha continued, "so that the wedding can take place." Meg's attendants cheered. "Then there will be a beautiful brunch." At that, everyone applauded.

"Before turning things over to Moke, let me just thank a few people who have made this lovely morning possible. First, our golf course superintendent, Ted Tamura, who has done such a beautiful job making Kukuna the treasure that it is, a blend of nature and loving care. And he hasn't had an easy time of it, have you, Ted?" Ted grinned and accepted his applause. "I also want to thank our grounds manager, Keoki Kalama, for all he's done to keep things running smoothly through a hectic and sometimes frantic week." Keoki smiled graciously as he, too, accepted

applause. "Of course we must give Sugar Boyd, our Director of Romance, a fine hand for making this a wedding we'll remember forever." Sugar curtsied in her billowing red mu'umu'u. "I'd also like to thank our special friends, Harry Winslow and June Jacobs, without whose help Kukuna might not have opened on time."

As soon as Martha had said that part of her rehearsed speech, she regretted it. Win and June smiled and acknowledged their sprinkling of applause, but they were not standing together, they both wore dark glasses, and, although they were dressed nicely, they both seemed a bit the worse for wear.

"And now," Martha concluded, "allow me to present to you our own *kahuna* and our very dear friend, Moke Kahoohano."

Moke advanced front and center, the picture of dignity in black shirt and pants, his white cassock knotted over one shoulder. An open lei of *maile* leaves hung around his neck. He wore a wreath of red *lehua* blossoms on his head, and on his feet he wore black sneakers. In his left hand he held a wooden bowl of water, and in his right he held two *ti* leaves. He smiled at the crowd and began to speak in Hawaiian.

Ben Kamelele, the resident showman, stood beside him and translated the Hawaiian blessing into English. "Moke is now asking the spirits below ground for forgiveness. He is telling them not to worry. There will be no more troubles here. This land, this *'āina* that covers them now, is much lovelier now than it was when they knew it. In their honor, the land will be kept beautiful. They should be proud.

"Now Moke is talking to you, to us all, to the people here this morning. He is asking us to pray for the peaceful use of this land. Let this land be opened to everybody. May it be a safe refuge for everyone who comes here. Because this land was once a battleground, there are bound to be bones now and then that will work their way to the surface. Let them be. Let no more problems befall them, or us."

Moke nodded his thanks to Ben, who stepped back and re-

joined the circle of witnesses. He stood next to Aiulani and took her hand in his.

Moke dipped a leaf into the bowl, and said, in English, "This *ti* leaf is a reminder of the land and our responsibility to it. If we take care of the land, it in turn will care for us. This water is salted. It symbolizes purity." He turned and waved the wet leaves toward the golf course and the mountains beyond. Speaking first in Hawaiian and then in English, he continued with his blessing. "Bless this Hawai'i we call our home. Bless this ground we step on. Bless all those who have passed before, and all those yet to come. Make the world a more peaceful place. Keep us safe. Guide us and protect us. And let the blessings flow."

Moke beamed a huge smile to the whole circle of guests and staff, then stepped back so that Ted Tamura could come forward.

"Aloha, my friends," Ted said. "Thank you, Moke, for that lovely blessing. It has taken us two years to create the golf course you see before you today. As Mrs. Masters said, it has not been an easy journey. The spirits of the land can be strong-willed, and we had our struggles along the way. But I'm proud to say that we negotiated a good relationship with the powers that be, and the job is now complete. Kukuna is finished and ready for golf. I went over the entire golf course this morning, and I am happy to report that you are about to play golf on the the most beautiful course in the world."

A cheer started with the groundskeeping crew and quickly spread to the entire hotel staff, and on to the whole wedding party.

Wally Wood and his Warriors stepped up to the tee. A ball was placed for the champ, who took a few practice swings off to one side.

"Speech!" called one of the reporters, and the other media people echoed the request.

Wally grinned, holding his driver like a microphone. The crowed hushed. "Well, of course I want to thank Mrs. Masters and the entire staff of the Mauna Makai for treating us to such fine

hospitality. And when we get to the fairway of the fourteenth hole, I have a longer and sweeter speech prepared for my bride-to-be. But right now, I don't feel like addressing you folks. I feel like addressing the ball here. For all you people from the press, and all our friends who came so far to see me swat this sucker, I have only one word. Fore!"

Wally Wood, the darling of the PGA Tour with the U.S. Open, the British Open, and the Players Championship—all of which he had won in the same year—stepped up to the tee, addressed the ball, pulled his club back behind his shoulders, and went into a graceful, powerful swing. The sweet spot kissed that ball goodbye, and it lifted and flew like a god with wings.

31. *Joining Hands*

"Then," Moke sweetly intoned, "I pronounce you husband and wife."

Meg and Wally turned to each other and kissed to the tune of clicking cameras. Martha breathed a sigh of relief. We've gotten this far without a hitch, she thought. A picture-perfect wedding.

When the kiss ended, the bride and groom faced the assembled gathering and bowed to a hearty hand of applause. Sugar came forward and kissed both of them on both cheeks, then turned to the witnesses and said, "We're going to take a few minutes now to do pictures. I'd like everyone in the wedding party to line up here in front of the wall. The photo session will be directed by the official wedding photographer, but I'm sure there are a number of you nice people from the press who will want to take pictures as well. Meanwhile, the rest of us can get started on the champagne and brunch, which has been laid out for you on the other side of the wall, over there. Once again, thank you all for coming!"

Beautiful, Martha thought. All the pictures of this famous wedding would feature the *pāpōhaku* of Kukuna. The image of that wall would soon be as familiar as Mount Rushmore, and the Mauna Makai would become a mecca for golfers, the jewel of the Kohala Coast. It was what Martha and her husband had always dreamed of; it was too bad he hadn't lived to see the dream come true, but perhaps he knew, wherever he was. If so, he was happy today. Everyone was happy today.

Meg was certainly in heaven. There she stood, in her lovely white low-cut gown, beaming like a princess. Apparently she had recovered from that awful snit that had threatened to ruin the wedding. Well, she may have lost a two-cent stamp, but she had won a prize, all right. The most famous, most glamorous, and one of the most wealthy golfers in the world at her side, smiling into her eyes before the entire world. He was handsomely dressed, too, all in elegant whites, although Martha knew from a close-up inspection that his gorgeous shirt had been designed for profit as well as beauty. His collar was decorated with a Macintosh apple on one side and a Pepsi logo on the other, a tiny rendering of the Merrill Lynch bull rode high on his chest (where on plainer shirts one might find an alligator or a polo player), and the colorful stitching that accented the sleeves was a complex design made up of Nike swooshes.

The rest of the wedding party was a festival of color. The four groomsmen, Wally's Warriors, wore matching aloha shirts and white slacks, and the bridesmaids (the "Boston Belles," as Sugar called them) were wrapped in knee-length cocktail dresses made from the same material as the men's shirts.

There they all stood, gracing the wall, holding hands and smiling to the world.

That wall! Thank heaven it had survived the week from hell.

When the photo-shoot was finished, the wedding party relaxed and began to move down the wall toward the lavish buffet spread. As they walked, the bride and groom held hands and three

of the Warriors paired off with three of the Boston Belles; but one of the Belles, Taffy, broke away and found Sonny in the crowd. There, in front of a surprised gang of Sonny's groundskeeping buddies, she grabbed his hands and gave him a happy smooch that turned his face to grinning crimson.

Brunch was beginning, and guests and staff were taking plates of food to tables that had been set up on the fairway during the wedding. To one side of the tables, Keoki had erected a small raised stage, where Ben now played sweet songs on his guitar while Aiulani danced a lyrical hula.

There he was, dear Keoki, sitting at a nearby table and beaming with pride at his daughter. Perhaps he heard wedding bells in Ben's music. Martha wondered how Keoki reacted to weddings. His wife had died ten years ago, and he had never remarried. He seemed blissful, sitting there watching his daughter dance and listening to the songs of the young man who meant so much to her.

Martha heaped her plate with food, tucked a bottle of champagne under her arm, and walked over to Keoki's table and sat down beside him.

June was in a foul mood. Weddings, shmeddings.

She poked her way along the buffet and helped herself to tiny servings of roast pork, scrambled eggs, fruit salad, and croissants. She wasn't the least bit hungry, and she was in no mood for champagne. She carried her plate to the farthest table and sat by herself.

You're a first-class loser, she told herself. Dumped by two guys in one day. Nice going.

Well, Charlie was no great loss. He had been a huge mistake. One hell of a fling, but gone like cotton candy, leaving a sick taste in her mouth and a sicker feeling in her gut. She didn't miss him one bit. And she didn't care where the hell he'd gone to. She wasn't even curious.

The one she missed was Win. Sweet, solid Win, the man of

her life. How could she have done this to him? How could she have done this to herself?

And where the hell had he spent last night?

June was past being jealous about that. Whatever he did, wherever he'd been, whomever he'd been with, she hoped he was happy. He deserved to be happy. She deserved to be lonely and depressed. She deserved to feel unattractive and tired. She embraced her aching heart.

That's the problem with weddings. Everyone looks so happy, so fresh, so well-rested, so hopeful for a bright tomorrow. The guitar in the distance playing lilting melodies, the chatter and laughter of guests, the blue sky, the warm breeze… God, how boring. Borrrring.

June stared at her scrambled eggs. Her dark glasses made them look slightly green. Yuck. She nibbled a croissant. She ate one purplish strawberry. Then she returned her attention to the scrambled eggs.

"May I sit here?"

June looked up at the man who had just spoken. He, too, wore dark glasses.

"It's a free country," she answered.

The man placed his plate on the table and sat down. He took off the shades and reached across the table, offering his hand. "Please," he said. "Call me Win."

She reached out with trembling fingers. His hand felt warm. Strong. Solid. Forgiving.

Sugar glided from table to table, making sure people were enjoying themselves. When she reached the bride's table, Meg leapt to her feet and embraced the Director of Romance. Then the two women smiled at each other and held hands. Meg's smile was the brightest Sugar had ever seen, but then Sugar always felt that way about all her brides. That's what made her job worthwhile.

Meg said, "I'm sorry I was such a little bitch about that wall and about that silly postage stamp. I don't know what got into me. Prenuptual hives, I guess."

"It happens," Sugar said. "I've seen that a lot."

"I'll bet you have. By the way, whatever happened to that little creep who stole my stamp?"

"The gossip is he's still at large. The police tried to cut him off at the airport, but he never showed up. So I suppose he's still on the island, unless he hitched a ride in a power boat."

"Well," Meg said with a carefree shrug, "I'm not going to worry about it now. That stamp was worth a million dollars, but then my husband earns more than that in a year just by wearing billboard signs on his clothes."

"What are your plans now?" Sugar asked. "Off on a honeymoon?"

"We're flying out first thing in the morning," Meg said. "Wally has a tournament to play in Australia, and then there's an exhibition game in Hong Kong. After that, the French Riviera."

"Sounds exciting. Another tournament?"

"No, that one's for me. A shopping trip."

"Oh?"

"Yep. My husband's going to buy me a villa."

"That's lovely. And I'm glad to see you looking so happy."

Meg laughed. "Wouldn't you be?"

The brunch came to an end, and Whambo and his Warriors stood up from their various tables. Each carried an open bottle of champagne to the utility cart where their golf bags were stacked. Whooping, cracking jokes, and swigging straight from their bottles, they stumbled off to find the tee to the fifteenth hole.

Ted, who had joined Martha and Keoki at the table by the stage, said, "I'm glad those guys are walking. They're in no condition to drive carts."

Keoki laughed. "I'm not sure they're in much condition to

walk, either. Let's just hope they don't turn your whole golf course into divots."

Ted shivered.

Martha said, "The course looks lovely, Ted. You've done a splendid job."

Ted smiled. "Thanks. I've got a good crew. And of course Doug Banner's design is the main thing."

"No," Martha said. "The main thing is that you really care about your work. You love this golf course, and it shows."

"The main thing," Ted countered, "is the spirits have finally decided it's okay for us to have a golf course. I don't know how or why it happened, but the spirits have decided to cooperate. They're even helping out my crew. It's amazing."

"What do you mean?" Martha asked.

"You know that bunker out at the sixteenth green? The deep one where we almost lost a bulldozer?"

"How could I forget? We discovered that we were shaping right on top of a lava tube. Don't tell me it caved in again?"

"No," Ted said. "We packed that hole up good and tight with dirt. But I discovered something strange out there this morning when I rode around the whole golf course to be sure everything was in order for today's game. Remember all that wind we had last night?"

"*Hulumano,*" Keoki said.

"You're telling me," Ted agreed. "So I wanted to be sure the course was free of dead wood and stuff, and I wanted to point out to my crew which greens and bunkers had to be cleaned up. I found leaves scattered on some of the greens and in some of the bunkers, but when I got out there to the sixteenth, the green was clean and clear. Explain that."

"Coincidence?" Martha offered.

"I don't think so," Ted said. "I don't think anything that happens on a golf course is a coincidence. But the strangest thing was the sand trap. It was full of beautiful new sand, and it was freshly

raked. I've seen a lot of sand in my day, and this stuff was different from the sand that was in that bunker yesterday. It's finer, it's whiter, it's just…better. And freshly raked. I mean after all that wind last night, how could it look so good?"

"Did you ask your crew about this?" Martha asked.

"Of course. Every single one of them as they showed up. They were eager to get their jobs done so they could get dressed for the wedding, but still I held them up and interrogated each and every one of them. None of them had been out on the course this morning."

"So is there a problem?" Keoki asked.

"Nope," Ted said. "I guess not. I don't like not knowing what's going on, but as long as it's good for the golf course, I'm happy. Well, folks, I gotta run. I want to keep an eye on those golfers. Nothing can tear up a golf course like golfers. I'd rather deal with spirits any day."

Ted stood up, bowed, and smiled. He walked away humming along to the sound of Ben's guitar.

Martha and Keoki sat side by side and watched the party disperse. The golfers, the wedding party, the media, the staff, they all drifted away except for the half-dozen kitchen workers who were busy packing dishes and serving equipment into bussing trays and stacking the trays on utility carts.

Aiulani and Ben walked off the stage and came over to the table. Ben shook hands with Martha and Keoki, Aiulani kissed her father, and they went on their way, holding hands.

"It's been quite a day," Martha said, after they had sat silently together for several minutes.

"Quite a week," Keoki answered.

Underneath the table, Martha reached for Keoki's waiting hand. She squeezed, and Keoki squeezed back.

"Quite a life," Martha said.

32. Magic

Win felt the magic again as his swing hit the ball and sent it high into the air, straight down the center of the first fairway. It soared high and long and finally dropped and bounced for joy, as if the ball itself were eager to keep moving to the cup.

"Nice shot, babe," June said.

"This course is magic," Win said. "When Wally and I played on Tuesday...."

"You played golf with Wally Wood?"

"Yep," Win answered, trying to make it sound casual, as if a round of golf with the great Whambo was nothing extra special. "And we both played rather well, I might add."

"But the golf course wasn't open," June pointed out. "So how did you manage to play a round?"

"It wasn't a full round," Win explained, "and we weren't really playing."

"I see," June countered, with that cute little smirk Win loved. "You were dreaming."

"Drive, June. Just drive. You'll see."

June teed up and addressed the ball. She lifted the head of the driver behind her shoulders and let fly. *Thwack!* Sure enough, her drive was high, straight, and true, and it came to rest beside Win's ball, well along on the way to greenland.

"See," Win said. "What did I tell you? This course is magic."

"I believe in magic," June admitted. "Especially when it concerns Kukuna. But I also think we're both pretty good golfers. Maybe that had something to do with it. Did you really play golf with Wally Wood?"

"Yes. And I'm telling you, we could do no wrong."

"Sneaking onto the course isn't wrong?"

"It was illegal, maybe, but not wrong. Not if Wally Wood did

it." The last thing Win wanted right now was an argument. "I won't do it again," he promised.

"If you do," June said, "take me with you next time."

They kissed and shouldered their bags.

Yes, Harry Winslow and June Jacobs were both good golfers. But there was more to it than that. Kukuna *was* magic, or so it seemed, as shot after shot satisfied and even astounded them. Win was par for the first hole and June got a birdie; Win got his birdie on hole two, and June got a par. Perhaps it was the magic of the course, or perhaps it was the fact that Win and June were finally on vacation. It was Friday afternoon, the wedding party had moved on, the tension in the air around Mauna Makai had evaporated, and the chemistry in the air between the lovers had returned.

Just before they reached the green of the third hole, Win said, "Come with me a sec. I want to show you something." He led her down the trail through the grove of *kiawe* trees. "I want you to tell me if you see anything strange," he said. "Remember that petroglyph of the man with the stick? I want you to tell me if it's been changed."

When they reached the lava scar covered with rock carvings, Win did a double-take. "My God, it's changed!"

"Isn't that what you just said?" June said. "Yes, you're right, it is different."

"But it's been changed *again!*" Win exclaimed. "Look. He's following through."

Indeed he was. That stick figure had the graceful posture of a man who has just completed an excellent golf swing and is watching his ball soar to glory.

"I wonder who could be tampering with the petroglyphs," June said. "That's a crime."

"I'm not tampering," said a voice behind them. "I'm merely working on it."

Win heard the voice and recognized it. He said to June, "Did you hear that?"

"Hear what?"

Oh lord, Win thought. I really am nuts, aren't I? "June, please turn around and tell me if you see anybody."

They both turned to face the voice, and there he was, Angus MacNeil, still in his sailor suit, still carrying that hand-made sandalwood club in one hand. He carried a package under his other arm. A package wrapped in tapa cloth.

Win held his breath.

June smiled and said, "Hello. Nice to see you again."

Win breathed in relief. So he wasn't crazy after all. "You've seen this man before?" he asked June.

"Of course," June said. "He's the one who lives in the cave under hole sixteen. Right?" she asked the old man.

Angus nodded. "I wouldn't exactly call it living, but that's who I am. Angus MacNeil is my name."

"And you're the one who's been changing the petroglyph?" Win asked.

"That's true. It's a work in progress, you see."

June said, "And I'll bet you're the one who's been throwing monkey wrenches into the golf course construction project."

"Well," the old salt answered, "I've had a little help with that. Monkey wrenches can sometimes be rather heavy. But yes, I've done my part to keep things interesting."

"What was that all about, anyway?" Win asked.

"I like to think of myself as what the Hawaiians call an *'aumakua*," Angus explained. "An ancestor ghost. I took it upon myself to make sure this land would be treated properly. This was my wife's family home, you know. They allowed me to live here for all my life, long after my dear wife died. I spent the rest of my days and then some playing golf in these fields. So you can understand that I was upset when a crew of living people started carving the fields up, shoving the earth around as if they owned the place. I got no peace at all, with all that noise and disruption. Those huge machines of theirs roaring around like giants, like dragons, like weapons of

war. They even caved in my cave! Do you know they tried to tear down my wall? I was bloody brassed off, I'll tell you that."

"I can see how that must have upset you," June said.

"The living can be quite arrogant," Angus went on. "As if they're the only ones around. It really is too bad."

"I see your point."

"But then, you know, I convinced them not to tear down the wall, and that's when I became aware that they were intending to turn my fields into a golf course. A proper golf course! At last I might get to play on real fairways and greens instead of stubbly weeds and fields of lava. At that point I decided to let them have their way. Of course I had to get involved from time to time, to make sure the living were doing things right. So I did a few things."

"Did a few things?" Win said. "You mean like making the irrigation system go haywire?"

"Yes, I did that."

"Salt in the fertilizer?"

Angus nodded. "That too."

"The fire? The blood in the bunker?"

"Aye. I did my part."

Win scratched his head. "You sound like a trouble-maker, Mr. MacNeil. How were these pranks of yours supposed to help build the golf course?"

Angus MacNeil squinted his eyes and waggled his club at Win. "I expect you find my methods unorthodox. Well, perhaps they are. But look at the results, Mr. Winslow."

"Call me Win."

"I'll call you Mr. Winslow, if you please. Just look at the results. Have you ever seen a golf course as lovely as Kukuna?"

"You're right," June said. "It has turned out for the best. Kukuna is a fine golf course, perhaps the best in the world, and I'm sure it couldn't have happened so beautifully without your help, even if your help appeared to be a major inconvenience from time to time."

"I'll take that as a compliment."

Win said, "Now that the golf course is finished and open for play, can we count on no more of these monkey wrenches?"

"Well, now, that depends, doesn't it," Angus replied. "As long as the living don't try to take my wall apart again, and as long as they leave my cave alone, then I don't see any reason for me to make any trouble. But as I said, the living can be quite arrogant. And if I feel that I and my fellow spirits aren't shown the proper respect, mind, you'll be hearing from us again."

"That sounds more than fair and reasonable," Win said.

"By the way," said the old sailor. "I have a present for you two." He took the tapa-wrapped package from under his arm and handed it to Win, who accepted it with a bit of trepidation.

"The last time we opened a package wrapped like this, we had trouble for days," he said. "It was a can of worms."

"I can assure you there are no worms in that parcel, Mr. Winslow. Open it."

Win did as he was told, and inside the tapa cloth he found a bright green aloha shirt.

June gasped. "Charlie's shirt," she cried.

"How do you know that?" Win grumbled.

"I wish I didn't know it," June answered. "That's all I'll say." She turned to Angus and said, "Where is Charlie, by the way?"

"Why do you want to know that?" Win muttered.

"I don't, actually," June admitted.

"No," Angus agreed. "That's something you don't want to know. I will tell you that he dropped in on me the other evening. And he gave me that shirt. I don't wear shirts like that, so I'm giving it to you. Try it on, Mr. Winslow."

Win shook his head. "Not my style. I doubt if it would fit me, either."

"Well, at least look at what's in the pocket," the old ghost said with a wink.

Win reached into the breast pocket of Charlie's shirt and

pulled out the torn-off corner of an old envelope. Attached to the brown paper was a two-cent Hawaiian stamp. Missionary Issue.

"Remarkable," Win said. "Astounding."

"Unbelievable," June agreed.

"You'll have more use for that stamp than I will," Angus said. "There's no one I want to send a letter to. All my relatives in Scotland are dead."

"Thank you, Mr. MacNeil," June said. "We'll make sure this stamp ends up in the right hands."

"That's up to you," Angus said. "I've done my part. Now you can do yours."

"Mr. MacNeil," June said, "I want to apologize for patting you on the head in your cave that day we first met."

"Och, don't worry about that. A bonnie lass like you can pat me on the head any time and I won't mind." He winked again.

"Then how would you feel about a kiss on the cheek?"

Angus smiled. Win had never seen him smile before, and the effect was quite unsettling. "Miss Jacobs, I don't think you should do that. If I were made of flesh and blood, I'd be blushing right now."

June said, "I can't help it. I'm going to kiss you." She stepped forward until she was right in front of the old sailor, and she closed her eyes and bent forward to place her lips on his cheek.

Her lips met thin air.

When she opened her eyes, the ghost was gone.

Nowhere to be seen.

Epilogue

After a late dinner on their last night in Hawai'i, June and Win took a long walk, hand in hand, along the beach that stretched from the Mauna Makai down along the side of Kukuna. It was a moonless night, but the blazing stars gave them enough light to walk by. When they reached the overturned boat where Win had so recently shared his sorrow with Sugar, they sat down and embraced.

June said, "Win, I'm dreadfully sorry I got suckered into a shallow romance, and I'm even sorrier that I hurt you so. Will you ever forgive me?"

"I already have," Win assured her. "But I want you to promise me one thing."

"Anything."

"I want you to teach me to be more romantic."

"I'll do that on one condition," June answered.

"Anything."

"I want you to bring me back to Hawai'i. Soon."

"Of course," Win said. "After all we've been through over the past few days, I feel this place has become like another home for us."

"We've gone through a lot, that's for sure."

"It was a good test of our marriage," Win said.

"We aren't married, remember?"

"Well? Why not?"

"Do you mean that?" June gasped.

"I don't know," Win replied.

"Well, when you find out, let me be the second to know."

"I've been thinking," June said, as they walked back to the hotel. "We still haven't told Martha that we've got the postage stamp."

"I'm not sure I want to," Win said. "She's a good person, but is she the rightful owner? Should the stamp go to the resort?"

"We can't keep it," June pointed out. "We couldn't sell it. It's not ours."

"No, of course not. But I'm not sure where it belongs. It's worth a lot of money, and that money could do a lot of good, or a lot of harm. I don't think it belongs in a private collection, or even a museum or a library. But then where? Who? I just don't know the answer."

"Perhaps it's too big a question for you and me," June said. "Maybe we should entrust the stamp with someone wiser than we."

"Are you thinking of the same person I'm thinking of?" Win asked.

"Moke."

"That's my choice too. I don't really know him, but I know enough to know he's wise, and fair, and respected by everyone. He'll know what's right."

Later, out on their *lānai*, gazing up at the stars one last time before bed, June said, "I feel very protective of this place. It's like it's our home. Who will take care of it while we're away?"

"The spirits," Win replied. "Angus and his friends."

"The Night Marchers?"

"And the Menehune. And Pele. And all the rest of the gods."

"You do believe, don't you, Win?"

"When the evidence is this compelling, you bet I do. And June, I want you to know that I believe in you."

"But you can see me," June said.

"Let's go inside. Let's turn out the light. And I'll show you that I believe in you even when I can't see you. I'll prove it."

They went inside and closed the screen door behind them. They undressed for bed, and just before turning out the light they discovered another pillow legend that was waiting for them. Win handed it to June, who read it aloud:

Guardians from the ancient past
Please keep watch over this home
From the top to the bottom
From side to side, from east to west
From the upland side to the seaward side
On the inside, on the outside
Watch over this home and protect it
Keep it safe from trouble
Until we return
Aloha

In the middle of the night, Win felt June stirring beside him. "That's lovely," she murmured.

"What is?" Win murmured back.

"I hear ukuleles. Listen. Can you hear them? Someone's serenading us."

They listened. Yes. Ukuleles.

"Friendly ghosts," Win whispered.

"Yes."

June slipped from the sheets and pattered barefoot to the *lānai*.

Win joined her, wrapping his arms around her from behind.

No one was out there, but the strumming continued, a soft, gentle, lovely lilt in the breeze.

Glossary

a'ā rough lava

āina land

ali'i nobility

aloha hello, goodbye, I love you

'aumakua personal god or ancestor ghost

haku lei braided lei of leaves often worn by male entertainers

Halema'uma'u crater within the volcano that is said to be home to the goddess Pele

hana hou do it again; to repeat, renew

Hāpuna a beautiful white sand beach; also name of a golf resort

haole Caucasian person

hapa-haole part white, part native

heiau pre-Christian place of worship

holokū Victorian-style long dress with a yoke and, often, a short train

holomū a long fitted dress combining the best features of a *holokū* and a *mu'umu'u*

Hualalai a volcanic mountain above the Kona Coast; also name of a golf resort

huhū angry, upset

hui a group, association, or partnership

hula halau hula school

hulumano sudden warm wind that heralds the coming of Night Marchers

imu underground oven, cooking pit for a *lū'au*

kahu honored attendant

kahuna priest, healer, person in tune with the spirits

kama'āina local person, old-timer, Hawai'i resident

Kamapua'a in Hawaiian legend, a creature half-man, half-pig

Kanaloa god of the ocean

Kāne man

kapu taboo, forbidden

kauwā outcasts, slaves

kiawe very common thorny tree

Kīlauea Hawai'i's only (at the moment) active volcano

King Kālakaua often referred to as the "merrie monarch." Reigned from 1873 until his death in 1891.

Kohala the northern region of the island of Hawai'i

Kohala Coast begins at about the Kona airport and extends north for forty miles

Kona Coast southerly part of the island of Hawai'i

Ku god of war

kukuna ray of light
kupuna an elder
lānai veranda, porch
laulau steamed taro leaves stuffed with pork, beef or fish
lehua a lovely feathery red blossom
lomi salmon salted salmon mixed with tomato and onions
lomilomi a unique massage, island-style
Lono god of the elements
lūʻau Hawaiian feast, usually with entertainment
mahalo thank you
mai tai rum and fruit juice concoction
maile shiny, fragrant leaves twined to make an open-faced lei
makaʻāinana what common people were called in the old days
makai toward the sea
malihini newcomer
malo loincloth
mana a supernatural power
mauka toward the mountain
mauna mountain
mele song, anthem or chant
Menehune legendary little people who achieved incredible building
 tasks
moa chicken; a favorite dish at a *lūʻau* is pieces of moa cooked in coco-
 nut milk
muʻumuʻu a long, loose and very comfortable shapeless dress
naupaka small white flower that grows by the ocean and in the moun-
 tains
Niʻihau private island northwest of Kauai, renowned for its seashells
ʻohana family
ōhiʻa distinctive white-barked native tree
pāhoehoe smooth lava
paniolo cowboy
papaʻa burned or cooked very crisp
pāpōhaku old stone wall, usually made of lava rocks
pau finished, over
pilikia trouble, problems
puka hole, opening
pūpū appetizers
pupule crazy
Queen Kaʻahumanu Highway named for the widowed queen of King
 Kamehameha I who united the islands and died in 1819
Queen Liliʻuokalani Hawaiʻi's last queen, sister of King Kalākaua
ti leaf a long leaf of the ti plant that serves many uses
uwehe a provocative dance movement in hula
wahine woman, lady